# ISRAEL
## HISTORY & ART

Twenty Centuries of People and Places

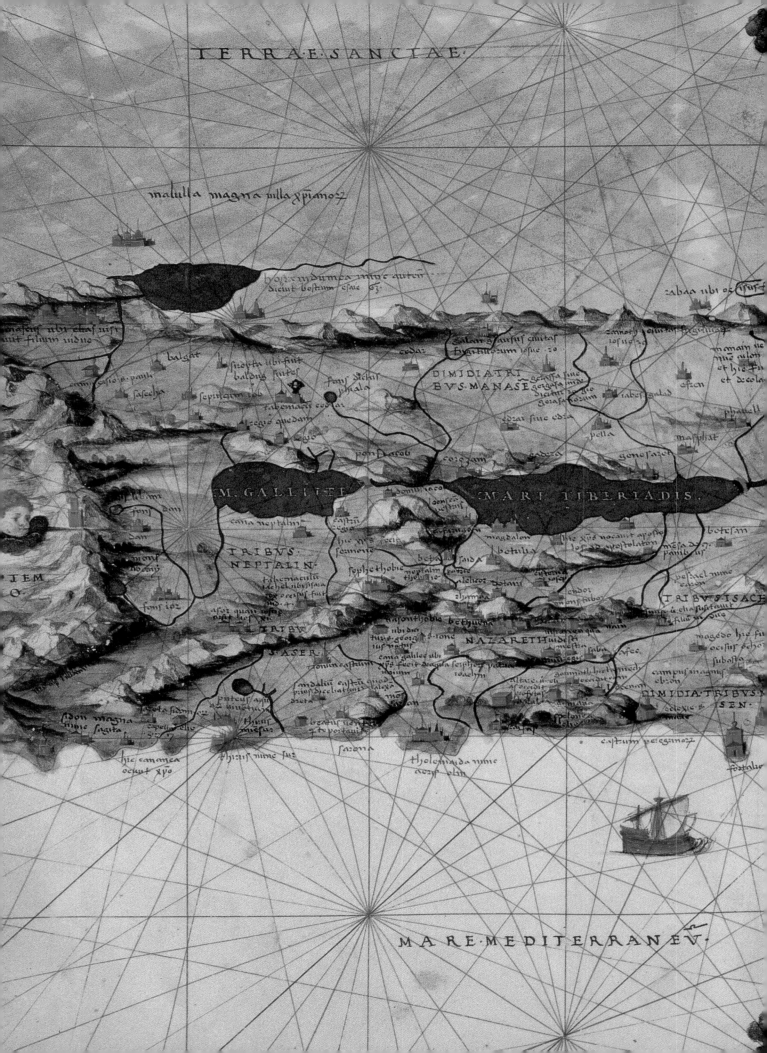

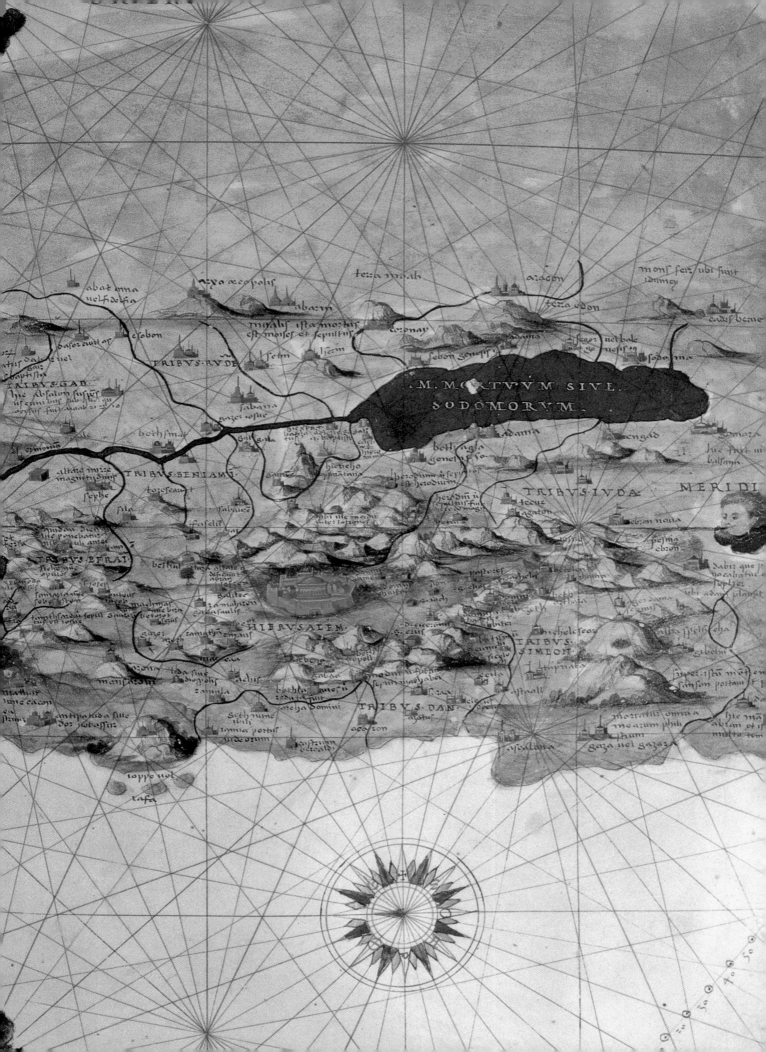

We take pleasure in sharing the magical and
inspiring sites and culture of Israel with you,
as a token of our appreciation.

As we set our sights on new horizons,
we look forward to the fruition
of our common goals.

We wish you years of
prosperity and triumphs.

With kindest regards,

TowerJazz

# ISRAEL
## HISTORY & ART

## Twenty Centuries of People and Places

Dan Bahat, in collaboration with Ram Ben-Shalom

Design: Dafna Graif

# ISRAEL – HISTORY & ART
Twenty Centuries of People and Places

Dr. Dan Bahat – Senior Lecturer at the Department
of Eretz-Israel Studies, Bar-Ilan University, formerly
Jerusalem District Archeologist

Dr. Ram Ben-Shalom – Head of the Department
of History, Philosophy and Jewish Studies, The Open
University of Israel, and Lecturer at the Department
of Jewish History, Haifa University

Editor: David Arnon
Graphic editing and design: Dafna Graif
English translation and text editing: Richard Flantz
Production: David Arnon

Color separations and plates: Total plus Shapiro Ltd.
Printing: Offset AB Ltd.
Gold embossing: Hi-Tec Print Ltd.

© 2010. All rights reserved, Matan Arts Publishers Ltd.
9th Edition-September 2010
MATAN ARTS PUBLISHERS Ltd.

P.O.B. 19 Kfar HaOranim 73134, Israel
Tel: +972-8-9764080, Fax: +972-8-9764081
E-mail: mtn@matan-arts.co.il
Web Site: www.matan-arts.co.il

On the cover:·
In the background: *A Map of The Holy Land*, c. 1574,
Collection Palazzo Farnese, Italy.
Above: Seven-branched bronze candelabrum (menorah),
6th century (the Byzantine period), found in the synagogue at Ein-Gedi,
Collection The Antiquities Authority, The Israel Museum, Jerusalem.
Below: *The Spies*, detail from *A Map of Eretz-Israel*, Amsterdam, 1652,
Private collection.

On pp. 2-3:
*Map of The Holy Land*, by Agnese Batista, 1544, Biblioteca Marciana, Venice

# Contents

# Translator's Note

Three terms – "Israel", "Eretz-Israel", and "the Jewish people" – that appear throughout the translation of this book require an introductory comment. In the Jewish collective consciousness, besides being the name of the state which was founded in 1948, Israel (*isra-el* = "he strove with God"), the name given by the angel to Jacob (Genesis 32:28), is also the name of the entire Jewish people, traditionally the descendants of the tribes of the sons of Jacob, and by derivation, also the name of the land from which the Jewish people stemmed and which is an intrinsic part of its history.

Hebrew also makes specific distinctions by means of constructs: the land is called *Eretz-Israel,* where *Eretz-* means "the Land of", and Israel means both Jacob and the Jewish people; the "of" does not necessarily signify physical ownership of the land, nor even habitation in it, as the history of the past 2000 years makes evident. Similarly, *'Am-Israel* (*'Am-* = "the People of") is the name of the Jewish people, through all its dispersions, while *Medinat-Israel* is the name of the State of Israel, where a portion of the Jewish people constitutes a majority, and which is situated within a portion of the historic *Eretz-Israel.*

*Eretz-Israel* is both a geographical and a spiritual entity. Its boundaries have varied over the millennia, and it has had, and still has, numerous names. In Abraham's day it was called Canaan. For believers of all the three major monotheistic religions, it is "The Holy Land". The Romans also called it Palestine, as it was often called throughout the West until the State of Israel arose in 1948, and this its name in Arabic to this day (*Falastin*). Today we find ourselves looking forward to a peace settlement based essentially on a political partition of the geographical entity between two peoples who feel a historical affinity to its entirety. This affinity is also expressed by the name each people gives to this entity, and for Hebrew-speaking Jews and Israelis its name is *Eretz-Israel.*

Since there is no translation for *Eretz-Israel* other than "Land of Israel", which in English and in most European languages is an awkward structure and also has confusing connotations, this Hebrew name appears throughout the book in English transliteration. To some readers this practice will not be unfamiliar, for it has been appearing in an increasing number of translations. For *'Am-Israel,* however, an accepted "equivalent" exists: "the Jewish people", and that is how this term is translated in the book. Although something is inevitably lost in this asymmetrical proceeding, my hope is that the information in this note will help readers sense something of the resonance of the source in the translation.

# Foreword

Israel, the land and the people – it is doubtful whether a parallel may be found in the annals of human civilization: a land and a people that have existed for several millennia and have known many upheavals, many moments of greatness and decline, and many dramatic events, some of which have had considerable influence throughout the entire world.

In this book we have made it our aim to present the fascinating and magnificent past of Eretz-Israel and of the Jewish people in the past 2000 years, in a way that will arouse interest among as broad a public as possible, and constitute a stimulus to further reading. We have sought to integrate a comprehensive historical description with works of art, archeological findings, and photographs of landscapes, so as to make perceptible the uniqueness of each region and period, and to convey to the reader the spiritual and material aroma of this country throughout all these years.

The task that we took upon ourselves would not have become a reality without an open and fruitful cooperation among the authors, translators, editors, designers and researchers. For their contribution to the achievement of this task, I wish to extend my thanks to Dr. Dan Bahat, a scholar whose writing integrates a profound knowledge of the history and the art of Eretz-Israel with a youthful spirit and an inexhaustible energy to explore this country and the world; to Dr. Ram Ben-Shalom, who narrates the history of the Jewish people in his own lucid and fascinating way; to Dafna Graif, the talented designer; to Daphna Raz, for her punctilious editing of the original Hebrew texts; to Richard Flantz, for his accurate and sensitive translation and editing of the English texts; to the staff of The Israel Museum, and especially to Amalia Keshet; and to the entire staff of Matan Arts Publishers.

David Arnon
Editor and Publisher

# Introduction

About two thousand years ago, after the destruction of the Second Temple, and in the course of the 1st century C.E., the Jewish people gradually began losing its possession of its land. This process led to a prolonged Exile, which came to an end only after the return of a considerable portion of the Jewish people to Eretz-Israel in the 20th century – two thousand years of exile, during which the Jewish people did not cease to hold its distant land sacred, and to long for its future return to its country.

During the 1st century, too, the teachings of Jesus of Nazareth began to spread beyond the borders of this land, and in later centuries Christians became involved in various ways in the country's history. In the 7th century, constitutive events of Islam took place in Eretz-Israel. As a consequence of these developments, the country gradually became a center of attraction for ever-increasing populations throughout the world.

This book lays out before the reader some chapters of the story of Eretz-Israel in these eventful two thousand years, as well as chapters from the history of the Jewish people in the Diaspora, in a way which aims to be accessible to everyone, and at the same time lucid and accurate.

Eretz-Israel has been favored with both physical and cultural diversity. A fascinating variety of landscapes – from the snow-covered mountains and the fertile valleys abounding with water in the north, through the enchanted Mediterranean coasts and the strips of rock mountains in the center, to the arid Negev desert in the south – serves as a backdrop to innumerable events and constitutes an ethnic, national and religious meeting-point probably unparalleled anywhere else in the world.

The first six chapters of the book describe the various geographic regions of Eretz-Israel. Each of the chapters is devoted to a different region, and includes a comprehensive historical survey which is illustrated by artworks, archeological findings, and photographs. The combination of all these media helps to bring to life the unique atmosphere of each region.

The seventh chapter narrates the story of the Jewish people in the Diaspora – the other side of the coin; the people who constantly looked to Eretz-Israel from afar. This chapter, too, is interlaced with representative works of art and folk craft.

Of course, limitations of space make it impossible to include all the windings of two thousand years of history and intensive creation in the one book. Nonetheless, we think that a book such as this one, which integrates content and images in a way that is both comprehensive and compact, – will bring ample reward and pleasure to its readers, both those familiar with the material, and those for whom much of what they find here is new.

Dan Bahat, Ram Ben-Shalom

NAZARETH

**Map by Jan Janssonius** (detail)
Amsterdam, 1657, Laor Collection, Jewish National
and University Library, Jerusalem

# The Galilee

**4 B.C.E.~27 C.E.** Herod Antipas reigns over Judea and the Galilee

**39 C.E.** The Galilee becomes part of the Province of Syria

**138~161** The reign of Antoninus Pius: The Galilee becomes the
most important center for the Jews in the country

**193~235** The reign of Septimus Severus and his heirs: the height of prosperity in the Galilee

**200** The completion of the Mishnah, during the time of Rabbi Judah Ha-Nassi

**4th century** Christianity penetrates into the country
Conflicts between Christians and Jews in the Galilee

**614** The Persians invade the region

**640** Conquest of the region by the Muslims

**1104** Capture of Acre by the Crusaders. the beginnings of Christian rule in the Galilee

**1291** Acre falls to the Mamluks

**1516** Conquest of the region by the Turks

**1917** Conquest of the region by the British

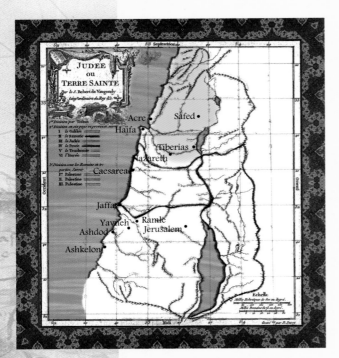

*The Galilee, on a map of the Holy Land from 1790 by
Robert de Vangondy, France*

**Carved stone box**
*13th-14th centuries (the Mamluk period), found at
Megiddo, Collection The Israel Museum, Jerusalem*

lready in the biblical period the northern region of Eretz-Israel was called
"Galilee", but at that time the name referred to a much larger area than
that known to us as the Galilee of today.

The natural boundaries of the Galilee are the Jezreel Valley in the
south, the Mediterranean Sea in the west, the northern Jordan Valley in the
east, and the Litani (or Leontis, in Greek) River in the north. Today most of the area of the Galilee is
contained within the boundaries of the State of Israel, and only its northern portion was torn from it in
the framework of the political agreements that were signed at the end of World War I, when the
Ottoman Empire was divided. The Litani River — which is also called Al-Kasmiyah, *i.e.,* "The Divider"
(between the Galilee and Lebanon) — is today within the bounds of Lebanon.

The Galilee is a unique geographical unit in the landscape of Israel. The two large lakes in it — the
Kinneret (known as the Sea of Galilee) and the Huleh — and the abundance of water that flows from the
springs at the bottom of the high mountains, make it the greenest of the country's regions, a district that
attracts many visitors and tourists because of its manifold beauty.

This northern region is divided into the Upper Galilee and the Lower Galilee. The Upper Galilee is a

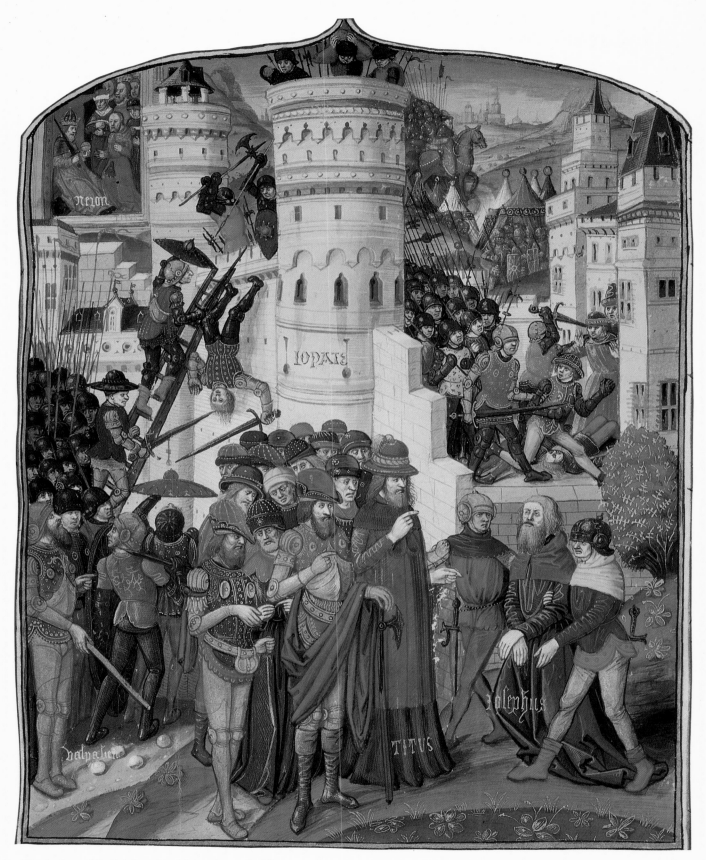

***The Capture of Yodfat: Josephus taken prisoner by Titus***

*From an illuminated manuscript of Josephus'* **The Wars of the Jews**, *France, late 15th century,*

*Collection Musée Conde, Chantilly, France*

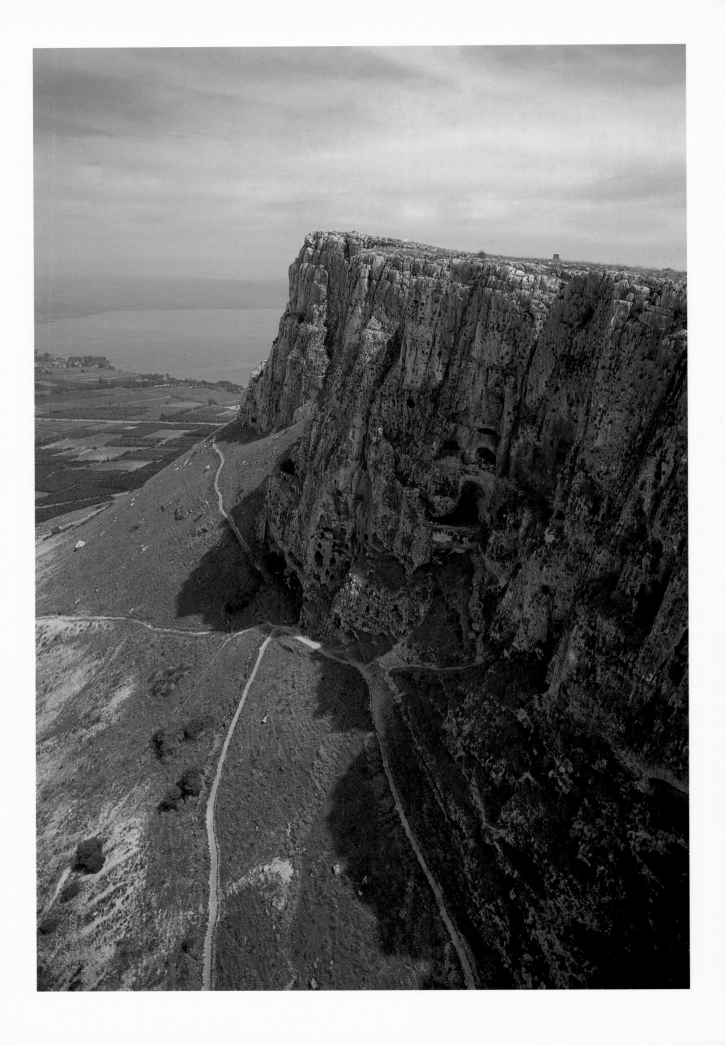

mountainous tract which reaches a height of 1,208 m. above sea level. Its high summits, its many streams and the tangled vegetation around them, create an almost impassable terrain. Hence human habitation in antiquity concentrated mostly around, and to a lesser extent only in, this mountainous tract — and to this day the area has *tells* [mounds] in which ancient Canaanite and Israelite cities are buried. The Lower Galilee, in contrast, abounds in broad valleys sunken among mountains about 600 m. in height. Ways of passage in the Lower Galilee are relatively comfortable, and this region has always constituted a tight geographical unit crisscrossed by trade routes.

The chief route of the "Sea Road" (Via Maris, in Latin), which connected Egypt with Mesopotamia and was the most important trade route of the ancient world, passed through the northern Jordan Valley, which is also included within the Galilee. The history of this district is different to that of the other parts of the Galilee, for it was not always inhabited by the same peoples who inhabited the mountainous Galilee. Another route of the Sea Road passed through the Jezreel Valley and along the Coastal Plain, and for this reason the population of this district resembled that of the northern Jordan Valley. Hence, the history of the region around the mountainous Galilee is connected with events of world importance, while the mountain district itself remained very far from the spotlights and therefore historians know less about it.

The Galilee is mentioned in the Bible several times. The chapters that describe the division of the land among the tribes also refer to the division of the Galilee among the tribe of Asher in the west, the tribe of Naphtali in the north, the tribe of Zebulun in the south-west, and the tribe of Issachar in the south-east. In another place in the Bible we read of the city of sanctuary, Kadesh — situated on the ridge overlooking Lake Kinneret, which is also included within the geographical bounds of the Galilee — as "Kadesh in the Galilee, in [the] mountain [country of] Naphtali". The Bible also mentions "the land of Cabul" in the Western Galilee, and recounts that the towns within its bounds were given by King Solomon to King Hiram of Tyre in return for the latter's

*Seal of Nahmanides*

*Before 1270, found in Spain or Eretz-Israel*

*Collection The Israel Museum, Jerusalem*

*On the facing page:*

**Mt. Arbel, with the Sea of Galilee in the background**

*The Sea of Galilee (Lake Kinneret, Lake Gennaseret, Lake Tiberias) is a body of fresh water with an area of 165 square kilometers and a depth of about 40 meters, situated about 210 meters beneath the level of the Mediterranean Sea. It receives most of its water from the Jordan River, which flows into it from the north, and also from the floodwaters that flow into it during the rainy winter days. The Jordan also flows out of it at its southern end, thus preserving its water from becoming salty.*

*The lake is rich in fish, and already in ancient times the inhabitants of settlements in the vicinity earned their living by fishing. Since the valleys around it are narrow, agriculture does not play an important part in the economy of the local inhabitants. Only the valleys of Genossar and Bteha at its north, and the Jordan Valley at its south permit agriculture; these are also the famous regions in the lake's history, which became famous in the world by virtue of the villages of Capernaum, Bethsaida and Chorazin, which Jesus visited during his journeys in the Galilee. Some of Jesus' disciples, such as Andrew and Peter, were fishermen from this region. The miracles that Jesus performed in the vicinity of the lake, and the synagogues he preached in, made the region a focus of attraction for Christian pilgrims since the rise of Christianity.*

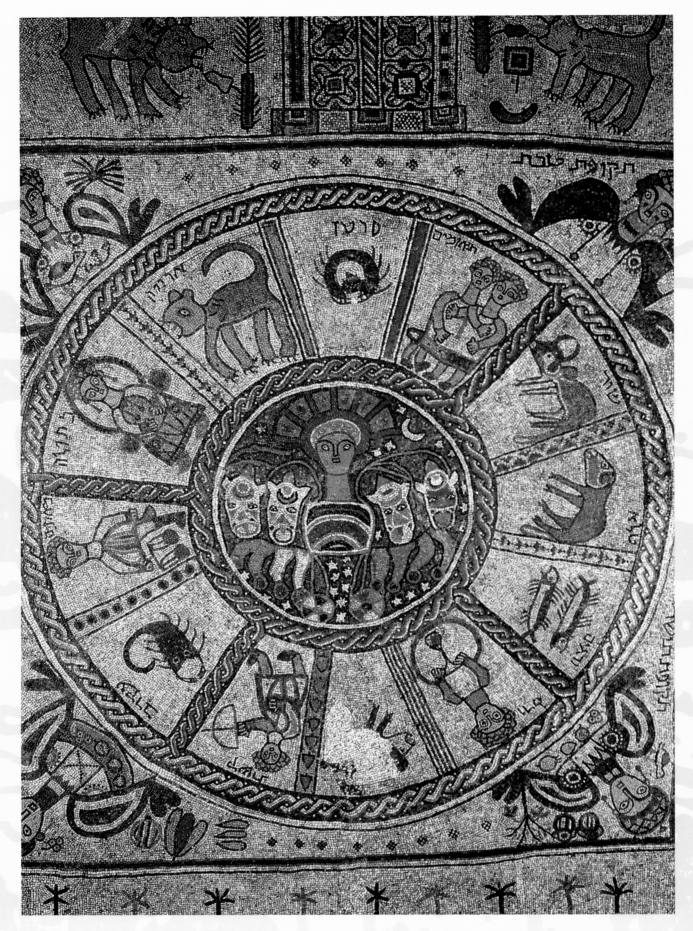

assistance in building the Temple (one of the villages in the Western Galilee is called Cabul to this day). After the break-up of the kingdom of David and Solomon into the kingdoms of Israel and Judah, the entire northern area of the kingdom of Israel was called "Galilee", but after the Assyrian conquest, only the northern province of this kingdom was called by this name. The Bible details the territories that were conquered by the Assyrians, and includes among these "Galilee, the entire region of Naphtali", the latter being the northernmost of the tribes of Israel (apart from a splinter of the tribe of Dan, which was expelled from its heritage in the center of the country and settled in the Canaanite town of Layish, at the north-eastern edge of the Galilee).

Very little information exists about the Jewish Galilee during the Persian and the Hellenistic periods, until the rise of the Hasmoneans. The Hasmoneans' victory over the Seleucid Greeks after a prolonged revolt (167-147 B.C.E.) enabled them to establish a small state in Judea, which gradually extended its boundaries. In the early days of Hasmonean rule, annexation of new districts to Judea had to be approved by the Seleucids, but with the passage of time the Hasmoneans were freed from this requirement. After the collapse of the Seleucid state, and as a consequence of the sense of danger that began to be felt in the country following the migration of Arab tribes into northern Transjordan, the Hasmoneans sought to expand in the direction of the Galilee, which was separated from Judea by the barrier created by the gentile town Caesarea (then still called Stratonos Pyrgos) in the west, through Samaria, to Beit-She'an. Only during the reign of Aristobulus (104-103 B.C.E.) did the Hasmoneans manage to capture Beit-She'an, and thus to penetrate into the Galilee and to annex it to the kingdom of Judea. Before the revolt, the Galilee had been populated mainly by Jews, but during the time of the revolt the Jewish inhabitants were evacuated from the region by Simon the Hasmonean, after they were attacked by the gentiles (the Jews of Arbel, for example, were killed when Bacchides passed through the Galilee on his expedition from Syria to Eretz-Israel).

After the conquest of the Galilee, Aristobulus converted its non-Jewish inhabitants to Judaism, and thus began the glorious period of the Galilee and its Jews, which lasted until Crusader times. The Hasmonean regime divided the country and named its provinces in accordance with the historical division inscribed in the Scriptures, and from then on the name "Galilee" began to refer to the area of land known to us today by this name. In the Hasmonean period the Galilee was not a place of distinctive spiritual creation, and it is mentioned rather as a source of rebellions (against Herod, for example) or as a place of exile (Hyrcanus, for example, sent his banished son Alexander Yannai to the Galilee).

The administrative boundaries of the Galilee, as marked out by Aristobulus, remained unchanged even after the conquest of Eretz-Israel by Pompey (63 B.C.E.). In the Roman and Byzantine periods that followed, the Galilee became the most important center of Jewish settlement in Eretz-Israel. Although Beit-She'an was now no longer part of it, most of its extensive area remained within its bounds throughout the entire Roman-Byzantine period. When Herod was proclaimed king of Judea by the Romans (40 B.C.E.), he was constrained to exert force to take the power from the Hasmoneans, who continued to oppose him from several centers of rebellion in the Galilee. Herod suppressed the opposition with great force, which aroused many of the Jewish inhabitants of the Galilee against him. On Herod's death (4 B.C.E.), the kingdom was divided among his sons, and the rule of the Galilee was placed in the hands of his son Herod Antipas. The division of the kingdom reestablished the barrier that divided between Judea and the Galilee.

This was a period of economic flourishing for the Galilee. From what we read in both the Mishnah and the New Testament, we get a picture of a prospering district whose inhabitants engage in agriculture, fishing in the Sea of Galilee (two of the apostles in the New Testament were fishermen) and various crafts (Joseph, the husband of Mary of Nazareth, was a carpenter). The sources mention the names of many places in the Galilee, but the text does not always make clear whether the reference is

*Head of a Crusader*
Stone sculpture, 12th century (the Crusader period), found in Montfort
Collection The Israel Museum, Jerusalem

On the facing page:
*Zodiac*
Detail from a mosaic, 6th century (the Byzantine period), in the synagogue at Beit-Alfa

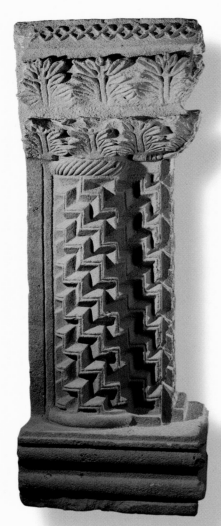

**Column from a synagogue**

*The Byzantine period, found at the synagogue in Khorazin, Collection The Antiquities Authority, The Israel Museum, Jerusalem*

to a village, a town or a city. Nonetheless, it certain that at this time the Galilee was a center of everyday life, and that it had not yet developed into the religious and spiritual center which made it famous after the destruction of the Second Temple. It is known that the religious scholars who were active at Usha in the Galilee had studied in Judea, not in the Galilee; this fact is attested to by Rabbi Yossi ben-Perura, Rabbi Yehuda ben-Alai, and others.

It appears that the Galilee was almost unharmed in the war in which the Temple was destroyed. Although Josephus describes several cruel battles which actually destroyed cities such as Yodfat and Gamla, the Galilee's rapid recovery may indicate that other settlements were not harmed. After a brief respite, however, the ferment against the Romans began again, starting from the Revolt of Trajan (115 C.E.) which occurred mainly in the Diaspora but also had an impact on events in Eretz-Israel, and reached its peak in the Bar-Kochba Revolt (129-135 C.E.).

After the destruction of Jerusalem (70 C.E.), the spiritual center of the Jewish people moved to Yavneh, on the Coastal Plain. This center, headed by Rabbi Yohanan ben-Zakkai, worked to rehabilitate the damage done by the destruction and to maintain its position, until the Bar-Kochba Revolt. After the revolt, the status of Judea in Jewish life was gravely weakened, and when the Samaritans settled in Yavneh the Jews ceased being a majority there.

From the archeological findings we know that the Bar-Kochba Revolt also encompassed the Galilee, but its results there were not as grave as in Judea. The remaining sages therefore gathered in Usha, in the Lower Galilee, where (in about 140 C.E.) they reconvened the Sanhedrin (the highest religious-judicial authority of the Jewish people) and made the Galilee the center of Jewish life in Eretz-Israel. The Jerusalemite priestly families, too, moved to the Galilee, and the places they lived in were frequently mentioned in prayers. The establishment of this center was made possible due to the new conditions that developed in the country during the reign of Emperor Antoninus-Pius (138-161), who succeeded Hadrian, the promulgator of the oppressive decrees that had led to the revolt. Most of the population of the Galilee in this period was Jewish, while the gentiles lived mainly in the large towns, such as Tiberias and Sepphoris.

In the days of Rabbi Simon ben-Gamliel, the Sanhedrin moved to nearby Shfaram, and a relatively short time later to Beit-She'arim, always remaining within the bounds of the Lower Galilee. The flourishing of Beit-She'arim is linked with the personality of Rabbi Judah Ha-Nassi (c. 180-225), who was the Jews' leader during the reign of Emperor Marcus Aurelius, and transformed his city into a spiritual center of world repute; the importance of this center was so great that many Jews from the Diaspora sought to have their bones buried in its famous graveyard. The title *"Nassi"* [literally: "elevated one"; commonly translated as "prince", and in modern Hebrew "president"] designated his leadership of the entire people, not only in Eretz-Israel but also in all the Jewish communities in the world. Its bearer received the respect due to a king, and many legends spread among the people about the extraordinary connections between Rabbi Judah Ha-Nassi and the emperor. After Rabbi Judah's death and his burial at Beit-She'arim, the Sanhedrin moved to Sepphoris.

The accession of Constantine the Great to the throne of the Roman Empire made possible the gradual absorption of Christianity throughout the Byzantine Empire, which had seceded from the Western half of the Roman Empire. In the Galilee, too, the number of Christians kept increasing. We know, for example, about the missionary, Joseph the Apostate from Tiberias, who attempted to establish churches throughout the Galilee and was rejected by the Jews. Christianity, however, continued to develop in the region, and already at the Church Council in Nicaea (325), the Galilee (although not its major cities) was represented. The new state of affairs resulted in intolerance towards the Jews, and the increasing number of confrontations led to a Jewish revolt which was centered in the Galilee (the Revolt of Gallus, 351). At various sites from this period which have been excavated in the Galilee, archeologists have discerned signs of the destruction which occurred there following the revolt. Shortly afterwards (162-63), a severe earthquake struck the Galilee, and the remainder of the fourth century is marked by efforts to rehabilitate the Jewish communities there.

Many documents and archeological findings attest to Christendom's increasing hold on the Galilee. The documented events include the participation of the Bishop of Tiberias at the Lateran Church Council in Rome (449), the appearance of a representative of Sepphoris at the Church Council in Chalcedon (in present-day Turkey) (451), while the findings include the discovery and excavation of many churches throughout the entire Galilee, both the Upper and the Lower. Concurrently with these phenomena there

is also a discernible decline in Jewish creativity in the Galilee at this time, but this should not lead us to conclude that the Jewish population there decreased: on the contrary, the Galilee continued to be an important Jewish center. The center of Jewish activity in this period was located in Tiberias, for since the abolition of the position and powers of the *"Nassi"* in 415 by command of Emperor Theodosius II, the

*On the following pages:*

### Mt. Tabor

*Mount Tabor is situated in the heart of the Jezreel Valley and rises to a height of about 550 meters above the valley below it. These physical features have contributed to its conspicuous presence throughout all the periods. In the biblical period the mountain served as a border point at the juncture of the inheritances of three tribes. It is described as the place where the Israelite tribes assembled under the leadership of Deborah and Barak in their war against the Canaanites. Torches used to be lit on the mountain, and the war between the Roman commander Pompey and Alexander the Hasmonean was waged in its environs (63 B.C.E.).*

*In the Christian tradition, Mount Tabor is thought of as the Mount of the Transfiguration. The New Testament (Matthew 17:1-13) recounts that Jesus ascended the mountain with three of his disciples, and that he was transfigured there while Moses and Elias appeared before him. Although the name of the mountain is not mentioned, early Christian traditions associate the event with Mount Tabor, and already in the 6th century a church was built on its summit, and attracted many pilgrims.*

head of the Tiberias *Yeshivah* was considered the leader of the Jews. Tiberias was also a center of pilgrimage for Jews from all over the world as long as the prohibition against Jews entering Jerusalem remained in force. The number of Jewish inhabitants in Tiberias was so great that in the earthquake which hit the town in 749, thirty synagogues were destroyed.

With the conquest of Eretz-Israel by the Muslims (638-641), Jews were once again permitted to live in Jerusalem, and the first to go there were Jews from Tiberias. But the Jewish communities in the Galilee, with Tiberias as their center, continued to prosper during the period of Muslim rule as well, and at this time too the head of the Tiberias *Yeshivah* was considered the leader of World Jewry. It was in Tiberias that the "Tiberian" method of marking vowel points in Hebrew was invented, and this is the method that is employed in Hebrew to this day. One of the main sources of livelihood in Tiberias was based on the hot springs adjacent to the town, and we also know about a "Jews' Market" which existed there. The Jews of the Galilee continued to conduct their routines of life throughout the Muslim period, as we learn from various sources which mention the names of many Jewish villages in the Galilee. Most of the villages mentioned are in the Upper Galilee, in the vicinity of Safed, about which the documentation is relatively sparse.

In 1033 another severe earthquake occurred in Eretz-Israel, and caused damage to many places of settlement. Various documents from the period inform us about the existence of Jewish communities in these places. Villages or towns which had been fortunate and were in a relatively good situation received

***Gold diadem with semi-precious stones***

*The late Roman period, found in a tomb at Kfar Giladi, Collection The Antiquities Authority, The Israel Museum, Jerusalem*

requests for assistance from settlements that had suffered greater damage, and from these letters we learn about the existence of settlements such as Gush-Khalav, Achbara, Ein-Zeitim, Kfar-Manda, and others.

The arrival of the Crusaders in Eretz-Israel raised the Galilee to a central position in their regime.

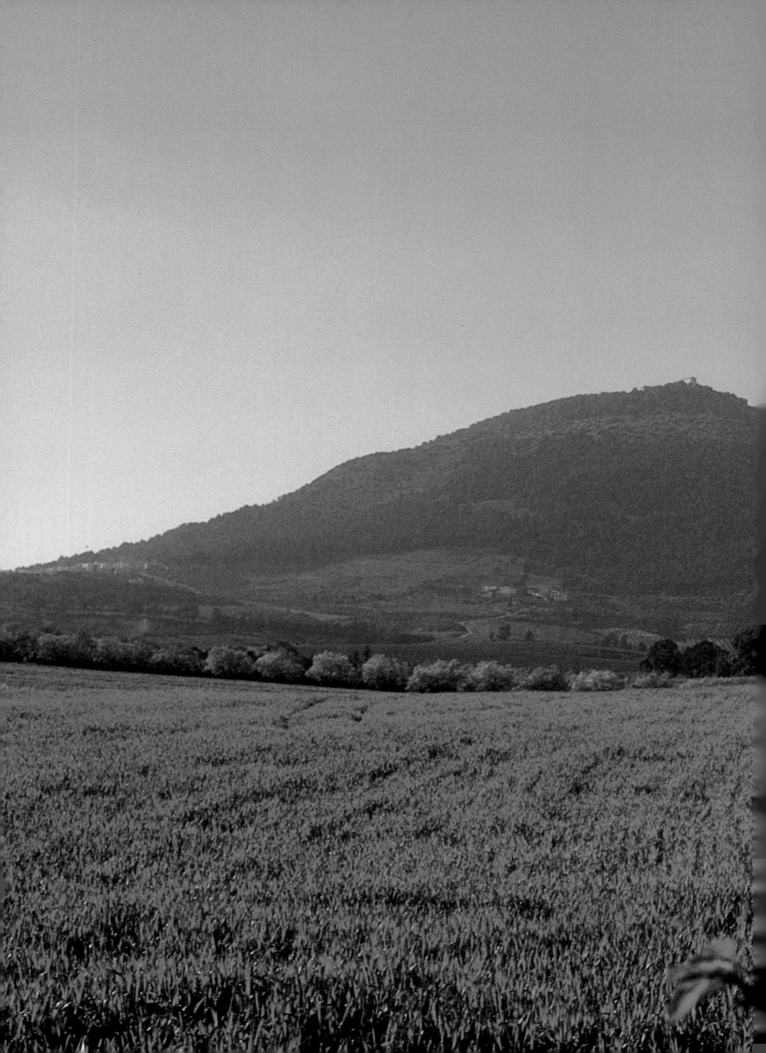

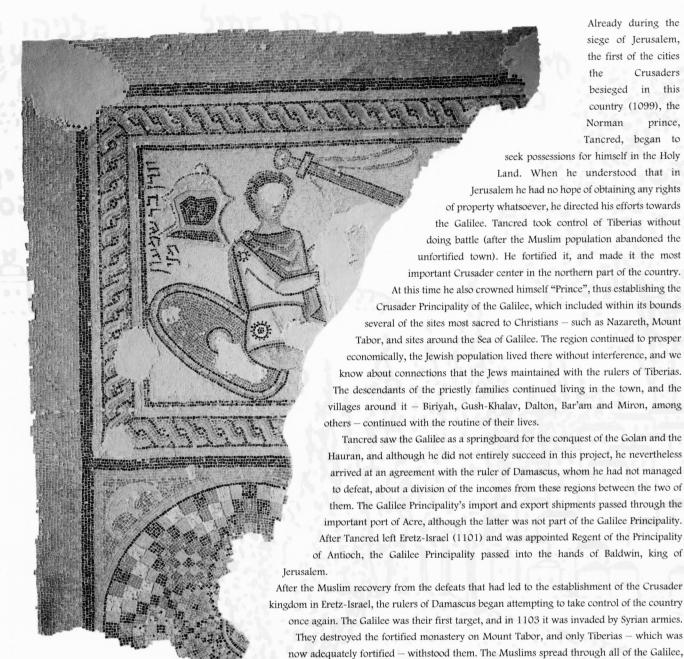

**Mosaic fragment**

7th century (the Byzantine period), found at the synagogue in Meroth.
Collection The Antiquities Authority, The Israel Museum, Jerusalem

Already during the siege of Jerusalem, the first of the cities the Crusaders besieged in this country (1099), the Norman prince, Tancred, began to seek possessions for himself in the Holy Land. When he understood that in Jerusalem he had no hope of obtaining any rights of property whatsoever, he directed his efforts towards the Galilee. Tancred took control of Tiberias without doing battle (after the Muslim population abandoned the unfortified town). He fortified it, and made it the most important Crusader center in the northern part of the country. At this time he also crowned himself "Prince", thus establishing the Crusader Principality of the Galilee, which included within its bounds several of the sites most sacred to Christians — such as Nazareth, Mount Tabor, and sites around the Sea of Galilee. The region continued to prosper economically, the Jewish population lived there without interference, and we know about connections that the Jews maintained with the rulers of Tiberias. The descendants of the priestly families continued living in the town, and the villages around it — Biriyah, Gush-Khalav, Dalton, Bar'am and Miron, among others — continued with the routine of their lives.

Tancred saw the Galilee as a springboard for the conquest of the Golan and the Hauran, and although he did not entirely succeed in this project, he nevertheless arrived at an agreement with the ruler of Damascus, whom he had not managed to defeat, about a division of the incomes from these regions between the two of them. The Galilee Principality's import and export shipments passed through the important port of Acre, although the latter was not part of the Galilee Principality. After Tancred left Eretz-Israel (1101) and was appointed Regent of the Principality of Antioch, the Galilee Principality passed into the hands of Baldwin, king of Jerusalem.

After the Muslim recovery from the defeats that had led to the establishment of the Crusader kingdom in Eretz-Israel, the rulers of Damascus began attempting to take control of the country once again. The Galilee was their first target, and in 1103 it was invaded by Syrian armies. They destroyed the fortified monastery on Mount Tabor, and only Tiberias — which was now adequately fortified — withstood them. The Muslims spread through all of the Galilee, but lacked further plans and finally withdrew. The importance of the campaign, as the Muslims saw it, was that it had proved their ability to expel the Christians from the region.

Throughout the entire Crusader period, the Galilee Principality served as a wall of defense for the kingdom, and the annals of the period are full of descriptions of the Muslim attempts to take control of the areas adjacent to the Galilee, and of the successes of the rulers of the Galilee — in most cases with the assistance of the kings of Jerusalem — in expelling them. The Galilee Principality remained the most important principality in the Crusader regime, even though in 1107 the Seignory of Tibnin (today in southern Lebanon) and small seignories in the Jezreel Valley (Jezreel, Lajun and Jenin) were torn away from it.

With Saladin's successful unification of Egypt and Syria, the Muslims began to make seasonal attacks on the Crusader Kingdom of Jerusalem. In the course of this prolonged war, the Crusaders again attempted to conquer Damascus (1182), but apart from demonstrating the kingdom's power, the battle achieved nothing. The final and crushing offensive by the Muslims, which brought destruction upon the entire Crusader kingdom, took place in the Galilee: Saladin's army deployed itself south of the Sea of Galilee, in an area then called Ikhawana, and from there invaded the Galilee by way of the Jezreel Valley

and the Beit-She'an area, because Tiberias was well fortified. After the capture of Tiberias, Saladin advanced in the direction of Sepphoris, where the main force of the Crusader army was concentrated. The armies met at the Horns of Hattin, and in this battle the Crusader army suffered a crushing defeat which in effect eliminated the Crusader kingdom (4 July 1187).

The campaigns conducted by the Crusaders in their attempt to reconquer the country and renew their kingdom all took place on the coastal plain of the Galilee (1189), and their capture of Acre (13 July 1191) opened the way for the constituting of the second Crusader kingdom. After establishing themselves at Acre, the Crusaders gradually began expanding their holdings in the direction of the Galilee. In the course of a brief period the Galilee was again brought under their rule, although within more limited bounds, which extended to Nazareth and encompassed the roads leading to it from the Coastal Plain. Most of the Crusader remains known to us in the Galilee — such as those in Acre, Montfort, Yehi'am and Safed — are from the period of the second kingdom. In the 13th century, struggles took place among the heirs of Saladin, who had died in 1192, and these struggles had an influence on the course of events in the country. The Crusaders occasionally came to the assistance of one side

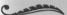

*Below:*

### Nazareth

*David Roberts (1796-1864), 1842, Stapleton Collection, London*

*Nazareth, a city in the Galilee which today serves as a regional administrative center, is not mentioned in ancient Jewish sources. Since archeological excavations have proved the continuous existence of settlement there throughout the First and Second Temple periods, this absence of reference in the sources is not adequately understood. Later sources refer to the habitation of Jews in the city, among them one of the 24 priestly families, the Pitzetz family.*

*Nazareth became a focus of world interest and a most sacred city for Christians because it was the abode of Jesus's family during his childhood and adolescence, and also the place where he became aware of his mission.*

*With the spread of Christianity, a strong Christian community began to grow in Nazareth, and churches were erected there. During the Crusader period Nazareth became a central city, and then the Church of the Annunciation, one of the most magnificent Crusader churches in the country, was built there. The first modern road in the country was built between Haifa and Nazareth, to provide easier passage for the pilgrims who made regular visits to the city.*

or another, and thus were able to expand their territory in the Galilee as far as Banyas (1240). The entire Galilee again came under the rule of the Crusaders, who began to rebuild the fortifications that had been destroyed by the Muslims.

In 1244 warriors of the Turkish Khwarazmi tribe invaded the country and damaged villages and towns throughout the entire country, although it appears that these were rapidly rehabilitated. In 1250 the Mamluks took control of Egypt, and they too began fighting the Crusaders. In 1260 the Mongol army, too, arrived in Eretz-Israel, filling all its inhabitants with terror. But in the end the Mongols were defeated by the Mamluk army at the Battle of Ein-Harod (Ein-Jalud), and were expelled from the

country. The Mamluks began destroying every important Crusader site that fell into their hands, such as the Church of the Annunciation in Nazareth, and essentially continued the policy that had been initiated in the period of Saladin's heirs, who had managed to dismantle the fortifications of Mount Tabor, Banyas, Safed, and Belvoir (Kochav-Hayarden). By 1226, it appears, all the Galilee was in the hands of the Mamluks, apart from enclaves such as Montfort, Safed, Hunnin and Tibnin, which were also captured gradually. With the capture of Acre in 1291, the second Crusader kingdom came to an end, and the Galilee was annexed into the bounds of the Mamluk state.

Throughout the entire 13th century the Galilee managed to preserve its distinctive Jewish character, and a variety of documents by visitors to the region attest to the central presence of the Jewish settlements there. The settlements mentioned in these documents are all known to us from previous centuries, and from this we may learn that the many upheavals that occurred in the country during this century did not significantly affect their situation.

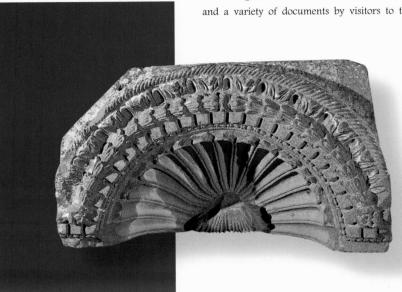

In the framework of the Mamluk state, all of Eretz-Israel was part of a single administrative unit, which also included Syria and Transjordan. In this period, the Galilee belonged to the Safed governorship, but it was Damascus that administered matters of state which went beyond issues of everyday life. Safed was the seat of a number of officials of the local administration: the superintendent of the mail horses, the superintendent of the ruler's property, a chief judge, the superintendent of the markets, and others. The Mamluk mail routes — the development of which was an important achievement for this long and narrow state, where communication by mail was essential for its existence — passed through the Galilee. One mail route led from Jenin through Beit-She'an to Irbid in Transjordan, and another led northwards from Jenin, through Hattin and Safed, to Damascus. *Khans*, wayside inns, that were built along these routes, remain standing to this day in several places in the Galilee. As a rule, the Mamluks specialized in building, and some of the beautiful buildings that they built have remained standing in the Galilee — such as the *khans* at Beit-She'an, the hospital at Safed, and the water-supply structures in this city.

A number of Christian centers, such as Nazareth and Tiberias, remained active in the Galilee. Produce from the Galilee was brought to the port of Acre, where it was sold to merchants who came from Italy to buy imported goods from the East. A 14th-century document describes the Galilee as a region rich in a variety of agricultural crops. Jews, too, lived in some of the places referred to in the description — Alma, Dalton, Gush-Khalav, Amuka, Bar'am, Kfar- Hananiah, etc., — and their occupations included house-whitewashing, commerce, perfume-making, and peddling. The Jews had a custom of making pilgrimages to the grave of Shimon bar-Yochai in Meiron, and before this to the homes of Hillel and Shammai, who had lived there — and similarly to them Christian pilgrims, too, began visiting places sacred to them in the Galilee. In the 14th century the book *Kaftor vaPerach* ["Flower and Bud"] by Ashtori Haparchi — a book describing the geography of Eretz-Israel, which has not lost its freshness to this day — was written in Beit-She'an. Many Jews settled in Safed, which in the 15th century became the largest Jewish center in the country, and was encompassed by a number of other Jewish villages.

In 1517 the country was conquered by the Ottoman Turks. In Safed the heads of the community were massacred, but on the whole the Ottoman occupation was not a harsh one, and it improved the security situation in the country. In the 16th century the Ottoman Empire was ruled by sultans who were benevolent to the population — the most famous of these being Suleiman the Magnificent — but already in the 17th century a rapid deterioration began in the various systems of governance. Corruption among the local governors spread rapidly, and life in the Empire lost much of its quality. Safed remained the capital of the province, which was divided into the precincts of Safed, Tavnin, Tyre, Beaufort, Acre and Tiberias — but with the passage of time the administrative division was changed, and Safed became the

*Ornamental stonework*

The Byzantine period, found in the synagogue at Khorazin, Collection The Antiquities Authority, The Israel Museum, Jerusalem

center of a *sanjak* [district] within the framework of the Damascus sector. The frequent changes of administrative divisions, and the distance of the rulers from the regions under their rule, resulted in anarchy. The Bedouin tribes revolted and harassed the population, which also suffered from arbitrary tax-collecting by the governors who replaced one another in rapid succession.

The history of Eretz-Israel during the 17th and 18th centuries is characterized by the rise of local rulers, who fought against the central government and created independent states for themselves until they were removed from office by the Turkish central government. Already in the late 16th century, the Galilee had a local ruler named Fahed a-Din, who annexed the province of Safed to his domain in 1602. In the 18th century the Galilee was ruled by Daher al-'Amar, who made Tiberias his capital. He fortified the Galilee, and remains of his fortifications can be seen to this day not only in Tiberias, but also in Acre, Deir-Hanna, Yechiam and elsewhere. Daher al-'Amar was called "King of the Galilee", after the region which was the center of his activity, and developed trade links with European merchants who arrived at the port of Acre. In diverse ways he conquered most of Eretz-Israel, apart from the Jerusalem region, but in the end he fell to the Sultan, who succeeded in killing him in 1775, after about half a century of his rule in the Galilee. After his death the Galilee was taken over by another local ruler, Jazar Pasha, who made Acre his capital (1776-1804). For some time the Galilee suffered from the struggles between Daher al-'Amar's heirs and Jazar Pasha, who established his rule after succeeding to suppress the Bedouin of the Galilee.

At the end of the 18th century (1799), Napoleon reached Eretz-Israel and halted outside the walls of Acre, which he placed under siege. In the end Napoleon discontinued the siege of Acre and retreated to Egypt, thus giving a great boost to the prestige of Jazar Pasha, whose relations with France were not good in any case. Our knowledge about the Galilee in this period is quite extensive. It appears that in the 18th century, with the deterioration of the security situation as a consequence of the struggles described above, the agriculture in the region became sparse (whereas in the 16th century 280 villages,

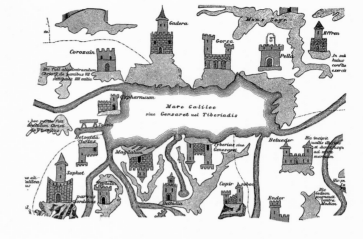

**The Sea of Galilee and its environs**
*Detail from a Latin map of the Holy Land,*
*c. 1300. Collection The Municipal Library,*
*Florence*

**Map by Jan Janssonius** *(detail)*
*Amsterdam, 1657, Laor Collection, Jewish*
*National and University Library, Jerusalem*

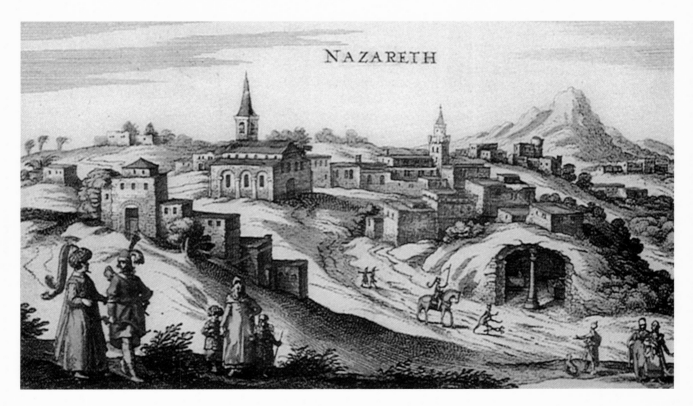

with many hamlets beside them, had been counted in the Safed province alone), and the number of inhabitants began to decline.

No discussion of the history of the Galilee under the Turkish rule can be complete without mentioning the centrality of Safed in the life of the Jews in this period, and the unique creativity that brought it glory from the 16th century on. At this time Jews from Portugal and Spain began arriving in the country, and established a movement for the renewal of the Sanhedrin, thus expressing the aspiration to renew the centrality of Eretz-Israel in the life of Jews the world over. A messianic movement was born in Safed, and important works were written there, such as the *Shulhan Aruch* ["Prepared Table"] — the authoritative codex of Jewish observances to this day — by Rabbi Joseph Caro (1555). Several years after the publication of this book, the first printing press in this city was set up. Safed became a center of Kabbalist circles who were influenced by the Holy Ari (Isaac ben Solomon Luria, 1534-72), who composed his famous book, *The Zohar*, in Safed.

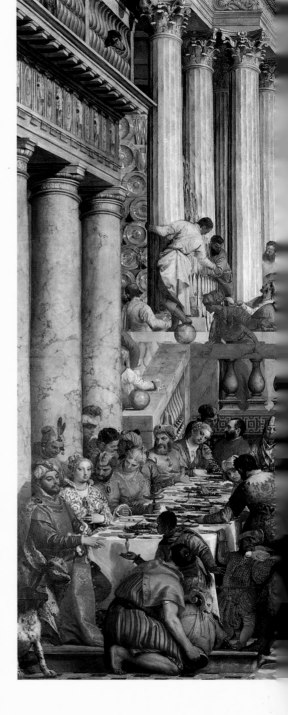

In the course of the 19th century the disintegration of the Ottoman Empire became more rapid, and one consequence of this was a great increase in the influence of the European powers in Eretz-Israel. The Galilee was pushed to the periphery, while the coastal areas and their port towns prospered. Soon, however, the region began to feel the effects of the new winds of the 20th century, which were brought there by the Zionist movement with the beginnings of new Jewish settlement in the Coastal Plain and in the Galilee.

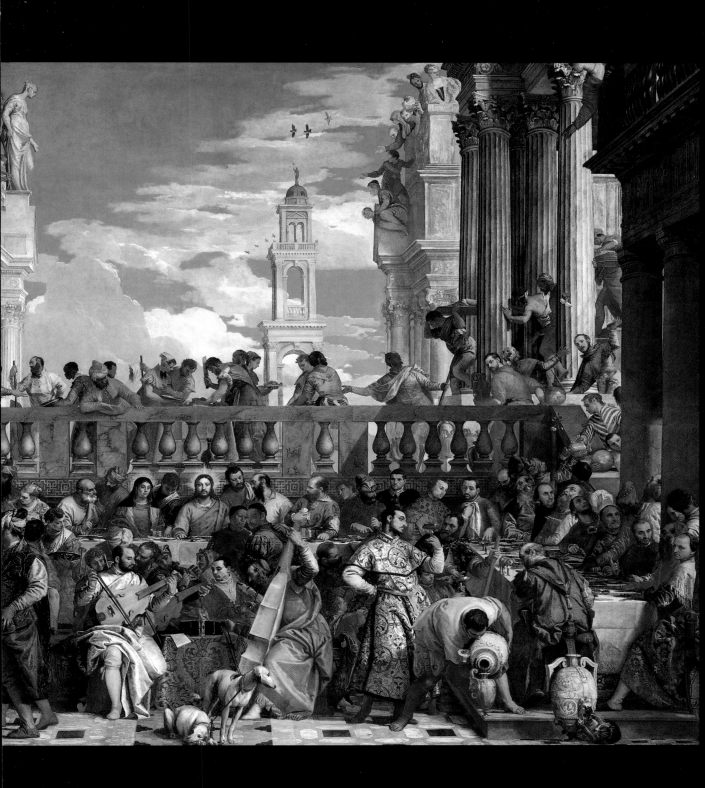

*The Wedding at Cana*
Paolo (Caliari) Veronese (1528-1588),
1562-63, Collection The Louvre, Paris

**Tiberias Landscape** (detail)

*Nachum Gutman (1898-1980), 1928*

*Collection The Israel Museum, Jerusalem*

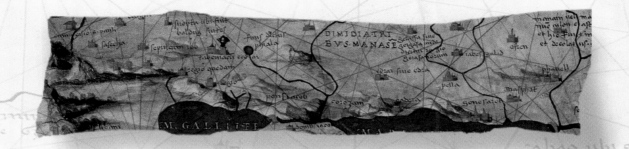

# The Golan and the Jordan River

**4. B.C.E.~3 C.E.**  Ruled by Philip, son of Herod

**39 C.E.**  The Golan becomes part of the Roman Province of Syria

**4th century**  Beginnings of Christian expansion in the Golan

**640**  Conquest of the Golan by the Muslims

**12th century**  The Golan is a battleground for conflicts between the Crusaders
and the rulers of Damascus

**13th century**  Various Ayyubid princes fight one another in the Golan

**14th~15th centuries**  The Golan is a transit area in the Mamluk state

**1516**  The Golan is conquered by the Ottomans and becomes less important

**1917~1920**  The Golan becomes part of Syria under the French Mandante

**1946~1967**  Syria rules over the Golan

**1967**  Beginning of Israeli rule

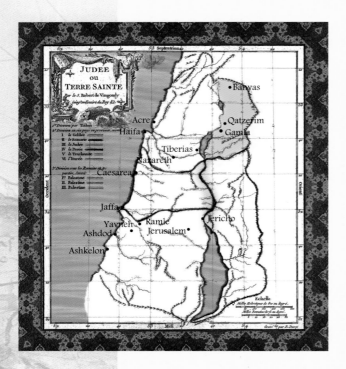

**The Golan and the Jordan River,** on a map of the Holy Land from
1790 by Robert de Vangondy, France

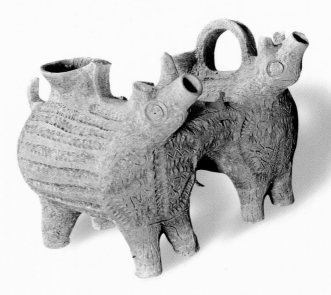

**Bull-shaped twin vessel**
4th-5th centuries (the Byzantine period)
Found at Beit-She'an, Collection The Israel
Museum, Jerusalem

riginally the name "Golan" referred specifically to one of the
"sanctuary towns" situated in the Bashan region, within the
territorial bounds of the northern half of the tribe of Manasseh;
the precise location of this town is unknown. In the Second
Temple period the name "Golanitis" is mentioned in the writings
of the historian Josephus Flavius, now as the name of a region; and in the Byzantine period
the name "Golon" appears in the writings of Eusebius, a 4th-century Church Father, and
here it designates a large village, but nothing in the texts of these authors either informs us
of the precise location of the places they refer to. A village which to this day bears the
name Saum Al-Jaulan may perhaps cast light on the location of the ancient Golan: from its
position we may conclude that the ancient Golan of the tribe of Manasseh extended
northwards of the present-day Golan. During most of the biblical period this region was
within the bounds of the country of the Arameans, and for this reason it is hardly
mentioned in the Scriptures.

The present-day Golan is well-defined in the political sense: following the 1967 Six-Day
War, the region was annexed into the bounds of the State of Israel. Before this it had

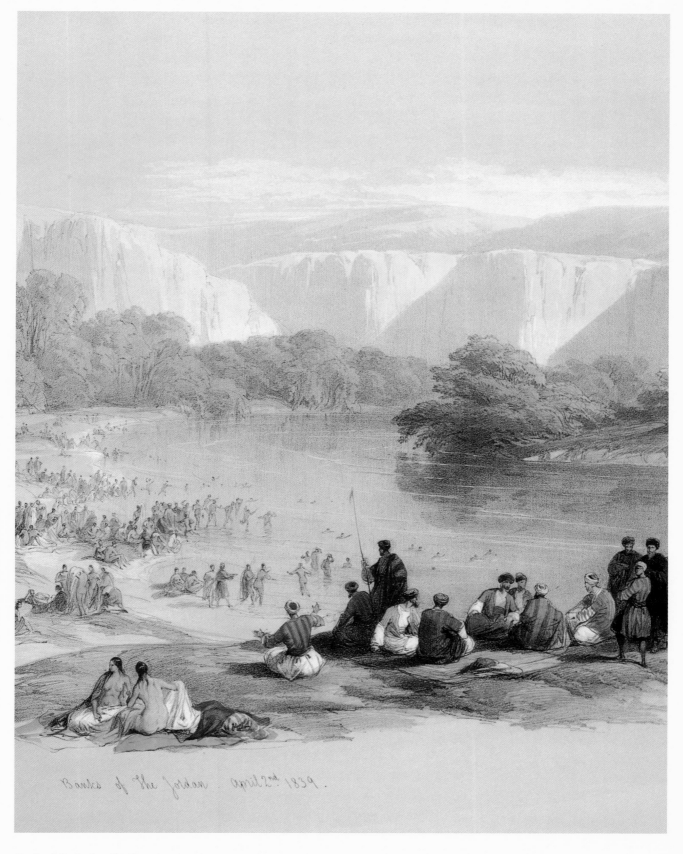

**Banks of the Jordan** (detail)

David Roberts, 1839, Stapleton Collection, London

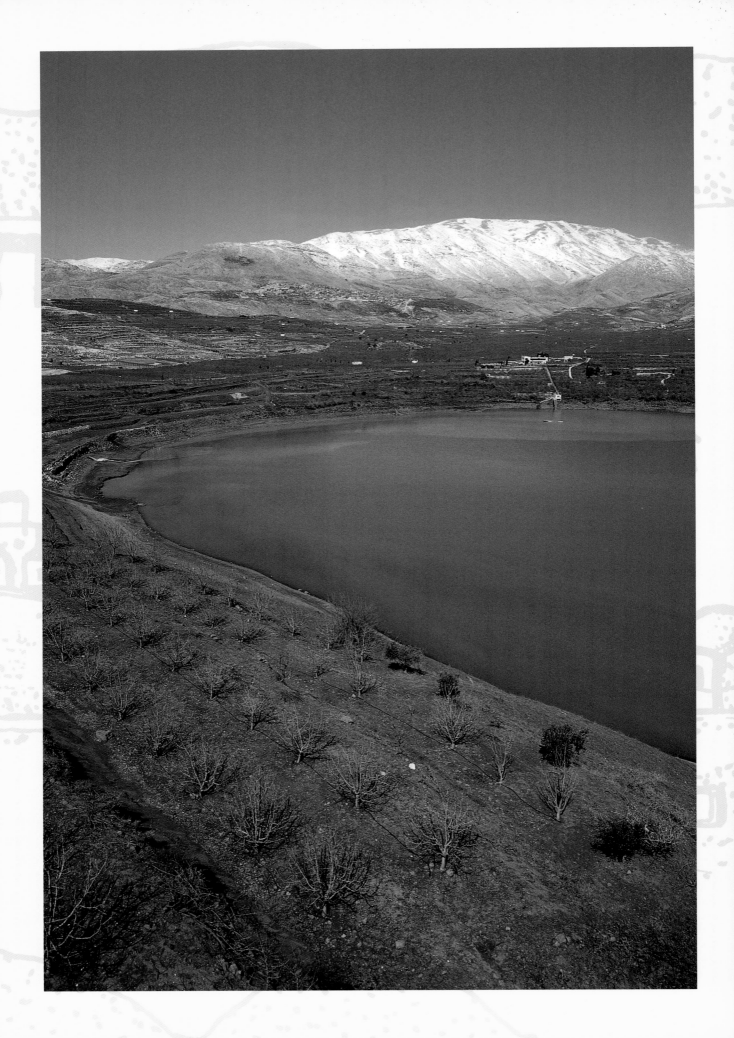

belonged to Syria, which had received it at the end of the First World War as an outcome of border agreements between England and France, and had ruled there for over twenty years.

The geographical boundaries of the Golan are the southern slopes of Mount Hermon in the north; the Yarmuk River in the south; the Jordan Valley, from the sources of the river to the Sea of Galilee, in the west; and the Rukkad River, from its sources to the point where it flows into the Yarmuk, in the east. The Golan is thus a well-defined geographical unit. The entire region is characterized by its volcanic landscape, the result of ancient activity of volcanoes in the eastern Golan. These volcanoes are extinct today — but the lava they emitted at the time covered the entire region with a thick layer of black basalt. Black basalt stone is therefore the most common building material in the Golan.

The Golan country is rich in water, although it contains no large creeks, only flat streams that conduct water throughout most of the year, beside which many villages were established in ancient times. Here and there remnants of the ancient forests which once covered the region may be found in the Golan, where the annual rainfall ranges between 300 mm. in the south to 1200 mm. on and around Mt. Hermon in the north. Furthermore, some of the most important roads in the Middle East pass through the Golan — such as the road from Egypt to Damascus, and the road from Damascus to the Mediterranean Sea, which passes south of Mt. Hermon.

From the Muslim period until more recent times, however, the Golan was relatively unpopulated, and for this reason historical sites from more ancient periods were preserved there in much better condition than contemporary sites in other parts of the country.

With the development of towns in Eretz-Israel at the beginning of the third millennium B.C.E., fortified towns began to arise in the Golan as well. For the construction of these towns the builders exploited the deep valleys which had formed around the flat streams of water flowing towards the Jordan Valley.

During the First Temple period the Golan was ruled by the Arameans (whose capital was Damascus), and throughout the first half of the first millennium B.C.E. it was an arena for battles between the Arameans and the Israelites. In the period following the destruction of the First Temple (586 B.C.E.), and until the conquest of the country by Alexander the Great (333 B.C.E.), the Golan was totally depopulated, and remained untouched by the events in the region. It was not until later that the great flourishing of the Golan began, which

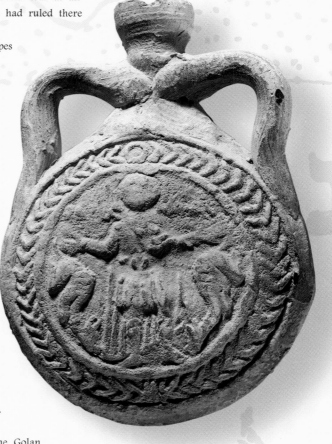

*Pilgrim's Flask*

*6th century (the Byzantine period), Collection The Antiquities Authority, The Israel Museum, Jerusalem*

**The Sea of Galilee and the tombs of Jewish holy men in Tiberias**

*Detail from a Hebrew pictorial map of Eretz-Israel and its boundaries by Rabbi Haim Pinie, Poland, 1875, Collection The Municipal Library, Florence*

*On the facing page:*
**Brechat Ram, on the Golan Heights, with Mt. Hermon in the background**

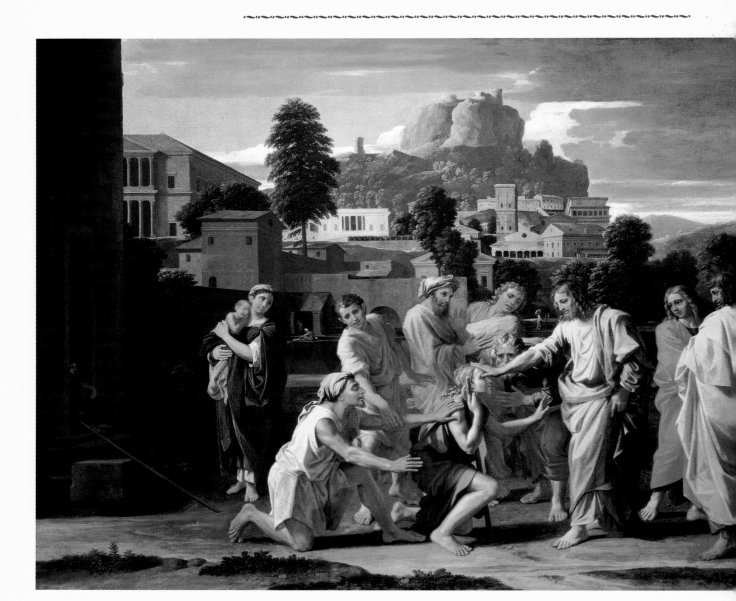

continued almost unbroken from the Hellenistic period (the 2nd century B.C.E.) until the early Muslim period (around the 9th century C.E.). Most of the remains that can be seen in the region stem from this prolonged period, and they are the landmarks that characterize the Golan landscape to this day.

The inhabitants of the Golan during this period were a mixture of populations – but already then the Arab element was prominent in the region, after the Arab Ituraean tribe settled in the northern Golan and at the foot of Mt. Hermon. The tribe established itself in the region in the 2nd century B.C.E., and almost founded a state of its own, with its capital in the town of Khalkis in the Lebanon Valley (Beka'a); in the northern Golan they lived mainly in small, unfortified villages, which they abandoned in the Roman period and moved to the large fortified towns in the neighboring areas.

The region's affairs at this time were administered mainly from Damascus. Towards the mid-2nd century B.C.E. the Seleucid Greeks began building defensive forts along the roads in the Golan leading to and from Damascus; thus, for example, the fort of Gamla was built by one of the local rulers of the region.

In this period the rise of the Hasmoneans in Judea began. The Hasmoneans intervened in the Golan because quite a number of Jews were living in this outlying region, mainly in its south. The Jews of the Golan, who suffered from attacks by their neighbors after the revolt against the Greeks and the successes of Judah the Maccabee, requested the latter to come to

their assistance. The apocryphal First Book of Maccabees indeed refers to two places (which are also known to us today) that Judah the Maccabee visited during his campaign in the region — Hispin and Alma, both of them in the southern Golan. In the year 101 B.C.E., Alexander Yannai, the great Hasmonean conqueror, captured various places in the southern Golan, where he encountered another Arab tribe which dwelt in the region — the Nabateans, who had arrived there due to their involvement with commerce. In 93 B.C.E., Alexander Yannai defeated the Nabatean king, Aretas, and expanded his dominion in the southern Golan, and as a consequence of this the Jewish population of the region gained in strength. The center of Jewish life in the region was most probably at Gamla — a town which would also be mentioned in the chronicles of the war that led to the destruction of the Second Temple, in which it took an active part.

In 63 B.C.E. the entire country was conquered by Pompey. This was beginning of the Roman rule, which lasted about 400 years. Gabinius, the Roman governor who was based in Syria, instituted a new administrative division of the country, in order to weaken the Jewish presence in the region. He severed the gentile towns in northern Transjordan and the Golan from the Jewish administrative district, and organized them in the Decapolis (Ten Cities) confederation; of these cities, the one that became most renowned was Beit-She'an, the only city in the confederation situated west of the Jordan. The other cities were all in Transjordan — among them the cities of Amman, Gerasa and Pella — and in the Golan, and in the Bashan to the east.

In 30 B.C.E., following King Herod's successes in administering the affairs of the state of Judea, the Romans also entrusted him with the administration of the Golan region; the areas under his administration were also extended by the Romans three years later, and confirmed again ten years later. In order to reinforce his rule in the Golan, Herod sent about 500 Jewish families who had returned from the Babylonian exile to settle there, together with loyal Idumaeans from his own tribe, and established a temple in the town of Banyas. After Herod's death the region passed to his son, Herod-Philippus, who continued to develop and extend the importance of his capital, Banyas. Phillipus also founded a new city on the northern shore of the Sea of Galilee, and called it Bethsayada (or Bethaisa), i.e., "Town of the Fishermen". After him, the Golan was ruled by Agrippa I (41-44 C.E.) and Agrippa II (53-95).

During the great revolt against the Romans (67 C.E.), Josephus Flavius was appointed commander of the rebel forces in the region. He engaged in the fortification of the Golan,

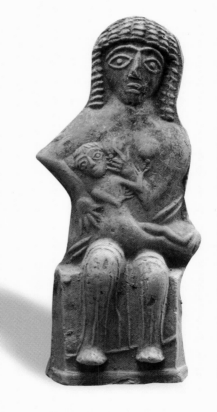

**Madonna and Child**

*Clay statuette, the Byzantine period,*
*Collection The Antiquities Authority,*
*The Israel Museum, Jerusalem*

**Conquest of Jericho**

*Detail from a mosaic, 432-440, Church*
*of Santa Maria Maggiore, Rome*

*On the preceding pages:*

**A View of the Hatzbani**

*In the Talmud we read that "the good of [Mount] Hermon is at its foot" i.e., the mountain pours down its goodness upon its environs by nourishing the sources of the Jordan, which emerge at the foot of Mt. Hermon..*

*The Jordan, the largest of Israel's rivers, receives its water from three principal sources. The easternmost source, the Sion Brook, springs from the town of Banyas, which in the New Testament is called Caesarea-Philippi. The springs of the Dan Brook, the most abundant of the sources, stem from close by to Tel Dan, the important biblical town in the northern inheritance of the tribe of Dan. In the heart of this town there is another spring, Ein-Leshem, which is named after the town's name before it was captured by the tribe of Dan. The third source is the Snir (Hatzbani) Brook, which rises in Lebanon and reaches the boundaries of Israel as an abundant brook. All three sources flow into the north of Lake Huleh , and emerge from it as a gushing river. Another source which reaches the Jordan further on is the 'Ayun Brook, which is known for the "Tanur" ("Furnace") waterfall along its bed, and which is dry in summer. The three sources were known to the ancients, who saw the name Jordan [Yarden] as a combination of "Yeor" and "Dan", as though the river had two sources.*

and especially of the cities of Gamla, Seleukia, and Sogani. The latter two cities did not participate in the revolt, and surrendered to Agrippa II, who ruled the region on behalf of the Romans. Gamla, in contrast, suffered a harsh siege, and Josephus' descriptions inform us about the intensity of the battles that took place there before it fell to the Romans. According to Josephus' descriptions, the siege of Gamla was no less intense than the more famous siege of Masada. He writes that in the course of the battles more than 7,000 people were killed, the villages around the city were destroyed, and the Jewish Golan was almost completely obliterated.

Archeological excavations at Gamla have exposed a city from the Second Temple period, built on an easily defensible site encompassed by deep ravines. The only direction from which it was relatively vulnerable to invaders was from the plateau above it, but even from here the access to the city was most difficult. The city was built on a steep slope, and its houses were arrayed along several streets that cut the slope lengthwise. The archeological findings clearly confirm what Josephus wrote about the siege of the city and the destruction wrought by the Romans. According to Josephus, the houses at the top of the slope collapsed upon the houses lower down, and this description matches the arrangement of the city perched on a very steep slope exposed by the excavations. A synagogue, too, was exposed at Gamla, and is one of the earliest

synagogues known to us in the country. Gamla had economic links with the port city of Tyre and the Phoenician coast, as the many coins found there indicate. It is probable that the region's produce, which was mainly oil, was exported through Tyre. Nevertheless, despite its location in the most remote outlying region of Judea, a considerable number of artifacts originating from Jerusalem have been discovered there, and are evidence of strong connections with the center.

Likewise, in the city of Banyas — the original name of which (in the Hellenistic and Roman periods) was Paneas, *i.e.*, "city of [the god] Pan" — as well, findings which confirm Josephus' descriptions have been found: remnants of a magnificent palace from the time of Herod and his descendants, as well as remnants of a temple which stood beside the bubbling springs near the city that supply water to the Jordan River. Banyas was a central city which served the entire Galilee as well, and for this reason — according to the New Testament, where the city is called Caesarea-Phillipi, after the son of Herod who had made it his seat and his capital — Jesus visited it, and it was there that he promised Peter the keys of the kingdom of heaven (Matthew 16:19).

Tangible evidence of the suppression of the Great Revolt by the Romans has been found at a number of contemporary sites exposed in archeological excavations. Gamla, for example, was abandoned and completely forgotten until its rediscovery in 1968 — and the entire Golan was abandoned by its Jewish inhabitants. In other towns in the region, such as Sussita, archeologists have discovered remnants of a new type of urban organization from the period after the revolt, manifested in magnificent public buildings, urban design of the classical Roman type, with a complex system of services, which included a magnificently built aqueduct to supply water from a long distance away, etc. The excellent state of preservation of the remains of towns in the Golan make possible a precise reconstruction, "from the foundations to the roofbeams", of the systems of construction used for building both private houses and public buildings. In the small villages in the region, magnificent villas have been discovered, and public fountains (nympheums) as well. A further indication of the prosperity of the Golan is the developed system of roads, marked out with milestones and benefiting from other services, that has been discovered in the region.

In the 4th century the population of Eretz-Israel increased considerably, and therefore spread out to areas that had not been inhabited before or that had been abandoned many generations earlier, such as the Negev. It is possible that this is the reason for the population growth in the Golan, which reached a density that had not been known there before. In this period, which is concurrent with the spread of Christianity, Jewish habitation, too, was renewed in the region (although it is difficult to know whether there was a connection between the two phenomena). Jews arrived in the Golan in increasing numbers, and their impressive presence is manifested in the 25 or so synagogues from this period that have been unearthed in the region. Typical architectural ornamentation and religious symbols enable us to sketch a map of the extension of Jewish and Christian villages and towns in the Golan. It appears that conversion to Christianity

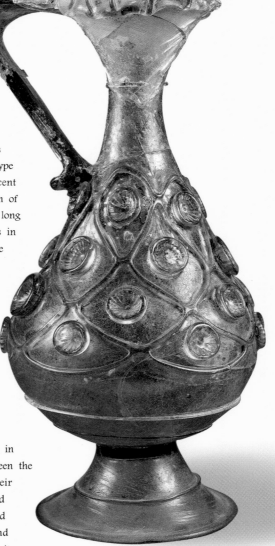

*Giant glass jug*

*4th-5th centuries (the Byzantine period), found in Eretz-Israel or Syria, Collection The Israel Museum, Jerusalem*

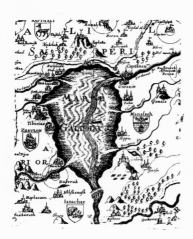

*The Sea of Galilee*

Illustrated map from the book

**A Pisgah-Sight of Palestine** *by*

*Thomas Fuller, London*

*Tiberias*

Illustration from the **Faithful Guide to the Holy City of Jerusalem**, *by the Italian pilgrim Pietro Antonio, 1703*

*The Capture of Jericho*

*Raphael (1483-1520), 1518-19*

*Vatican Palace, Rome*

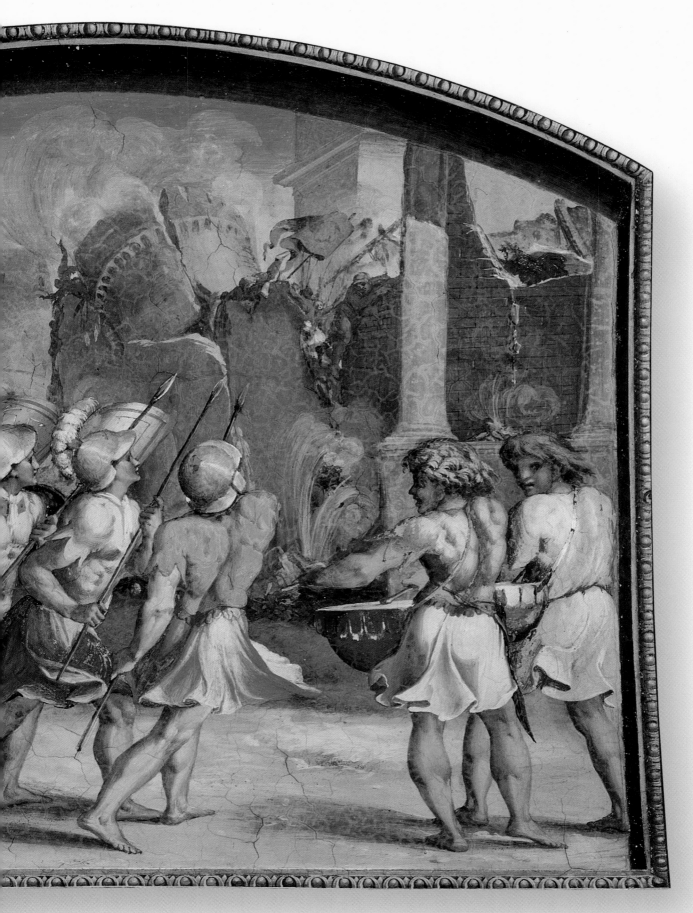

was a prevalent trend mainly among the Arab tribes (like the Ituraeans mentioned above) who had lived in the region since the Hellenistic period — and this phenomenon is also known to have occurred in all the territories of Transjordan.

Despite its prosperity in this period, however, the Golan remained an outlying area in the political sense. We deduce this from the fact that the historical information that has reached us about the Golan stems only from the archeological findings, while in the various literary sources it is hardly mentioned.

With the Muslim conquest of the country, the population of the Golan began to dwindle. The archeological excavations indicate that only about ten per cent of the various sites remained inhabited. Earthquakes occurred in the country, and only especially important towns were rehabilitated and continued to exist, while other settlements were simply abandoned. In the Ummayyad period a new road was built, ascending to the southern Golan in the vicinity of Aphek (Fik), and the city of Aphek became the major city in the region after Sussita was destroyed in the severe earthquake of 749. After the Abbasids took over the Caliphate from the Ummayyads in 750, the entire region suffered from great neglect. The Abbasid rulers, whose seat was in Baghdad, displayed no interest whatsoever in the Golan, which became a buffer area between Syria and Eretz-Israel. The role of the Golan as a border was especially prominent in the Crusader period, when Eretz-Israel was ruled by the Crusaders while Syria, and its capital Damascus, were the stronghold of Islam.

The Golan reappears on the stage of history in the Ottoman period (1516-1917), in the course of which it was used for passage between various parts of the empire. The bulk of human habitation in this part of the empire in this period was concentrated east of the Golan, along the main road taken by pilgrims from Damascus to Mecca — while the Golan itself was inhabited by Bedouin tribes, who did not permit the existence of permanent settlements. In the 19th century far-reaching changes took place in the Ottoman Empire as a consequence of the rising strength of the world powers. The Sultan, who reorganized his empire, proclaimed the abandoned territories in the Golan "crown property" ("Giftlik" in Turkish), and thus increased his revenues from taxation.

From 1840 on, the Druzes began immigrating to the Golan, after inter-religious conflicts in Lebanon. France's support of the Christians caused the Druzes to flee Lebanon, and they were attracted to the relatively uninhabited Golan, where they established villages for themselves at the foot of Mt. Hermon (while others settled in northern Eretz-Israel and on Mt. Carmel). The Ottoman authorities encouraged the Druze settlement in the Golan because they were interested in expanding their tax-collecting in the region. The gradual disintegration of the Ottoman Empire also contributed to the growth of settlement in the Golan, because it led to the migration of Muslim refugees from the areas they had been expelled from. The first refugees were the Circassians — a Muslim people of Caucasian origin which had lived in Bulgaria, and preferred to immigrate into the bounds of the Ottoman Empire rather than live under the rule of the Russian Tzar, who had obtained Bulgaria in 1878. The Circassians ousted the Bedouin and settled in

**Crescent-shaped gold earring**

Designed in Byzantine style at a workshop from the Ummayyad period (661-749), found at Beit-She'an, Collection The Israel Museum, Jerusalem

**Chancel screen from a church**

The Byzantine period, found at Sussita, Collection The Antiquities Authority, The Israel Museum, Jerusalem

various areas in the central Golan, and constituted the largest ethnic grouping in the Golan on the eve of the Six-Day War. (Circassians also immigrated into Eretz-Israel, where they established two villages — Kafr-Kama and Reihania, and to Jordan, where they contributed to the establishment of permanent urban settlement by rebuilding cities such as Gerasa, Amman, and several others.) The administrative center of the Circassians in the Golan was the city of Kuneitra. Many of them enlisted in the Ottoman army, and with their earnings supported their families, who remained in the Golan. In this period, the Bedouin began to understand the value of the lands in their possession, and became permanent inhabitants who owned large estates and ruled over serfs. In the 19th century, affairs in the region were conducted in accordance with the economic interests of the estate-owners, and less economically viable areas remained neglected.

The weakness of the disintegrating Ottoman Empire led to the involvement of other political factors in the region. In the 1840s, the Empire's governors in Egypt, who had attained real independence for themselves and could do whatever they wanted in the region, resettled Sudanese families in the southern Golan. The fluid state of affairs also enabled the Zionist movement to purchase lands in the Golan in the second half of the 19th century, and towards the century's end a number of Jewish colonies were established (such as B'nei-Yehuda, founded in 1886), which managed to prosper to some extent despite their isolated circumstances.

With the end of the First World War, and the division of the territories of the Ottoman Empire between the victorious powers, England and France, the Golan and Syria were given to the French, while Eretz-Israel was placed under the British Mandate. The border that was fixed at that time between the Golan and Eretz-Israel left all the Jordan's water sources within the bounds of Eretz-Israel. The border passed ten meters east of the shore of the Sea

**Tiberias Landscape**
*Nachum Gutman (1898-1980), 1928*
*Collection The Israel Museum, Jerusalem*

of Galilee, so that the entire lake, too, was included within the area of Eretz-Israel. Despite the political separation, trading relations were formed between these two districts, and large quantities of grain and meat produce from the Golan were exported to Eretz-Israel. At the same time, however, the Golan once again reverted to the status of a remote outlying area on the borders of Syria, and the French authorities did not devote much attention to its development.

After Syria was proclaimed independent in 1946, it converted the Golan into a military stronghold against Israel. Syria's steps influenced the appearance of the Golan, which became criss-crossed with communication trenches and fortifications. The size of the population remained the same as it had been under the French occupation, and the number of permanent inhabitants at the time was about 80,000. On the eve of the Six-Day War, the majority of settlements in the Golan, which were concentrated at the historical sites from the Roman-Byzantine period, were most poor and small; only the villages of the Circassians and the Druzes enjoyed good economic conditions and looked relatively well looked after.

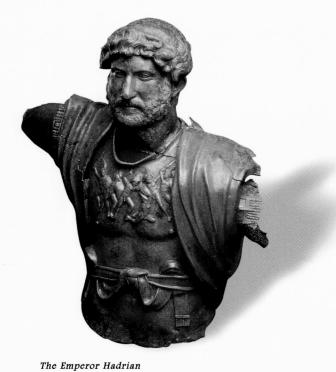

*The Emperor Hadrian*
*Bronze statue, the late Roman period,*
*found at the site of the Roman Sixth*
*Legion's camp near Beit-She'an, Collection*
*The Antiquities Authority, The Israel*
*Museum, Jerusalem*

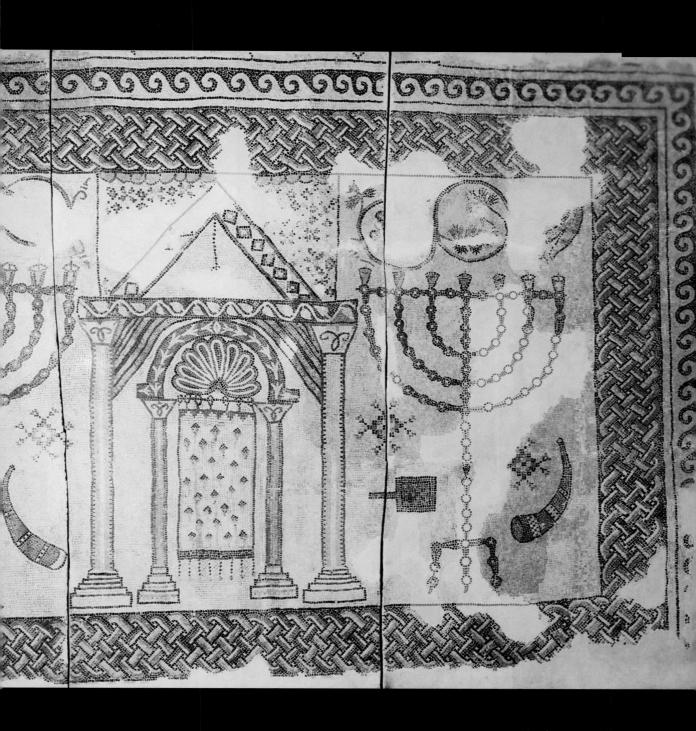

*Mosaic pavement* (detail)
*6th-7th centuries (the Byzantine period),*
*found at Beit-She'an, Collection The*
*Antiquities Authority, The Israel Museum,*
*Jerusalem*

*Departure for the Crusades* (detail)

*From a French illuminated manuscript, date unknown,*

*Collection of the Bibliotheque Nationale, Paris*

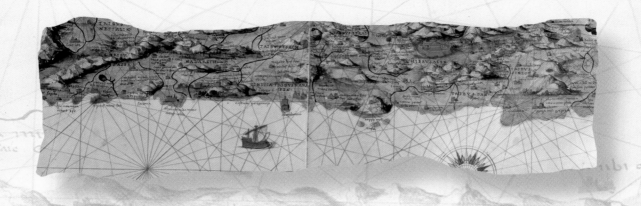

# The Coastal Plain

**70 C.E.** After the destruction of Jerusalem, Yavneh becomes the
important spiritual center in the country

**c. 335** Beginnings of the spread of Christianity in the region

**640** Conquest of the region by the Muslims

**661** Beginning of the Umayyad rule

**969~1071** The Fatimids rule in the region

**1071~1098** The Seljuks rule in the region

**1098** Reconquest of the region by the Fatimids

**1104~1291** The Crusaders rule in the region

**13th~15th centuries** The Mamluks rule in the region:
destruction of most of the coastal towns

**1799** Napoleon→s campaign of conquest along the coast to Acre

**1516~1917** The Ottomans rule in the region

**1917** Conquest of the region by the British

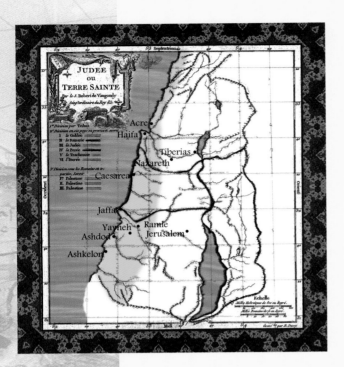

**The Coastal Plain,** *on a map of the Holy Land from 1790 by Robert de Vangondy, France*

**"The Good Shepherd"**

*Marble sculpture, the Byzantine period, found in the Gaza area, Collection The Antiquities Authority, The Israel Museum, Jerusalem*

retz-Israel is a narrow strip on the shore of the Mediterranean Sea, and its history has always been interwoven with the latter's history. The culture of the country is a Mediterranean culture, for its inhabitants have always maintained connections with the other countries on the shores of this sea. In the country's rear there is a large desert, which did not permit the passage of large-scale trade and communication routes from west to east, and most of the traffic of people and goods was concentrated in and along the coastal region.

The country's coast is flat, with very few bays, and in certain places is bounded by strips of sand of various widths. There is only one place in the country where the coastal strip is interrupted — where Mount Carmel cuts it from the south, penetrating all the way to the water line. The coastal strip is divided into several regions: the northernmost is the coast of the Western Galilee, which extends from the Rosh-Hanikra ridge in the north to Mt. Carmel in the south. The northern part of this region is the relatively narrow Acre Valley, where the coast is rocky, and the southern part is the Zebulun Valley, with broad sands that permit passage to the Jezreel Valley. South of Mt. Carmel the coast extends uninterruptedly to the border of the Sinai peninsula, and the Yarkon River marks and separates its two

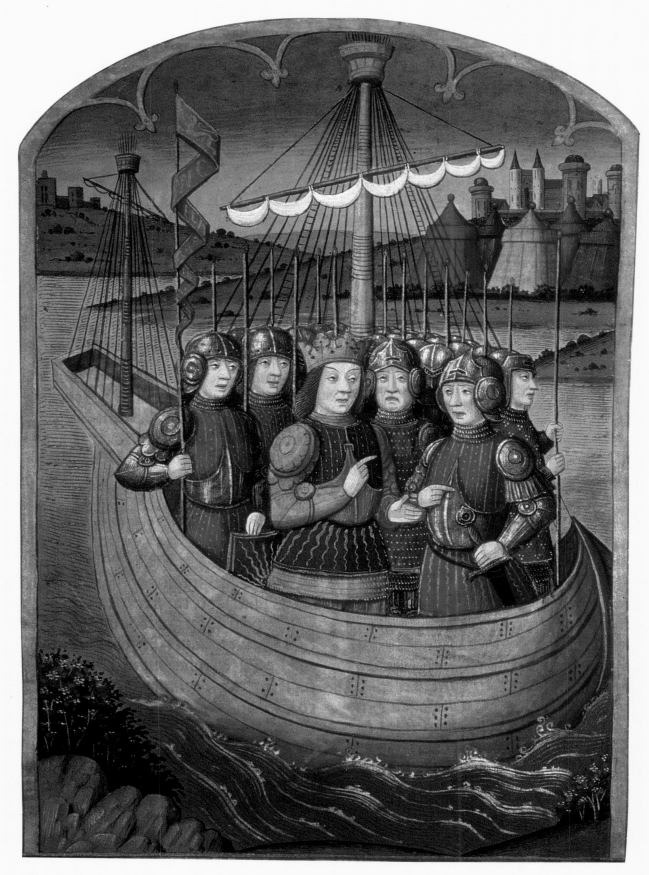

*King Arthur and his Knights embarking for the Holy Land*

From an illuminated manuscript by Antoine Verard, Paris, c. 1490. Collection Biblioteca Nazionale, Turin

major parts: the Sharon Plain to its north and the Shefela Plain to its south. Here and there sandstone hills reach as far as the coast and create small bays in it, which provide shelter and a harbor for sailing vessels; these places were employed by ancient shipping, and were the nuclei for the development of the important historical coastal towns such as Atlit, Dor, Caesarea, Rishpon, Jaffa, and others.

The entire area is relatively rich in fresh water, because all the streams from the mountain region drain into it. Underground water is plentiful as well, and wells dug along the coast used to provide the population with abundant water. As a result of population growth and increased pumping in more recent generations, however, the wells have become exhausted, and today this region too needs to receive its water from other sources.

Already at the very dawn of history the Coastal Plain served as a route of passage for external political forces such as Egypt, which became a power after the unification of its two parts — Upper Egypt and Lower Egypt. At that time — the early Bronze period (around the 28th century B.C.E.), a small settlement was established at Rosh-Hanikra, and its strategic position close to the ridge that separates Eretz-Israel from Lebanon points to the existence of an important route which passed through this place. This settlement continued to exist throughout the early Canaanite period, i.e., during the entire third millennium B.C.E. Among the few archeological findings that have been discovered at this place, there is a relatively large number of items which originate in Mesopotamia, and these attest to trade relations with that region.

More or less at the time when the Israelites established themselves in the mountain region, the coastal area was settled by the Philistines, who came from islands in the Mediterranean sea. A Philistine tribe by the name of Thekel settled in the northern Sharon, while the other Philistines settled in the Shefela. Of the Israelites, only the tribe of Dan attempted to establish possessions in the Shefela, and built the towns of Ayalon and She'albim in the Ayalon Valley, but was pushed back to the north, to the town of Dan in the Huleh

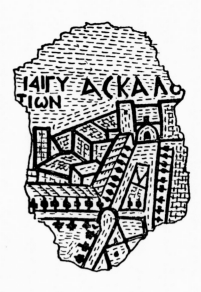

**Ashkelon**

*Detail from the mosaic Madaba map, c. 656, Church of St. George, Madaba, Jordan*

Valley. The inheritance of the tribe of Asher, according to the biblical division of the country among the tribes, partly overlaps the Acre Valley and the Carmel region — but there exists no archeological evidence that this division was actually implemented.

The Philistines established themselves along the Coastal Plain, and their five cities — Ekron, Ashdod, Gat, Ashkelon and Gaza — are all situated within it. When the Egyptians still ruled in this country, many Philistines served as soldiers in the Egyptian garrison, although in the 12th century B.C.E. the power of the Egyptians gradually waned, until they ceased being mentioned in the chronicles of the country for a long period. One of the documents tells about a late Egyptian attempt to enjoy the fruits of the land: a representative of the

**Fragment of stone screen**

*The Byzantine period, found in a synagogue in Ashkelon, Collection The Antiquities Authority, The Israel Museum, Jerusalem*

*On the facing page:*

**Old Jaffa, a view from the west**

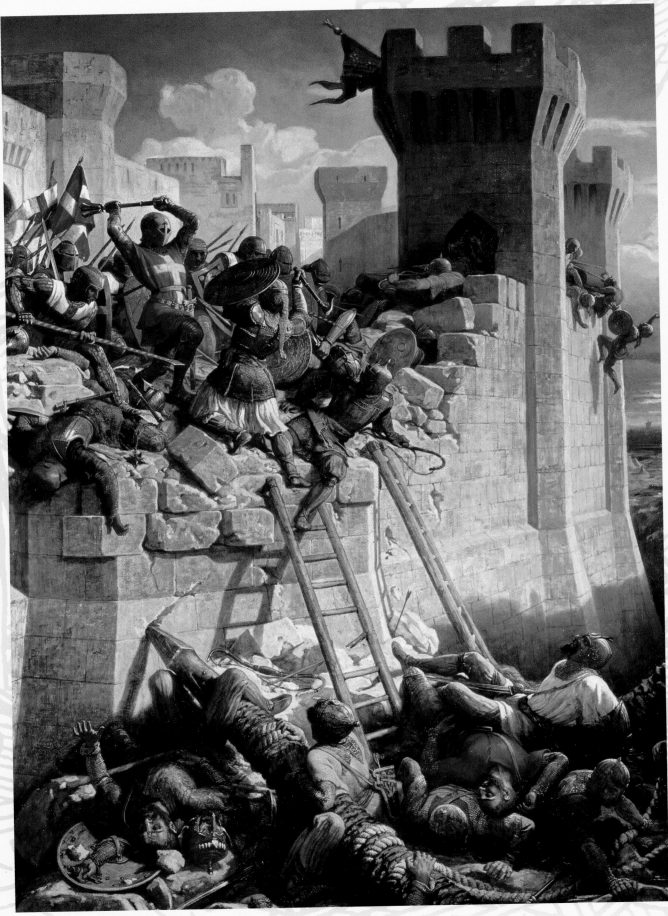

Egyptian kingdom arrived at the city of Dor to obtain a particular kind of timber, but was refused by the ruler of Dor, a member of the Philistine union; this rejection, of course, attests to the decline of Egypt's prestige in the region.

According to the Scriptures, the dangers posed to the Israelites by the Philistines encouraged them to unite and even to appoint a king who would rule them all. King Saul fought the Philistines, who had spread out into the mountain region. He also descended from there to the higher part of the Shefela, but did not reach the Coastal Plain. King David, however, after his victory over the Philistines at the Battle of the Refa'im Valley, pursued them as far as Gezer, and probably also captured their town of Gat. Some of the towns on the Coastal Plain are indeed mentioned in the lists of the Levite towns (Joshua 21) — Ga'aton, Iteke, Gezer, Ayalon, and Gat-Ramon — but it would appear that Judah and Israel ruled in these areas for brief periods only, and that this was also the case in the Acre valley, where the towns Mishal, Avdon, Helkat and Rechov are mentioned.

The Scriptures also describe the administrative districts instituted by King Solomon, and mention the names of towns in the Sharon and the Shefela such as Sha'albim, Ayalon, Beit-Shemesh, Dor, Arubot and Hefer. Here too it is difficult to know how long Israel's rule over these towns lasted.

With the disintegration of the Assyrian kingdom, the kingdom of Judah managed to expand towards the coast once again, but nor for a long time. The failure of the military campaigns of Pharaoh Necho II against the kings of Mesopotamia (609 B.C.E.) led to Babylon's rise to greatness, and, subsequently, to the destruction of the kingdom of Judah — but in the book of Nehemiah we find a list of towns, some of them in the Shefela, in which Jewish habitation continued. In 539 B.C.E., Babylon fell to the kingdom of Persia. The former Philistine towns continued to exist in this empire as miniature states, and the gentiles of the coastal region are referred to in Nehemiah by the collective term "Ashdodites", probably because of Ashdod's centrality in the lives of the gentiles in the region. After this the coastal region was placed under Phoenician rule, because the king of Persia needed the support of the Phoenicians in his wars against the Greeks.

With the conquests of Alexander the Great (333 B.C.E.), Greeks began settling in increasing numbers in the coastal towns (as well as in other parts of the Mediterranean basin). The first settlers were soldiers of Alexander's armies, but gradually

*A sailing boat in the port of Jaffa*
*From a pictorial map of the Holy Land attached to the* **Peregrinationes of Bernhard von Breidnbach**, *Germany, 1486, Collection British Library, London*

On the facing page:

**Guillaume de Clermont defending Ptolemais (Acre) in 1291**

*Dominique-Louis Papety (1815-49), 1845, Collection Chateau de Versailles, France*

*The meaning of this ancient city's name is not known. The name already appears in Egyptian sources from the 20th and 19th centuries B.C.E., and it is also mentioned in the lists of cities in this country captured by the kings of Egypt. In the Scriptures, Acre is apportioned to the inheritance of the tribe of Asher. The descriptions of the city's power in ancient times have been validated by archeological excavations conducted at Tel-Akko, which is close to the Acre of today.*

*In the classical period (Greece and Rome), the city was known by its Greek name, Ptolemais, and the classical tradition also attributed to the city the invention of the remedy "akka", which brought healing to Hercules. The river that flows beside Acre, the Na'aman, or, in Greek, the Belus, from the word Ba'al, is also called after him (the Greeks identified Hercules with the god Ba'al). The city and its port were very wealthy during the Roman period. In the 9th century the port of Acre was established in the place where it is situated today, and the city established itself around it at the point familiar to us at the north of the small bay on the Mediterranean coast. The city reached the height of its flourishing in the Crusader period, when it was the chief port in the country and a gateway to trade routes which passed through it. In the 12th century, when Jerusalem served as the capital of the first Crusader kingdom, Acre's importance was primarily economical, but during the period of the second Crusader kingdom (throughout the 13th century) it actually served as the capital of the country. At this time the magnificent buildings which gave it the medieval appearance familiar to us today were built.*

*After its capture by the Mamluks (1291), Acre declined from its grandeur, although in the Ottoman period it enjoyed economic and cultural flourishing, and even withstood the siege imposed on it by Napoleon (1799). It was only in the 20th century that the city of Haifa began to overshadow it in importance.*

*Napoleon visiting the plague-stricken in Jaffa* (11 March 1799)

*Antoine-Jean Gros (1771-1835), 1804, Collection The Louvre, Paris*

In 1799 Napoleon Bonaparte attempted to break the control that the eastern coastal towns exercised over the Mediterranean trade routes. From his base in Egypt, the north of which he had conquered before this, he set out on a campaign of conquest in Eretz-Israel, which he conducted concurrently with his battles with the British fleet. This campaign came to an end at Acre, where Napoleon suffered a crushing defeat which forced him to retrace his steps to Egypt.

On his way north, in March 1799, Napoleon captured Jaffa. The capture cost him much effort and led to the death of many of the city's inhabitants and to widespread destruction. Many of the Turkish soldiers who were in the city were killed in the battles, and others were murdered by the French army. As a consequence of the killing a terrible epidemic of plague broke out in the city, which Napoleon attempted to cope with by ordering the poisoning and quick burial of everyone affected by it. Jaffa was rehabilitated fairly soon after the disaster, but the story of the capture of Jaffa and the subsequent epidemic became notorious in Europe and spread quickly among Napoleon's enemies. Napoleon's visit to the Court of the Armenians, where many victims of the plague were abed, was memorialized in the famous painting by Antoine-Jean Gros (today in the collection of the Louvre Museum in Paris).

merchants and officials of the Greek regime also settled in the coastal towns. During the rule of the Ptolemids (301-200 B.C.E.), a Hellenistic life style became established in the region, and Hellenistic towns developed along the coast, from the Acre Valley down to the Sinai coast.

The friction between Jews and gentiles in these cities not infrequently led to riots, and already in 165 B.C.E. the Hellenistic towns were embroiled in armed conflicts, which finally led to the rise of the Hasmonean kingdom. Jaffa, for example, was captured by the Hasmoneans in order to provide their kingdom an access to the sea. Their occupation involved the Judaization of the town by means of deportation of the non-Jews and the settling of Jews there in their place. During the reign of the Hasmonean king Alexander Yannai (101-76 B.C.E.), the Hasmonean kingdom grew to its greatest extent. Before him, his brother Judah Aristobulus (104-101 B.C.E.) had conquered the Galilee, and from there had tried unsuccessfully to capture Acre and its environs. Alexander Yannai withdrew his forces from the borders of Acre, and in return for this concession received the coastal

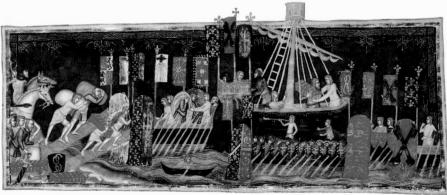

**Departure for the Crusades** (detail)

*From a French illuminated manuscript, date unknown, Collection Bibliothèque Nationale, Paris*

towns of Stratonos Pyrgos (later called Caesarea) and Dor from the Seleucids. He also captured Gaza and continued southward towards Antedon. The coastal towns began to lose their Hellenistic character, and became integrated in the kingdom of Judah, but the conquest of the country by the Roman commander Pompey (62 B.C.E.) put a stop to the Judaization of the Coastal Plain.

In the early phase of Roman rule in Eretz-Israel, Judah was accorded autonomy, and the Temple in Jerusalem continued to serve as a center for life in the country; for this reason it is customary to include these years in "the Second Temple period", which ended in 70 C.E., the year the Second Temple was destroyed. In the Jewish historiography of Eretz-Israel, only the years after the destruction of the Temple, through to the division of the Roman Empire (i.e., 70-352 C.E.), are called "the Roman period".

In this early period of Roman rule, the gentile population of the coastal towns gradually

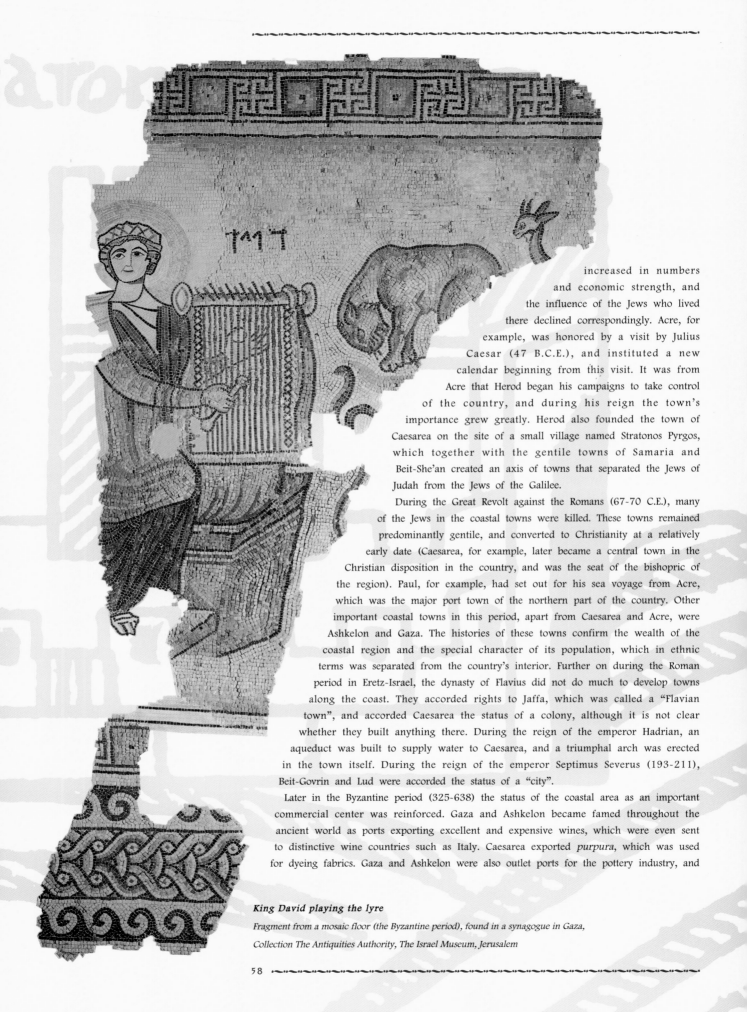

increased in numbers and economic strength, and the influence of the Jews who lived there declined correspondingly. Acre, for example, was honored by a visit by Julius Caesar (47 B.C.E.), and instituted a new calendar beginning from this visit. It was from Acre that Herod began his campaigns to take control of the country, and during his reign the town's importance grew greatly. Herod also founded the town of Caesarea on the site of a small village named Stratonos Pyrgos, which together with the gentile towns of Samaria and Beit-She'an created an axis of towns that separated the Jews of Judah from the Jews of the Galilee.

During the Great Revolt against the Romans (67-70 C.E.), many of the Jews in the coastal towns were killed. These towns remained predominantly gentile, and converted to Christianity at a relatively early date (Caesarea, for example, later became a central town in the Christian disposition in the country, and was the seat of the bishopric of the region). Paul, for example, had set out for his sea voyage from Acre, which was the major port town of the northern part of the country. Other important coastal towns in this period, apart from Caesarea and Acre, were Ashkelon and Gaza. The histories of these towns confirm the wealth of the coastal region and the special character of its population, which in ethnic terms was separated from the country's interior. Further on during the Roman period in Eretz-Israel, the dynasty of Flavius did not do much to develop towns along the coast. They accorded rights to Jaffa, which was called a "Flavian town", and accorded Caesarea the status of a colony, although it is not clear whether they built anything there. During the reign of the emperor Hadrian, an aqueduct was built to supply water to Caesarea, and a triumphal arch was erected in the town itself. During the reign of the emperor Septimus Severus (193-211), Beit-Govrin and Lud were accorded the status of a "city".

Later in the Byzantine period (325-638) the status of the coastal area as an important commercial center was reinforced. Gaza and Ashkelon became famed throughout the ancient world as ports exporting excellent and expensive wines, which were even sent to distinctive wine countries such as Italy. Caesarea exported *purpura*, which was used for dyeing fabrics. Gaza and Ashkelon were also outlet ports for the pottery industry, and

**King David playing the lyre**

*Fragment from a mosaic floor (the Byzantine period), found in a synagogue in Gaza,*

*Collection The Antiquities Authority, The Israel Museum, Jerusalem*

Gaza exported salted fish, imported dates from Greece, and was the final station of the Perfume Route which began in the south of the Arabian Peninsula, passed through Transjordan and the Negev, and was the life-artery of the Nabatean traders. All the coastal towns exported souvenirs and religious paraphernalia to the countries of Christendom.

The Muslims, who conquered Eretz-Israel in 638, viewed the Coastal Plain as a region of primary strategic importance, because it provided them an outlet to the countries of the Mediterranean. The important towns in the country were Tyre and Acre, which were included in the bounds of the Jordan Province (*Jund al-Urdun* in Arabic), as well as Caesarea, Jaffa, Arsuf, Ashkelon and Gaza, which were included in the bounds of the Palestine Province. In the early phase of the Muslim rule, at the time of the Ummayyad dynasty (until 750), these towns were rehabilitated because of their strategic importance. The last Ummayyad caliph, Marwan II (744-750), also renovated the ports of Acre and Tyre. The Ummayyads gave lands in the coastal region to their soldiers, in order to populate it with loyal inhabitants. Both the Ummayyads and the Abbasids, who reigned after them (750-969), transferred Muslim inhabitants from distant regions such as Persia and settled them in the coastal regions. In their time the town of Ashkelon was famed for its prosperity.

Immediately after the Muslim conquest, the Byzantines began a series of recurring attempts to reconquer the coastal towns — but after the Muslims fortified these towns and also set up a network of alarm and communications devices along the coast, they relinquished these attempts, although they continued making seasonal attacks from the direction of the sea by means of their fleets of ships. The Muslims did not retaliate to these sea attacks, until they strengthened their own fleet, and in 647-649 they even conquered Cyprus. For this campaign the Muslim fleet set out from Acre, which was fortified once more at this time. A ship-building works, the only one in the country, was also set up in Acre, but it was later transferred to Tyre. Throughout all these years, however, Acre remained the focus of Byzantine attacks, which damaged it severely, until the 9th century, when an especially strong port was built there, whose renown spread afar.

Even with the rise to power of the Abbasids (750), whose center was in distant Baghdad, the importance of the coastal towns in Eretz-Israel did not diminish, mainly because of the incessant war with the Byzantines. On two occasions during the Abbasids' rule, local governors they had appointed rebelled and became independent rulers. During these independent reigns as well — that of the Tulunids (878-905), who also fortified and reinforced the port of Acre, and of the Ikhshids (935-969) — these coastal cities continued to serve as ports of egress for sea forays against the Byzantines in the Mediterranean region.

In 969 the country was conquered by the Fatimids, whose center was in Cairo. The Fatimids continued developing the Muslim fleet, and sent a number of its ships to Ashkelon, Acre and Tyre. Their capacity to rule in the country was reinforced as a result of the development of trade connections between the towns on the coast and those in the interior, which supplied the needs of the coastal towns and benefited from trade with them.

*Seal of the Archbishop of Caesarea,*
*c. 1120, (Left: The Archbishop of Caesarea;*
*right: St. Peter baptizing the Roman soldier*
*Cornelius)*

**Marble pedestal**
*The Byzantine period, found in a*
*synagogue at Ashkelon, Collection The*
*Antiquities Authority, The Israel*
*Museum, Jerusalem*

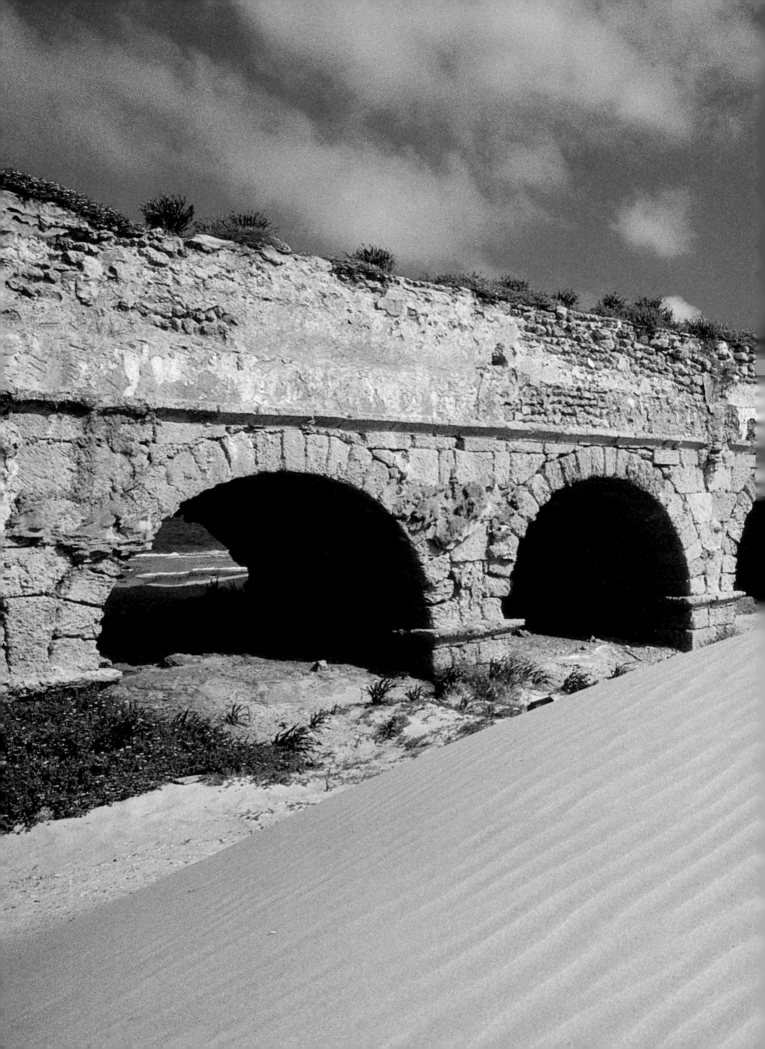

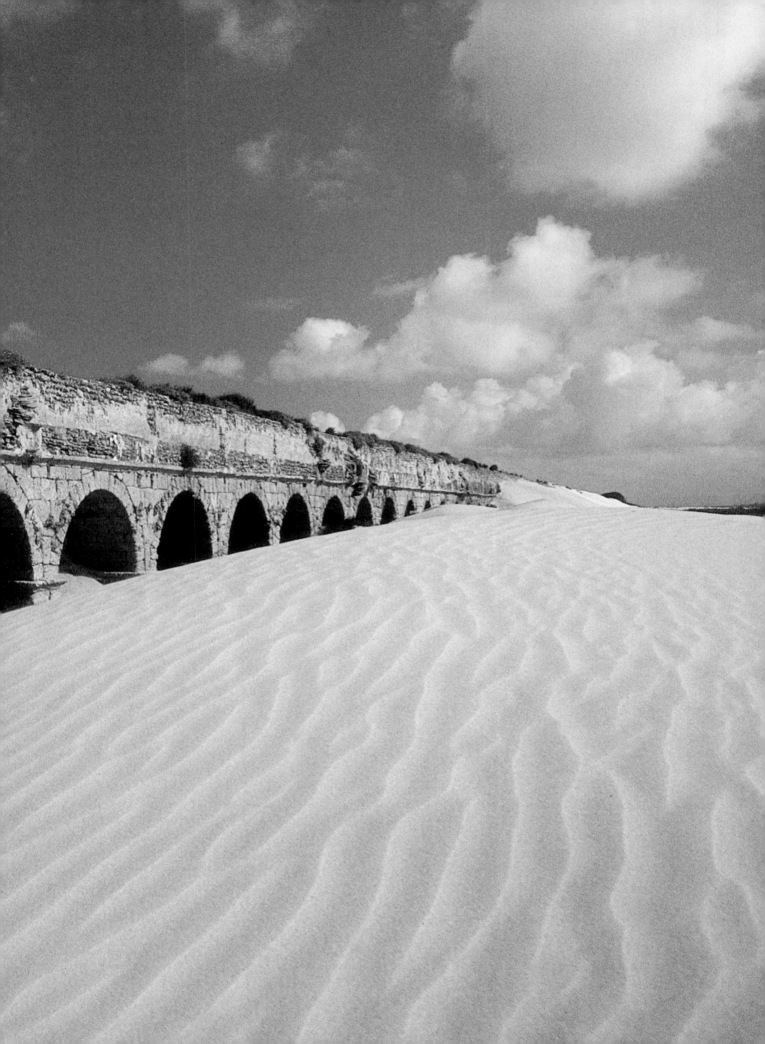

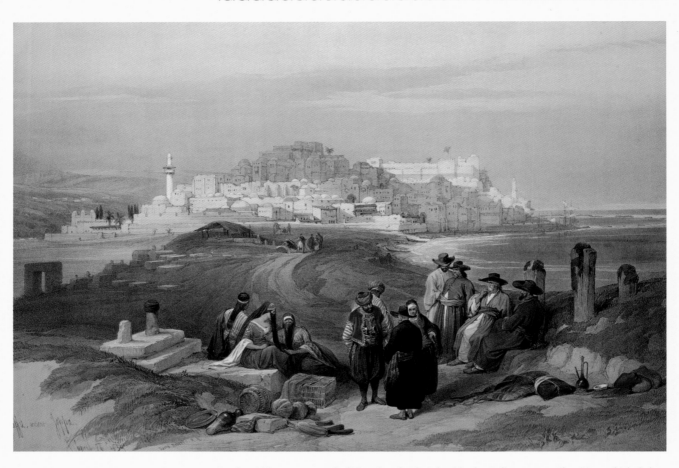

**Old Jaffa, a view from the north**

David Roberts, 1839

Stapleton collection, London

In the 11th century trade links also developed with the Italian mercantile cities, which led to a major invigoration of the coastal towns.

The Seljuk Turks, who ruled in the country from 1071 to 1098, did not manage to conquer the coastal towns, which remained under Fatimid rule. The latter pressed the inhabitants of the towns to reinforce their fortifications, which had been destroyed in the earthquake of 1033 and rebuilt afterwards. Even though the walls were new, further fortifications were necessary. Remnants of these fortifications projects – such as the fort at Kfar Lam near Moshav Habonim, and the fort of Ashdod-Yam – may be found along the coast of Eretz-Israel to this day. These structures, which were called *ribats* – i.e., forts which also provide lodgings for pilgrims (the literal meaning of the word is "sojourn in an outlying place", among other things for purposes of a holy war) – were used for negotiations over the release of Muslim captives who were brought to the shores of the country by the Byzantines, and signal fires were also lit on them for communications purposes.

Jews, too, lived in the coastal towns, and their number or the information about them casts light on the economic power of these towns. We know about the Jews of Rafah – which they identified as the biblical Hatzor – from a number of documents. Gaza was an important Jewish

*On the preceding pages:*

**The aqueduct in Caesarea**

Caesarea was founded by King Herod in about 20 B.C.E., and was named after Julius Caesar. Before this, the site had been occupied by a Phoenician settlement named Stratonos Pyrgos, which was captured from the Pheoenicians by the Hasmonean king Alexander Yannai. Herod chose this particular site because of its physical features, which were suitable for the construction of a magnificent port. The city he built was exceedingly magnificent, and its ruins extend over a large area, attesting to its power.

After some decades Caesarea became the seat of the Roman rulers of Eretz-Israel. Here, too, a dispute broke out between Jews and Christians, which was one of the first signs of the Great Revolt (67-70 C.E.) that led to the destruction of the Second Temple. During the Bar-Kochba Revolt (130-135), too, Caesarea was one of the centers of Roman rule in the country.

With the spread of Christianity, Caesarea became a bishopric. During the Byzantine period this bishopric became the central ("metropolitan") bishopric in the country, and the city reached the height of its flourishing and its extent, which is evinced by the extensive perimeter of its walls.

In the Muslim period the city's decline began, and even in the Crusader period, when it once again became an important center on the coast of Eretz-Israel, its area was much smaller. In 1248, Louis IX ("St. Louis") built fortifications in the city, remains of which exist to this day. In 1265 the city was captured and razed by the Mamluk sultan Baibars. In the 19th century it was inhabited by Muslim Ottomans from Bosnia, who abandoned it in 1948.

center, and Jews from Egypt even made pilgrimages to it for the holy days, because Gaza was the closest town to Egypt within the bounds of Eretz-Israel. In Ashkelon there was an important and very influential Jewish community (its size attests to the town's economic importance), which in the 10th century was a center for writers and copiers of books. Very little is known about Jaffa and Caesarea from the Jewish sources, but one of the documents in our possession states that at the time of the Muslim occupation there were one to two hundred thousand Jews living in Jaffa. It is clear that this number is highly exaggerated, but it is evidence of the large number of Jews in this town. Haifa had a special importance for Jews. Most of the information about this comes from the 11th century, and there we find, among other things, that there was a "meeting house" [beit va'ad] there — a community center of some kind where the learned elders would assemble. The important town of Acre, too, had a similar status among the Jews in Eretz-Israel.

In 1099 the Crusaders arrived in Eretz-Israel from Antioch, in northern Syria, which they had captured after a prolonged siege. The Crusaders' route only traversed the Coastal Plain, because their final destination was Jerusalem. The coastal towns did not block the Crusaders' route, for the Egyptian garrison stationed there was too small to fight them. The inhabitants of Jaffa abandoned the town when the Crusaders arrived, and Ramle too was evacuated in fear of the invaders.

In their capture of Jerusalem the Crusaders were assisted by ships from Genoa and England, which arrived at the port of Jaffa with cargo that enabled the Crusaders to build siege machines. The Coastal Plain was still full of Egyptian soldiers, and the caravans that traveled between the coast and Jerusalem encountered them all the time (the route between the coast and Jerusalem remained the weak point of the Crusaders' power during all the years of their rule in this country). A short while after the capture of Jerusalem, the Egyptian army arrived at the Yavneh region to fight against the Crusaders (12 August 1099), and when the battle was over only Ashkelon remained as a Muslim island in the heart of the Crusader kingdom. Ashkelon remained Muslim until it was captured by the Crusaders in 1153, and during all the years before this it constituted a threat to the Crusaders, who built forts in the Shefela in order to create bases from which to attack it.

In 1100 the Crusaders captured Haifa, in the framework of their strategy of striving to capture the coastal cities and to replace their inhabitants either by extermination or exile. In 1101 they captured Arsuf and Caesarea, and at this time the Egyptians also began their attacks on the Crusader kingdom (they managed to get as far as Lod [Lydda] before being driven back). In 1104 the Crusaders captured Acre and Byblos, in 1110 Beirut and Sidon, and the Crusader hold of the coast became permanent and stable (after this they also captured Tyre, in 1124, and Ashkelon, as already mentioned, in 1153).

In 1118 a caravan of Crusader soldiers, with King Baldwin I at their head, was seen on the southern coast. The king had set out on a journey of reconnaissance, to familiarize himself with the routes to Egypt passing through the Sinai peninsula, perhaps because he was thinking of using these for an attack at a later stage. In the course of this journey the king died. In 1123, the Egyptian fleet attacked the port of Jaffa, but was defeated by the Crusaders. Space does not suffice to describe the many upheavals of war witnessed by the Coastal Plain, especially its southern part, during the first half of the 12th century —

*Four parts of a jeweled pendant in fine gold peligree*

*909-1171 (the Fatimid period), found in Ashkelon, Collection The Antiquities Authority, The Israel Museum, Jerusalem*

**The way to the Holy Land**

*From an illustrated manuscript, 15th century*

**Pilgrims landing on the shore of the Holy Land**

*From the book* **Palestine, Past and Present,** *by H.S. Osborne, 1858*

**The Council of Acre and the Siege of Damascus, Second Crusade,**

*From an illuminated history of Acre by William of Tyr, c. 1289, Collection Municipal Library, Lyon, France*

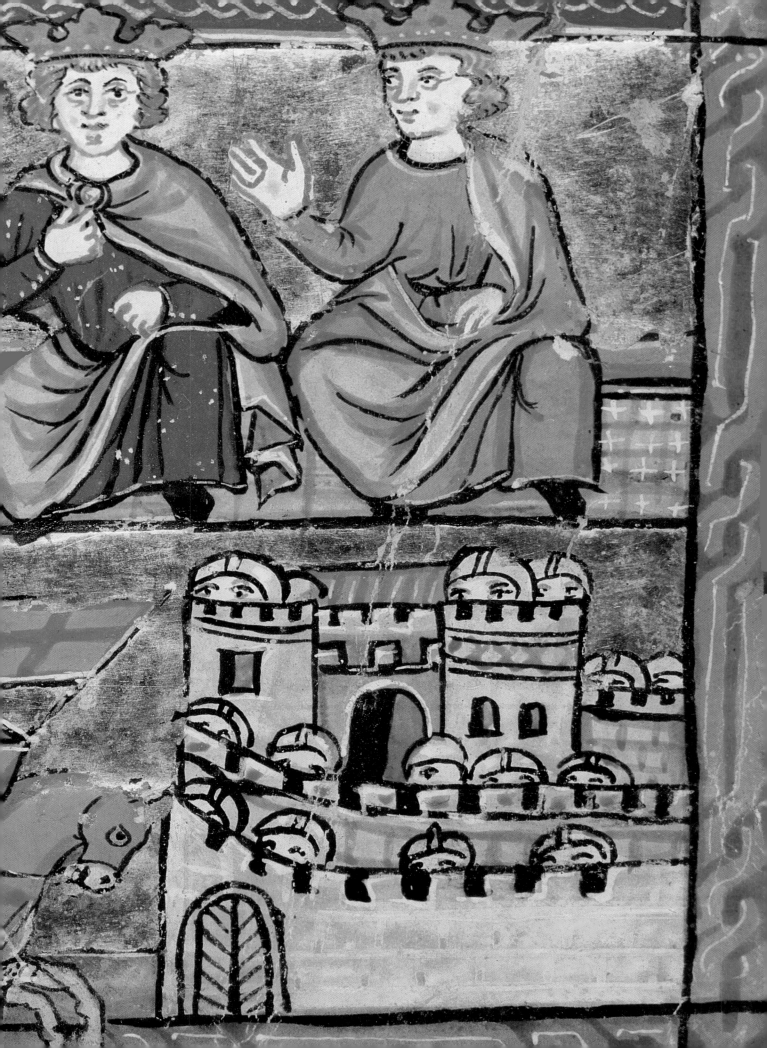

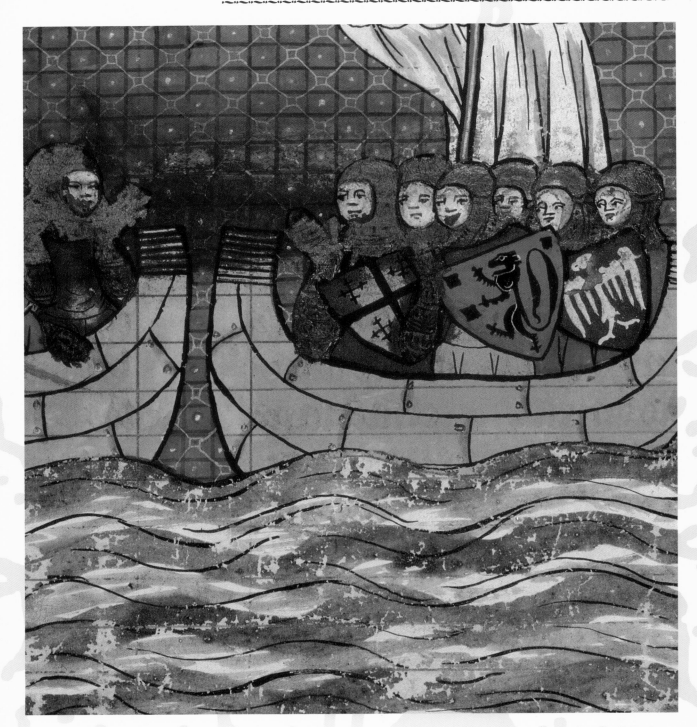

**The First Crusade sets sail** (detail)
From a French illuminated manuscript,
14th century, Collection Bibliothèque
Nationale, Paris

**Haifa (on the right) and Acre**
Detail from a pictorial map of Eretz-Israel
and its boundaries by Rabbi Haim Solomon
Pinie, Poland, 1875, Collection The
Municipal Library, Florence

upheavals which show that the region served as the principal arena of battles between the Egyptians and the Crusaders. In the second half of the century, however, until Saladin took control of Egypt in 1170, the Egyptian attacks on the Coastal Plain ceased almost entirely. The relative quiet on the southern Coastal Plain made possible its employment as a rear base for the Crusader army, which set out for Egypt in attempts to conquer it.

The Crusader strategy stated that only rule over Egypt could assure Christian rule in the Holy Land. For this reason, for example, the Egyptian town of Damietta was captured by King Amalric in 1169. But in the very same year Saladin began his annual raids against the Crusader kingdom, and the Coastal Plain was his first target before he attacked the Galilee. In 1177 he launched a major attack on the Shefela and reached as far as Ramle. Many people fled to Jerusalem, which also began preparing for a Muslim siege — but in a battle near Gezer (the Battle of Ramle, as the Muslims call it), Saladin suffered a great defeat. In a later battle, at The Horns of Hattin in the Galilee, Saladin's army managed to overcome the Crusaders completely, thus in effect bringing about the destruction of the first Crusader kingdom (1187). After this battle, Saladin captured all the coastal towns one after the other. The first to be captured was Acre, and from there a Muslim army — composed of Turkemans and Bedouin — advanced southwards in its conquests along the Coastal Plain. Another Muslim army — under the command of Saladin's brother, Al-Malik al-Adil — set out from Egypt towards this army, and the meeting of the two armies completed the conquest of the entire coast.

***Caesarea imprinted on a medallion***
*1st-2nd centuries (the Roman period), found*
*in the sea near the shore at Caesarea*

The Third Crusade attempted to restore the Holy Land to the Christians. It was led by Richard "Lion-Heart" of England, Philip August of France, and Frederick Barbarossa of Germany; the latter drowned in Anatolia during the course of the journey, and did not succeed in reaching Acre, the first town that the Crusaders managed to capture. On 12 July 1190, the date of the surrender of Acre, the second Crusader kingdom was born; it lasted exactly one hundred years (1190-1291). Since Philip August returned to France immediately after the conquests, Richard Lion-Heart became the leader of the Crusaders in the Holy Land.

He headed south along the coast, reached Caesarea, which had been abandoned by its inhabitants, and won a decisive victory against Saladin's army near Arsuf. Richard, however, chose to tarry in Jaffa instead of heading immediately for Jerusalem, and thus determined the narrow boundaries of the second Crusader kingdom, which was limited to the northern Coastal Plain, with its center at Acre (although for a brief period of 15 years, 1229-44, the Christians also ruled in Jerusalem). Saladin's army passed through all the forts of the Coastal Plain before the Crusader army could reach them, and destroyed them systematically. In this way Ashkelon too was destroyed, and its inhabitants (including the Jews among them) fled to Egypt and to Jerusalem. Richard was therefore constrained to build new forts in the Shefela — at Beit-Dagan and at Azur.

After failing to resolve their differences on the battlefield, Richard and Saladin signed the Treaty of Jaffa, which limited the Crusader kingdom to the Coastal Plain only. In return for their agreement to this limitation, the Christians were allowed free passage for pilgrims to Jerusalem (the treaty was signed after Saladin's unsuccessful attempt to capture Ashkelon, which he later

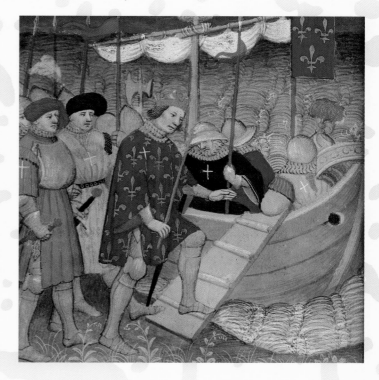

***St. Louis embarking for the Crusade***
*Anonymous painter, 15th century,*
*Collection The Louvre, Paris*

did capture, as mentioned above). Later crusades — the Fourth (1204), which did not even reach the Holy Land and stopped at Constantinople; the Fifth (1218), to Damietta, in Egypt; and the Sixth (1229), which resulted in the 15 years of Christian rule in Jerusalem — hardly affected the form or the boundaries of the Crusader kingdom.

The cultural development of the Coastal Plain is divided into two principal periods: before and after the 13th century C.E. This historical division stems from the destructive defense policy of the Ayyubids (1187-1250) and the Mamluks (1250-1517), which dramatically changed the character of the Coastal Plain in the following centuries. The Mamluks, after defeating the Mongols who invaded the country in 1260, addressed themselves to expelling the second Crusader kingdom — which by now was no more than remnants of its glorious predecessor, clustered along the Coastal Plain — from the country. From 1263 on, until his death in 1277, the Mamluk ruler Baibars conducted seasonal attacks on the Crusaders. In 1265 Baibars captured Caesarea, the most important and most fortified of the coastal towns (it had been excellently fortified by Louis IX — "Saint Louis" — after his return from captivity in Egypt), and went on to capture Haifa. In 1268 Jaffa was captured, and in 1291 Atlit and Acre as well, and this marked the end of the Crusader presence in Eretz-Israel. Since the Mamluks had an army based mainly on ground forces, and their fleet was incapable of withstanding its European adversaries, their weak point was the sea front, and in order to defend the country they chose to systematically devastate the Coastal Plain.

The Mamluks destroyed all the fortifications along the coast, including the walls of the towns. The inhabitants of the region, who were afraid to live in scattered settlements, abandoned them and moved to the mountain regions. From that time on the Coastal Plain remained desolate, without any large settlements, apart from a few towns such as Jaffa and Gaza. The irrigation channels were burst asunder, swamps spread in every place not covered with sand, oak trees grew wild and blocked the easy passages in the Sharon. The coast was not rehabilitated after this, apart from minor renovations carried out by the Ottomans in some of the port towns that were essential to them, such as Acre and Jaffa. Thus when the Zionist movement began its activities in Eretz-Israel in the late 19th century, lands in the Sharon and the Shefela were the first to be purchased, because no-one wanted them, and the first Jewish settlements were founded on the Coastal Plain. Mikveh-Israel, Petach-Tikvah, Rehovot, Rishon-Letzion, Nes-Tziona and other agricultural villages were the nucleus of the new Jewish settlement in Eretz-Israel, and today almost two million people live there. This has led to a major transformation in the natural appearance of the central Coastal Plain.

**The tower in Ramle**

*Anonymous draftsman, 1880*

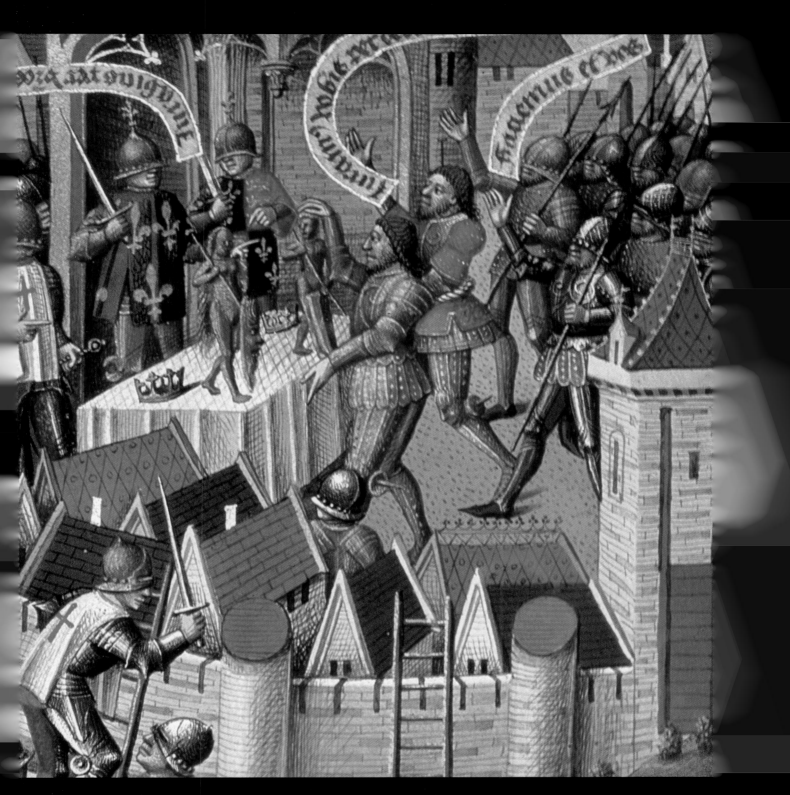

*Capture of Acre by the Crusaders in 1191*
*From a French illuminated manuscript by*
*Vincent de Beauvais, date unknown,*
*Collection Musée Conde, Chantilly, France*

***Rachel's Tomb*** (detail)

*Luigi Mayer, 1802*

*Collection The Israel Museum, Jerusalem*

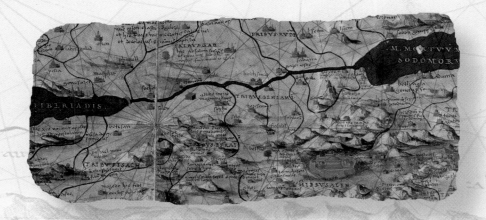

# Samaria and the Judean Mountains

**Samaria and the Judean Mountains** *on a map of the*
*Holy Land from 1790 by Robert de Vangondy, France*

**Segment of a mosaic floor**
*3rd century (the late Roman period), found in a Roman*
*villa in Shechem, Collection The Antiquities Authority,*
*The Israel Museum, Jerusalem*

he central mountain region of Eretz-Israel is divided into two:
Samaria in the north, and Judea in the south. Between these two
parts lies the Jerusalem area, which is lower: Mount Scopus, the
highest mountain in Jerusalem, reaches a height of 835 meters above
sea level, while Mount Ba'al-Hatzor in Samaria rises to a height of
1,016 meters, and Mount Halhul in Judea to a height of 1020 meters. The difference
between these three segments is conspicuous: the mountains around Hebron, which are in the
center of Judea, are steepest on their eastern side, and contain no comfortable passes.
Moreover, to the east of this region lies the Judean desert, and beyond it the Dead Sea,
which does not allow for passage eastward. The Judean mountains thus constitute a closed
area, which opens principally to the west, towards the Coastal Plain, along the creeks (*wadis*)
which descend from it. In contrast, the Jerusalem mountains, which are lower than the
neighboring mountains to the north and the south, provide more comfortable passage from
west to east. Jerusalem benefits from the traffic that passes through it, as do towns such as
Jericho, at the eastern edge of the pass, and Beit-Shemesh, Gezer, and other towns west of it.
Compared with the Judean mountains, the mountains of Samaria are open both to the west,
along routes that exploit the *wadis* that descend westwards from it, and to the east, towards

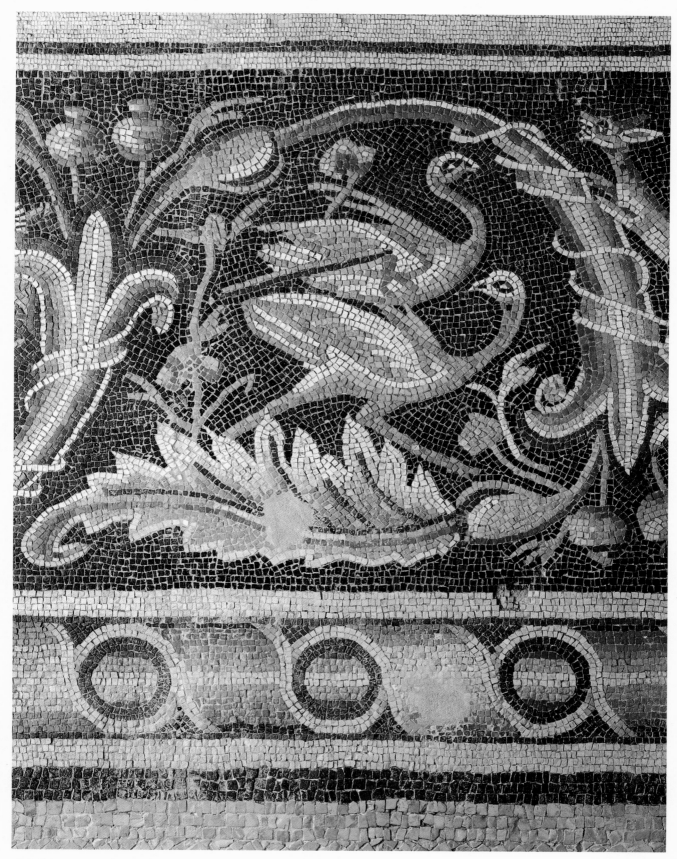

**Detail from a mosaic**

*4th century (the Byzantine period), found at the Samaritan synagogue at Khirbet-Smara. Collection The Arcehological Staff Officer, Judea and Samaria, The Israel Museum, Jerusalem*

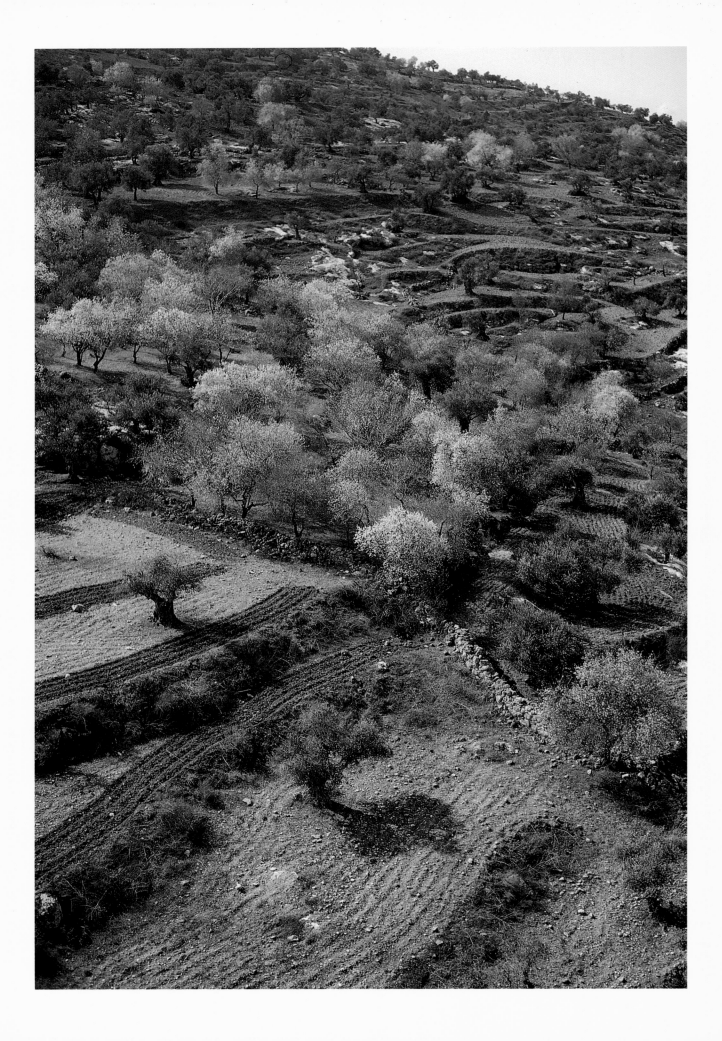

the Samarian desert, along several ravines which allow for comfortable passage (such as Nahal Korea or Tirzah, which in Arabic is called Wadi 'al-Faru). This narrow mountain pass is put to good use by the town of Shechem (Nablus), through the center of which it passes, and in ancient times other towns too resided along its route. Today the town of Tul-Karem resides at the western end of the pass, while its eastern end opens onto a fertile agricultural region which is called "Giftlik" because during the Ottoman regime it contained large government farms.

After the division of Eretz-Israel between Israel and Jordan in 1948, the area of Judea and Samaria was called "the West Bank", because from the Jordanian point of view this was a district adjacent to the Jordan, to its west. The entire region has an area of 3,650 sq. km., and a population of almost two million.

The region is mentioned in ancient sources. In the Tell El-Amarna Letters there is an account of its division between the Kingdom of Jerusalem and the Kingdom of Shechem, and the struggles between the two sides are described in great detail. In the territory between these two kingdoms there existed the confederation of Gibeonite towns, which was an important factor in the conquest of the country by the Israelites. It is possible that the confederation of Gibeonite towns was ruled by Jerusalem, in the absence of a ruler of its own. In the division of the country among the Israelite tribes, as described in the Scriptures, Samaria was allotted to the tribes of Joseph — the tribes of Ephraim and Manasseh — and of Benjamin. The latter dwelt in Jerusalem and its environs. Judea became almost exclusively the inheritance of the tribe of Judah, though the tribe of Simeon also dwelt there.

It was in the central section, the inheritance of the tribe of Benjamin, that the Kingdom of Israel became consolidated in the period of King Solomon. Since Jerusalem was not under Israelite rule after the conquest of the country, the affairs of the tribe of Benjamin were conducted in association with the other tribes of Joseph to the north, and it was only after the capture of Jerusalem by King David that the Benjamite country became a center, which

On the facing page:

*A landscape in Samaria — almonds in bloom*

**Rachel's Tomb**

*Drawing on an amulet against the evil eye, Jerusalem, c. 1900*

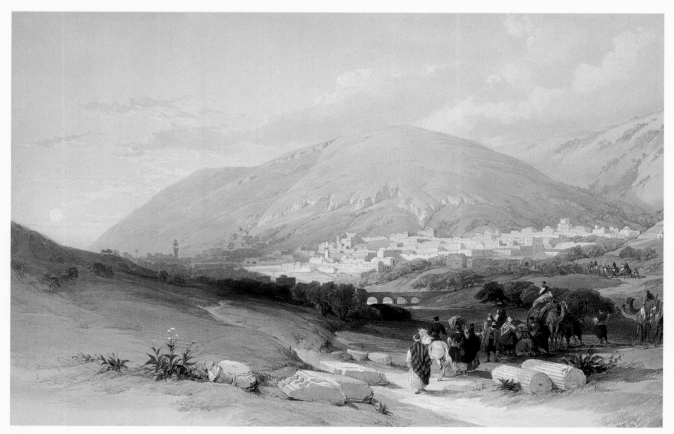

**Nablus, ancient Shechem**

*David Roberts, 1839, Stapleton collection, London*

increased in strength after the expulsion of the Philistines from the Bethlehem area and the mountainous tracts north of Jerusalem. David's conquests combined Samaria and Judea into a single unit, which split up only during the reign of Jeroboam, when it was divided between the kingdoms of Israel and Judah.

After the destruction of the Kingdom of Israel, the Philistines returned and gained control of its south-western corner, but the kings of Judah expelled them from there and annexed the district to their kingdom. As a consequence of this expansion northwards, and of the

**The Church of the Nativity, Bethlehem**

*Luigi Mayer, 1802, Stapleton collection, London*

physical deterioration of the southern area of Judah — which suffered in particular from attacks by the Babylonians during the war which led to the destruction of the First Temple — the territory of the state of Judah after the Return to Zion lay mainly northwards of Jerusalem, rather than in its traditional center, which was in the Hebron-Lachish region. The southernmost point of the second state of Judah was Beit-Tzur. At the same time, we should recall that the political borders did not always correspond with the actual bounds of habitation.

The decline in the power of the coastal towns during the Persian occupation enabled the Persian province of Judah to expand as far as Lod, on the Coastal Plain. In this period, habitation in this region grew to such proportions that in the Seleucid period (the early 2nd century B.C.E.), Lod was annexed to Judea.

In 333 B.C.E. the country was conquered by Alexander the Great. The kingdom of Judah did not suffer from this conquest, but in Samaria revolts broke out, which were harshly suppressed by the commanders of Alexander's army. Many refugees from Samaria fled to the

Samarian desert (in later years a similar phenomenon occurred in Judea, when refugees from the revolts against the Romans fled to the Judean desert), as we learn from letters (from the years 375-335 B.C.E.) that have been discovered in Wadi Dalya. In 312 B.C.E. the town of Samaria was destroyed by Alexander's heirs, who established a Macedonian colony there; the Samaritans, who had lived in Samaria since the time when they were brought there by the Assyrians, shifted their place of habitation to Shechem, which from then on became an important Samaritan center.

In 200 B.C.E., Antiochus III, a Seleucid-Greek king whose seat was at Antioch, conquered Eretz-Israel from the Ptolemies, the heirs of Alexander the Great who were based in Alexandria. His many harsh decrees and the increasing oppression of his rule over Judea led to the revolt of the Hasmoneans (beginning from 167 B.C.E.). The battles that were planned by Judah the Maccabee were marked by topographical insight, for all of them took place around Judea, and in effect marked out its borders. The first battle was at the steep ascent of Beit-Horon, the most important ascent from the coast to Jerusalem. There Judah defeated the army of Apollonius, the commander of the Seleucid army. The second battle, the Battle of Emmaus, took place on the western border of Judea, and there too the Seleucid army, under the command of Georgias, was defeated. The Seleucids, who understood that the Western border was well defended by Judah the Maccabee, decided to attack from the south, from the direction of Beit-Tzur on the southern border of Judea, but they failed there as well. (After this the Seleucids began employing a new method, that of attempting to weaken the state of Judea from within by introducing Hellenism into its bounds). Another battle took place at Ma'aleh Levonah in the north, which also concluded in a victory for Judah the Maccabee, but the great commander fell in the Battle of Hadasha, also on the northern border of Judea, which followed it. The independence of Judea was assured, however, and the Hasmonean rulers began to expand their new kingdom.

**Bethlehem**
*Detail from a mosaic, 5th century,*
*Cathedral of San Giovanni-in-Laterano,*
*Rome*

**Shechem and Mount Gerizim**
*Picture used to illustrate Hebrew books,*
*c. 1900, Jerusalem*

In 108-107 B.C.E., Shechem was captured and destroyed by John Hyrcanus, and during the entire Hasmonean period and the reign of Herod it continued to exist as no more than a small town. The administrative organization of the Hasmonean Kingdom of Judea did not change significantly over the years, and continued to operate in a similar framework during the reign of Herod as well.

Shechem had been important because it was a center for the Samaritans. The latter had

built a large temple on Mount Gerizim, which also continued to exist after the destruction of Shechem in the Hasmonean period. The Samaritans believed that Mount Gerizim — rather than Mount Moriah, which was in Jerusalem — was the chosen mountain; an echo of the dispute on this subject between them and the Jews appears in the New Testament (John 4:20): "Our fathers worshiped in this mountain; and ye say, that in Jerusalem is the place where men ought to worship". (The Samaritans managed to preserve their temple until it was destroyed, in 484 C.E., by the Christians, who saw it as a pagan temple; its destruction led to a Samaritan revolt.)

*Chancel screen from a church*

*5th-6th centuries (the Byzantine period), found in Massuot-Yitzhak, Collection The Antiquities Authority, The Israel Museum,*

The New Testament tells the story about Jesus' encounter with the Samaritan woman at Sychar (John 4:5-42). The place of the encounter, according to the Christian tradition, was the site of Jacob's well, and a church was erected there already in the Crusader period. John takes the trouble to note Jesus' passage "through Samaria", for this was an extraordinary choice. In the course of their dialogue, the Samaritan woman says to Jesus that "the Jews have no dealings with the Samaritans", and it is true that the history of Samaria is marked by many struggles, both ideological and territorial, between Jews and Samaritans. However, the lack of archeological findings that point to the existence of a town in this region during the period in question — between the reign of Hyrcanus and the reign of Vespasian — does not support the New Testament account. Yet the name of the town of Sychar is preserved in the name of the Arab village 'Aschar, which today is located to the south of Nablus — on the site where the ancient town of Shechem stood before the founding of the Roman town.

Shechem was rebuilt during the reign of the emperor Vespasian, who founded it in 72 C.E. on a new site, and called it Neapolis, "The New City" (its full name was Flavia Neapolis, after his family surname). The name "Nablus", which is employed today by the Arabs, is a distortion of the new Roman name, which replaced the earlier name almost completely. The new site had a major advantage because of its position in the narrow mountain passage between east and west — and it is probable that before this it was the site of the village Ma'abarta [a derivative of the Hebrew word for "passage"], the name of which refers to the pass where it was situated. Recent excavations have exposed remains of the Roman Neapolis, which appears to have been a well planned town, along the lines of Roman

**The Tombs of the Patriarchs in the Cave of Machpelah**

*From a Hebrew illustrated manuscript, c. 1400, Casale Monferrato, Northern Italy*

towns throughout the Empire. The emperor Hadrian built a temple in the town, for many of its inhabitants (apart from the Samaritans) were gentiles, as is also indicated by the archeological findings which reflect their way of life. These gentiles gradually became Christians, and several churches have also been discovered in the town.

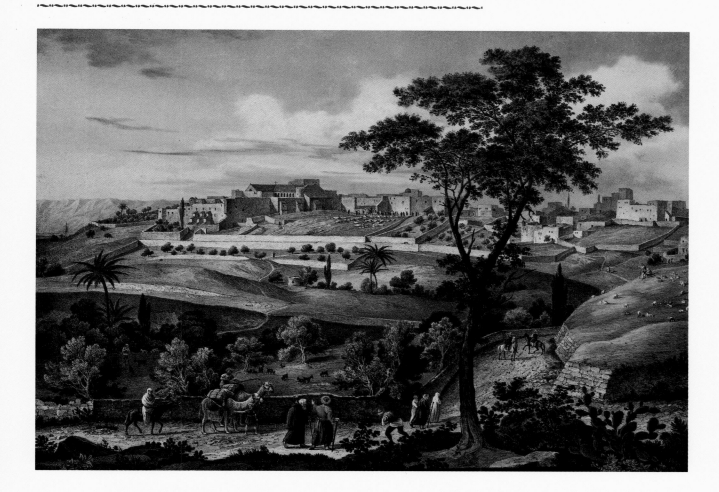

*A town in Judea, about 8 km. south of Jerusalem, at present within the bounds of the Palestinian Authority. In the past the majority of its inhabitants were Christians, but today its population is mostly Muslim. In the course of the centuries Jews too lived in Bethlehem, but always in very small numbers, since they refrained from living in places where crosses were visible from every corner in the town..*

*Bethlehem is an important town in the Jewish tradition. Benjamin, the youngest of Jacob's sons, was born in its environs. His mother Rachel died giving birth to him, and Rachel's Tomb, at the entrance to Bethlehem, is one of the most sacred places for the Jewish people. One of the Judges, Ibzan, also came from Bethlehem. The fame of Bethlehem, however, derives from its being the birthplace of King David, who spent the early years of his life there as a shepherd. From this derives the tradition that the Messiah, who was to stem from the House of David, would be born in Bethlehem, and for this reason the Christian tradition, too, determined Bethlehem as the place of Jesus's birth, and all four Gospels cite the direct link between David and Jesus.*

*The Church of the Nativity is one of the most ancient churches in Eretz-Israel. The building, which stands in the center of Bethlehem, was built by the Byzantine emperor Justinian, over a church that had stood there previously. In the late 3rd century St. Jerome settled in Bethlehem, and while there he also translated the Hebrew Bible into Latin (the Vulgate).*

The Jews maintained a certain presence in Shechem, but their number was never especially large. In the town of Samaria, too, the population was mainly gentile, and although in various sources there are occasional reports about Jews living in the town, their number was very small.

During the Second Temple period, the town of Jericho had an important economic status. The town was given by Anthony to Cleopatra VII, because of the high revenues it provided its rulers as a center of the perfume industry. Herod, too, leased the province of Jericho in order to benefit from its revenues.

The Bar-Kochba Revolt against the Romans took place mainly in Judea, and the village of Beitar, southwest of Jerusalem, was both its center and the place of the Jews' last stand before the suppression of the revolt, which was followed by the expulsion of the Jews from that part of the country. The 4th-century Christian theologian Eusebius of Caesarea, in his book *The Onomastikon*, writes about a number of Jewish settlements on the south side of the Hebron mountains which were inhabited by remnants of the Jewish towns that were destroyed during the Bar-Kochba revolt. Beside these six Jewish settlements the book mentions only two Christian settlements, which indicates that there was a Jewish majority in the region after the revolt as well. The Christian settlements mentioned were Yatir and Anim, and the

*On the following pages:*
**A landscape of hills in Samaria**

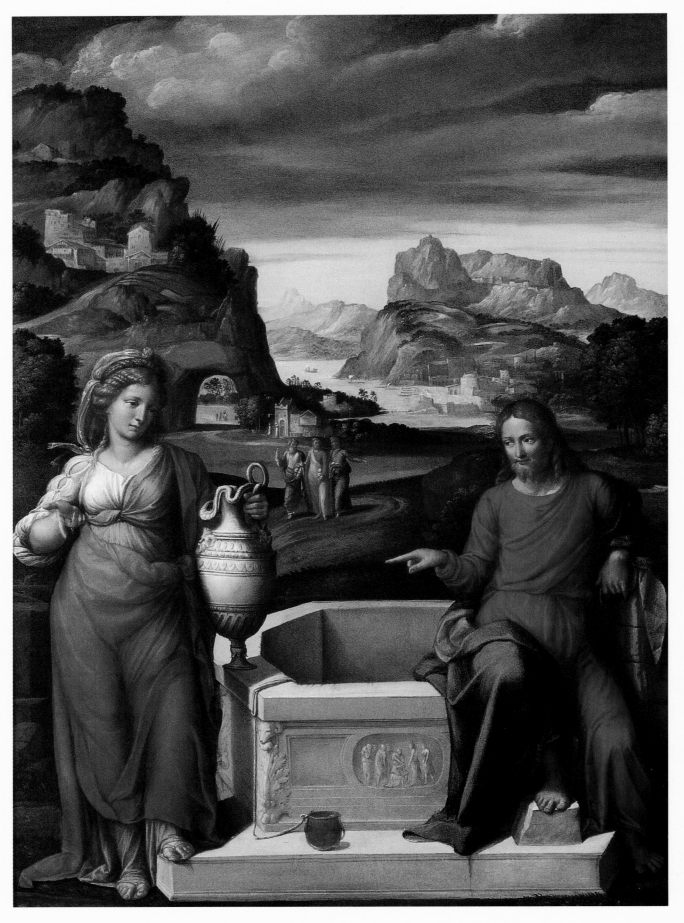

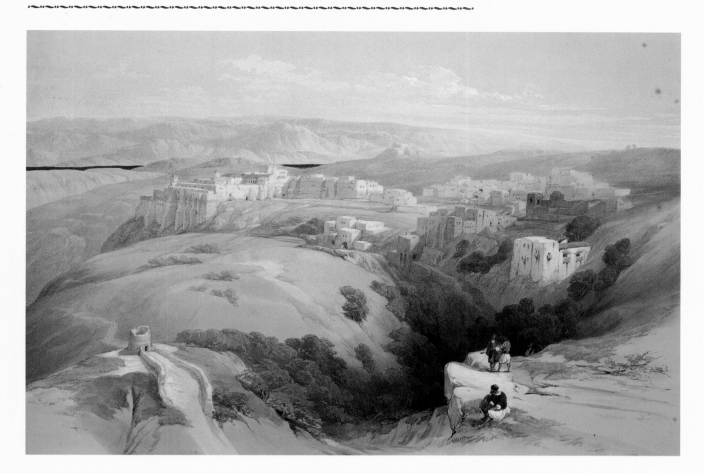

Jewish settlements were Yuta, Eshtmoa, Zif, Tala, Horma (and Ein-Gedi).

The Jewish settlements which survived for several centuries probably took part in the struggles between Jews and Christians throughout the Byzantine period. In 351 the Jews attempted to revolt against the Christian regime, and this led to the destruction of many of their settlements. In the 4th century the Samaritans too began to rebel against the Christians, and Samaritan revolts also broke out several times during the 5th and 6th centuries. (These revolts considerably weakened the country, and some historians believe that it was this weakness that finally made the incursion of the Muslims possible.) The Samaritans, in their revolts, exploited the terrain which was difficult to govern, and thus assisted the enemies of the Byzantine Empire, such as the Persians and the Arabs. Occasionally the Samaritans managed to overcome the Christians, and for a certain period they even maintained an independent kingdom, but their revolts were finally suppressed in 556.

Since the town of Samaria suffered less from the Samaritan revolts than did Neapolis, we may assume that the number of Christians there was greater, and their status more powerful, than in Neapolis. Samaria was the seat of a bishopric at a very early stage, and there were also a number of monasteries in the town. Nonetheless, Neapolis was of greater importance than Samaria, which began to decline in the 4th century: in the writings of the pilgrims, there are many more descriptions of Neapolis than of Samaria, despite the fact that since the time of Herod the latter was a magnificent city, perfectly planned, as may be seen today by anyone who visits its ruins.

What we know about the conquest of the country by the Muslims (638) and about the period of their rule is based on relatively few sources. The Samaria region was a part of the province of Palestine (*Jund Filastin*). The sources which describe Shechem-Neapolis, for example, almost always say that it was the city of the Samaritans, that it was a center of soap production (a known industry in Shechem to this day), and refer to its natural wealth (water springs, etc.). The sources which refer to the conquest of the Samaria region refer only to the towns of Shechem (Neapolis) and Samaria (Sebastia). During the Muslim period

*Bethlehem*

*David Roberts, 1839, Stapleton collection, London*

*On the facing page:*

**Jesus and the Samaritan Woman**

*Garofalo (Benvenuto Tissi), 1536*

*Collection The Israel Museum, Jerusalem*

*Right:* **Samuel is sent to anoint David as king** *(detail)*

*From a French illuminated manuscript, Paris, c.1250, Collection The Pierpont Morgan Library, New York*

*(Samuel, sent by God to Bethlehem; is greeted at the gates by six of the city's elders)*

**Sepulcrum Rachelis**

**Bethleem**

**Bethlehem and Rachel's Tomb**

*Detail from a pictorial map of the Holy Land, c. 1900, Collection The Municipal Library, Florence*

**The building over the Cave of Machpelah**

*Illustration from the **Faithful Guide to the Holy City of Jerusalem**, by the Italian pilgrim Pietro Antonio, c. 1700*

no events of note occurred in the region, and for this reason it is hardly mentioned in the histories. Shechem was inhabited mainly by Samaritans and also many Christians, a fact which facilitated its capture by the Crusaders, especially since there was no Muslim garrison based in the town.

At the time of the Crusader siege of Jerusalem (1099), Crusader soldiers arrived in Shechem to cut down trees in its vicinity for use in the siege. Afterwards Shechem was captured as well. with almost no resistance, by the Flemish noble Eustace (the brother of Godfrey of Bouillon) and the Norman prince Tancred. During the Crusader period, Shechem became the city of Manasseh of Herges, a friend of Mellisanda, regent of the Crusader kingdom and the widow of Fulk of Anjou, who resided in the town during the attempts of her son, Baldwin III, to wrest control of the kingdom from her.

In 1137 Shechem suffered from the invasion by Baseus, commander of the army of Damascus. After this the towns of Shechem and Samaria were attacked by Saladin (1148), and were saved from destruction only by a miracle. In 1186 the town became the property of the Ibelin family, one of the most important families among the Crusader nobility. During the twilight of the Crusader kingdom, the Crusader "parliament" convened in Shechem to appoint their next king, Guy de Lussignan (1186). On the eve of the Battle of The Horns of Hattin, too, the Crusaders assembled in Shechem, and from there issued the call for general

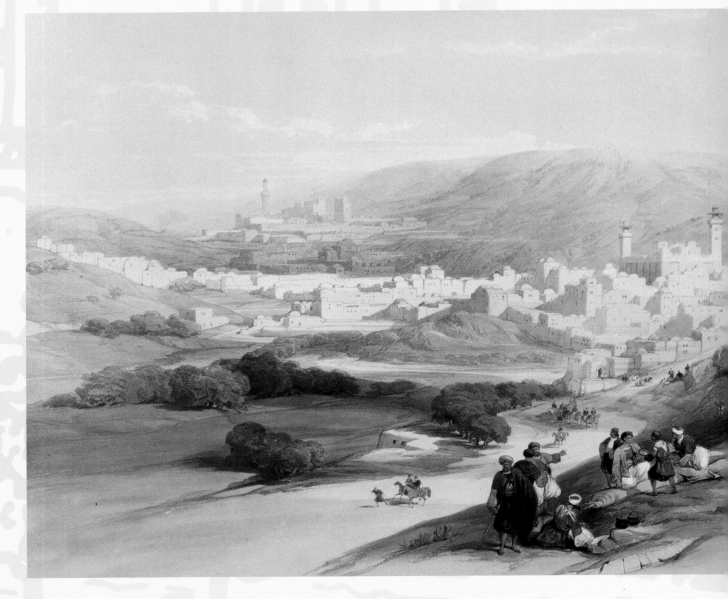

mobilization for the battle which concluded in the destruction of the first Crusader kingdom by Saladin (1187). After the defeat of the Crusaders, a Muslim army arrived in the town of Samaria, converted its magnificent church into a mosque, and also captured Shechem, whose Western-Christian inhabitants were allowed to depart in safety. Those who chose to remain were obliged to pay a head toll, and continued to till their lands. The army, which reached the heart of Samaria, concluded its campaign beside the Church of Jacob's Well.

Hebron is another town of some importance during the Crusader period. It is difficult to know how large the town was at this time, and it is possible that it did not extend beyond the bounds of the Cave of the Patriarchs (Machpelah) and several houses around it — but in the Crusader period relics were found there which were believed to be the bones of the forefathers, and this "discovery" greatly enhanced the town's prestige.

During the period of the second Crusader kingdom (1191-1291), which was established on the Coastal Plain, the various rival rulers fought one another over the control of Shechem, and for a long while the town was ruled by Al-Malak Al-Naser Daoud, ruler of the town of Kerak in Transjordan. In 1242 soldiers of the Templar order invaded Shechem and massacred its inhabitants, including the Eastern Christians among them, before they withdrew. There was also a small Jewish settlement in the town, and when it was invaded again in 1244, this time by the Khawarazmi tribe, the Jews sent their sacred paraphernalia to Jerusalem for protection until the danger passed.

*Seal of the Cave of Machpelah*
*c. 1868, Property of the Jewish community in Hebron*

From 1250 on, the country was gradually conquered by the Mamluks. In 1257, Shechem and Jenin were given to the Mamluk ruler Baibars, and Shechem became the center of a Mamluk province, on the basis of a division instituted by Al-Malik A-Nasr Muhammad Ibn Qalaun. Baibars settled families of Bedouin, and immigrants from more remote places, in Shechem, and gave them estates in the region, while taking care to separate the Qais (the veteran inhabitants) and the Yaman (the new immigrants). These terms stem from the early period of Islam, in the dispute that arose between the veteran inhabitants of the city of Medina and those who had been brought there by Muhammad after his famous *hegira* to the city (622). Similar disputes involving the rights of the first settlers were

### Hebron

*David Roberts, 1849, Stapleton collection, London*

Hebron was King David's first capital, and the most important among the cities of the tribe of Judah. According to Jewish tradition, the Cave of Machpelah [The Tomb of the Patriarchs] in this city is the burial place of the patriarchs Abraham, Isaac and Jacob. The building that stands above the cave today was built in the time of Herod, and is sacred to Christians and Muslims as well.

The city's historical center is a small tell named Tel-Rumeida, beside which there is another important site — Abraham's Tamarisk (actually: oak), supposed to be the tree under which Abraham was sitting when the three angels appeared to him. Jewish habitation in Hebron was uninterrupted until 1929, and it is considered to be one of the four cities sacred to Jews, along with Jerusalem, Safed, and Tiberias.

During the Crusader period the city was called St. Abraham, after the patriarch Abraham, and that is also the meaning of its Arabic name, Al-Khalil, which means "The Friend"; the Muslims think of Abraham as "God's Friend". As far as is known, monks during the Crusader period were the first to penetrate into the tombs in the Cave of Machpelah; they found the bones attributed to the Patriarchs there, and treated them with great respect, and reburied them after wrapping them in shrouds.

Hebron is also called Kiryat-Arba ("City of Four"), which was probably its Canaanite name, alluding to its division into four quarters. It is also referred to by this name in the Scriptures, by the scouts whom Joshua sent to spy out the Land.

The Jewish community in the city, which was wiped out in the Arab Riots of 1929, was renewed after the Six-Day War. Christians have not lived in Hebron, which is mostly Muslim, since the Crusader period.

widespread in all the Muslim countries, and determined the character of neighborly relations between villages and provinces. In 1486 an armed conflict broke out between the Qais and the Yaman in Shechem, which constrained the authorities to deport a number of families from the town.

With the Ottoman conquest of the country in 1517, the central regime was powerful enough to enforce order in the mountainous region of the country, but from the late 16th century on its power declined, and the security of the inhabitants worsened. Rebellions by local rulers, and the transformation of regions into almost independent states, became a constant source of trouble. We know, for example, that in the early 17th century Fahed A-Din, ruler of Galilee and southern Lebanon, tried to extend his rule to the mountains of Shechem, but the local rulers — members of the Tarabai family from Shechem — managed to repulse him (in this period Shechem was a center from which pilgrims set out for Mecca, a fact which heightened its prestige). In the 18th century another Galilean ruler, Daher al-'Amar, attempted to take control of the mountains of Shechem, but his endeavor failed as well.

Since pilgrims and tourists almost never visited the mountain regions, we do not possess detailed descriptions of the situation of Samaria during the Ottoman Empire, but taxation registers that have been preserved help us to reconstruct the picture. From these registers we can learn, for example, that the Samaria district did not change significantly between the 16th and the 19th centuries. Settlements known to us from previous periods continued to exist throughout the entire Ottoman period. Nonetheless, we know, for example, that during the last centuries of Ottoman rule the mountain area was an arena for conflicts between the Qais and the Yaman which influenced the history of the country in the Ottoman period. The center of the Yamans was at Abu-Gosh, in the heart of the country's mountainous region, while the Qais were concentrated in the south of Samaria.

The taxation registers from the 16th century do not refer to several areas in the mountain region, and this fact suggests a picture of a settlement containing scattered "islands" of uninhabited areas. It is possible, however, that these areas were inhabited by nomads, or that they were remote places which the tax-collectors did not reach, and therefore did not include them in their registers. In the 19th century many land properties were bought by wealthy *effendis*, who settled agricultural serfs on their estates and thus led to an increase in the population of the mountain region. The paving of improved roads, the construction of the railway from Jaffa to Jerusalem, and the increased involvement of the European powers in the country, all led to an improvement in security, which in turn contributed to greater population growth. In those years the mountain region of Eretz-Israel became the center of the Arab settlement in the country, even though the political center remained in coastal cities such as Jaffa and Haifa.

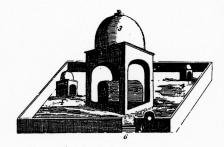

*Rachel's Tomb*
*Illustration from the book **The Holy Land** by the pilgrim Eugène Roger, 1631*

**Rachel's Tomb**

*Luigi Mayer, 1802, Collection Th[*

*Museum, Jerusalem*

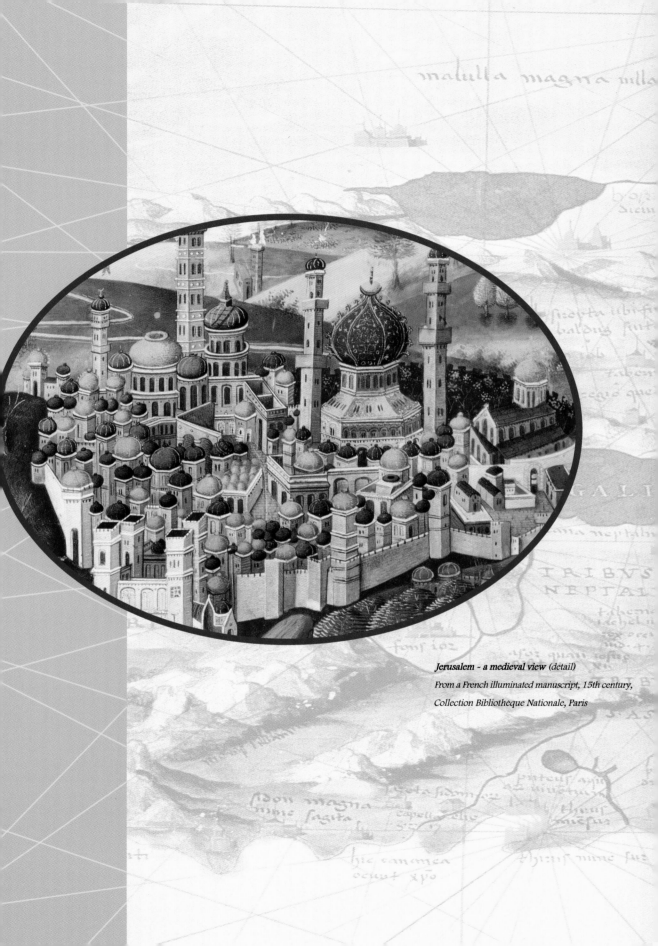

*Jerusalem - a medieval view* (detail)

From a French illuminated manuscript, 15th century,

Collection Bibliotheque Nationale, Paris

# Jerusalem
# and its Environs

**70 C.E.**  Destruction of the Second Temple

**135**  Beginning of the rebuilding of the city, under the Roman name
"Aelia Capitolina", by Hadrian

**335**  Consecration of the Church of the Holy Sepulcher in the city,
where many Christians lived.

**614**  Capture of the city by the Persians; their occupation lasted 15 years

**638**  Capture of the city by the Muslims

**1099**  Capture of the city by the Crusaders

**1187**  Capture of the city by Saladin

**1250**  Jerusalem becomes part of the Mamluk State

**1516**  Capture of the city by the Ottomans (Sultan Selim)

**1917**  Capture of the city by the British

**1948**  Jerusalem is declared the capital of the State of Israel

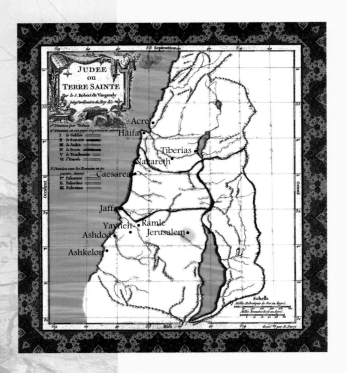

*Jerusalem and its environs, on a map of the Holy Land from 1790 by Robert de Vangondy, France*

**Glass pendant with menorah image**
*6th century (the Byzantine period), found in Jerusalem, Collection The Antiquities Authority, The Israel Museum, Jerusalem*

erusalem, the capital of Israel, is situated in the central part of the mountain range of Eretz-Israel. This part is lower than the ranges to its north — the Mountains of Samaria — and to its south — the Judean Mountains. Because of its comparatively low environments, with its easy passages eastwards and westwards, and the spring at its bottom which provides abundant water all year round, the Hill of the City of David — the historical nucleus of Jerusalem — attracted inhabitants since the most ancient times.

The archeological findings make it clear that the site was already inhabited as early as the fourth millennium B.C.E., although the remains from this period are partial and fragmented. Since the Hill of the City of David was inhabited throughout almost all the periods, and was rebuilt after every destruction, the ancient remains were not well preserved, and we have to reconstruct the city's history from the sparse findings, with cross-references to the historical sources, which in the case of Jerusalem are relatively plentiful.

The first time that Jerusalem is mentioned in writing is in Egyptian texts from the 20th and the 19th centuries B.C.E.: the Egyptians, who ruled in Eretz-Israel at this time and were apprehensive about a rebellion by the city's inhabitants, wrote its name on potsherds, in the belief that by breaking the shards they would also break the city's power. The very mention of Jerusalem in the Egyptian writings is evidence of its importance to the Egyptians, and of

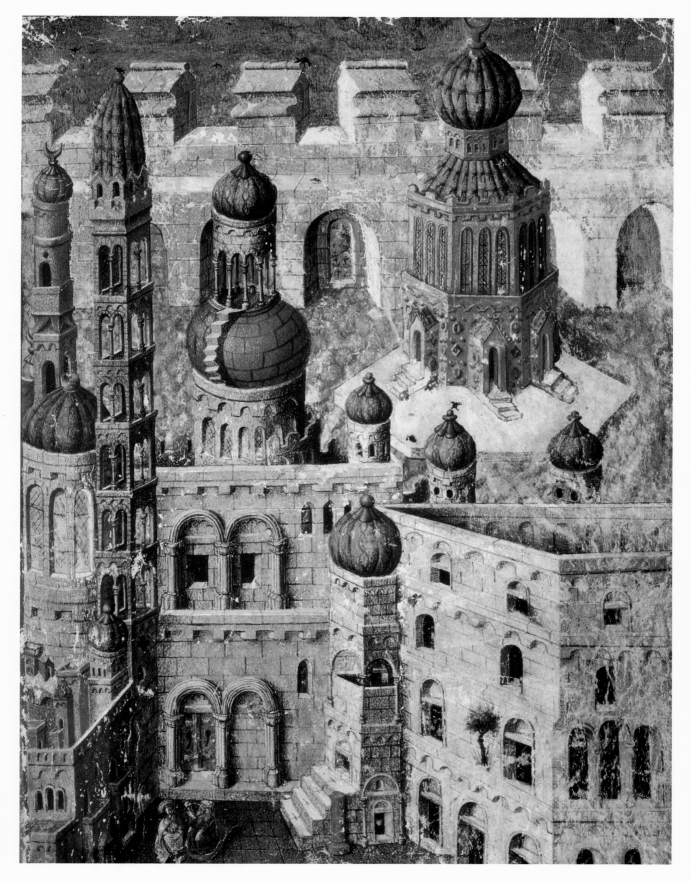

*View of Jerusalem and the Church of the Holy Sepulcher*

From the cover of **The Book of Hours** *by René of Anjou, 15th century, Collection The British Library, London*

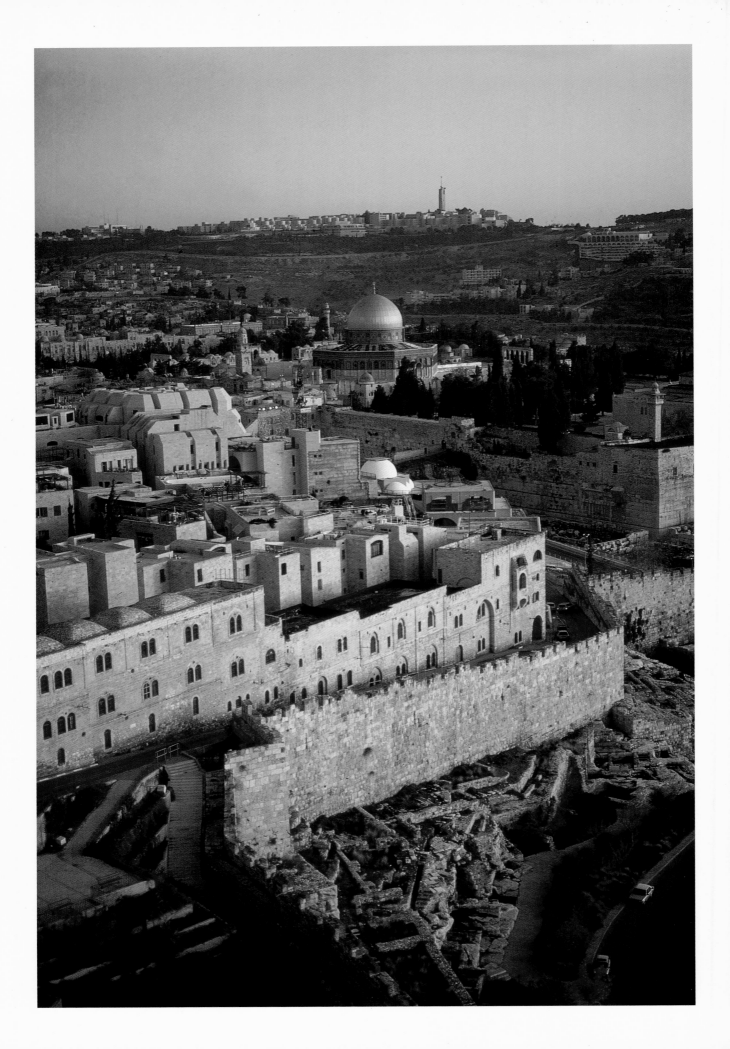

the fact that it was a real city — but in the absence of archeological findings from the period we have no idea what it looked like. The archeological excavations show that the site was inhabited long before this, in the early and middle Bronze Ages (from the latter part of the fourth millennium B.C.E. and throughout the entire third millennium B.C.E.).

The archeological findings indicate that in the 18th century B.C.E. impressive building projects began in the city. One of the research hypotheses is that this was the time of the period of the forefathers which is recounted in the Scriptures. Melchizedek, priest of the Supreme God, was king of Jerusalem at the time when it was first mentioned in the Book of Genesis. It is possible that the story of the encounter between Abraham and Melchizedek attests to an increase in Jerusalem's strength in those days; indeed, an increasing number of remains from this period have been discovered recently.

The Scriptures also contain a description of the capture of Jerusalem by the tribe of Judah (Judges 1:8) — but the course of events subsequent to its capture is not sufficiently clear, for Jerusalem is again described as a gentile city in later books in the Scriptures, such

**The Tower of David, on a Crusader seal**

c. 1150, *(Inscription around the edge: "City of the King of All Kings")*

as 2 Samuel, which tell about its capture by David. It is possible that after Joshua's victory over Adonizedek, king of Jerusalem — who led a local army in the battle in the Valley of Ayalon — the city was captured by the Jebusites, after whom it was called Jebus, the name under which it appears in the Scriptures in descriptions of the late Canaanite period. The story of the capture of the city by David is also not sufficiently clear, for the description in 2 Samuel is not identical to the description in 1 Chronicles. At any rate, it is clear that

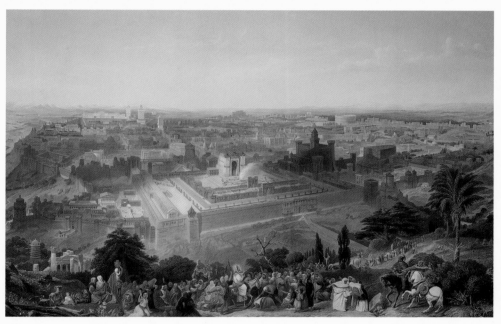

*Jerusalem in her Grandeur*

Henry Courtney Selous (1811-1890), 1860, Stapleton collection, London

after capturing the city David made it his capital, and thus determined its fate.

After the destruction of the First Temple by the Babylonians, who succeeded the Assyrians

**Baldwin enthroned as King of Jerusalem,** on a Crusader seal, c. 1150

as a major world power in this period (586 B.C.E.), Jewish inhabitants who did not go into exile remained in Jerusalem. A number of remains from the period indicate that there was continuous Jewish habitation in the city throughout all the years of the Exile, but in those years Jerusalem did not have any important political status; the city of Mitzpeh, north of Jerusalem, was the political center at this time, in place of the destroyed Jerusalem. A certain development occurred in the city's situation after the declaration by Cyrus (538 B.C.E.) and the Return to Zion, but it appears that the re-establishment of the Temple did not lead to spiritual elation among the people, who continued to struggle with problems of everyday

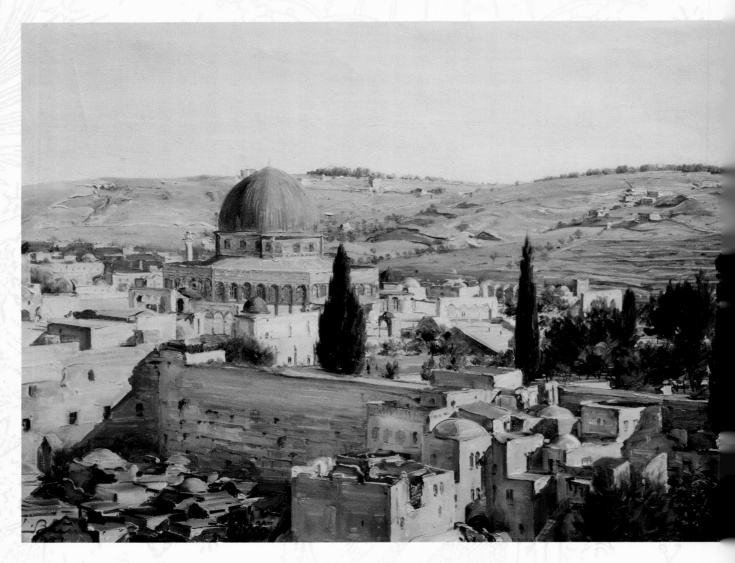

**The Mosque of the Dome of the Rock and the Western Wall**
*Ludwig Blum (1891-1975), 1937,*
*Collection The Israel Museum, Jerusalem,*
*loan by William Margolis*

existence. It was only at the time of Ezra and Nehemiah, the prominent leaders of the Jewish people in the mid-fifth century B.C.E., that a true recovery occurred.

In 333 B.C.E. the entire country was conquered by Alexander the Great, who did not reach Jerusalem or capture it in battle because — as the Talmud recounts — the High Priest, Simon, descended to Afek to inform him of the city's capitulation. In 200 B.C.E. the country was conquered once again, by the Seleucid king, Antiochus III. The harsh decrees promulgated against the Jewish religion by his heir, Antiochus IV, provoked the revolt of the Hasmoneans (167 B.C.E.) against the Seleucid Greeks, which concluded in the establishment of Judea as an independent state. The century or so during which the Hasmonean dynasty ruled in Judea were a magnificent period, for several of the kings of this dynasty extended the bounds of the state and brought it much wealth. The Hasmoneans' compliance with the Hellenistic ways which were dominant in the world at that time, and disputes which began

to emerge within the Hasmonean house itself, led to Roman intervention in affairs in the country, to their capture of Jerusalem in 63 B.C.E., and to the aggrandizement of Antipater, the Grand Vizier, an Idumaean in the Hasmonean court, whose son, Herod, took control of the Hasmonean royal house and tried to destroy every trace of it (40 B.C.E).

Despite the extreme despotism that characterized the rule of Herod (40-4 B.C.E.), who reigned under the aegis of the Romans, this was a period of great prosperity. Herod initiated building projects which surpassed anything previously known in Eretz-Israel. The acme of these was the rebuilding of the Temple on the Temple Mount, on a scale that was unparalleled anywhere in the world, with a splendor and magnificence that astonished even his many adversaries. Herod also built Caesarea and Samaria, but above all he continued aggrandizing his capital, Jerusalem, erecting many public buildings there. Of all his great building projects in the city, however, little has survived apart from the walls of the Temple Mount and the Tower of David. Echoes of Herod's extreme despotism appear in the writings of Joesphus, the great historian of the period, one of whose sources was the personal scribe of King Nikolaus of Damascus. Herod's deeds are mentioned in the Mishnah, too, as well as in the New Testament, which describes the life of Jesus during the reigns of Herod and his heirs.

After Herod's death he was succeeded by his less able sons, and the weakening of the dynasty undermined the political autonomy of Judea and led to an extension of the authority of the Roman Empire's local governors. The arbitrariness of these governors — the best known of whom was Pontius Pilate, who became famous through the trial of Jesus — led to the Great Revolt against the Roman rule (67-70 C.E.), which brought about the destruction of the Second Temple and the liquidation of the state of Judea.

Jerusalem remained in ruins for more than sixty years. In 129 C.E., the Emperor Hadrian arrived in Jerusalem, and decided to build a new pagan city there, called Aelia Capitolina — "Aelia" after himself (his full name was Aelius Publius Hadrianus), and "Capitolina" after the Capitoline trinity — Jupiter, Juno and Minerva; the latter was the patroness of the Roman city. Hadrian initiated most impressive building projects in the city. He erected a temple on the site where the Church of the Holy Sepulcher stands today, and it is possible that he also built a shrine on the Temple Mount, where the Temple had stood. He also erected triumphal arches, built two markets, and so on. The city was not fortified at the time, for already during the Great Revolt the Tenth Legion was permanently garrisoned there, and it defended the city. Jews were forbidden to live in the city, and this prohibition also extended to the Christian community, who lived in the city on an underground basis. Almost nothing is known about this time, and the little information we do have comes from later sources. In the late 3rd century, with the extensive reforms that took place in the disintegrating Roman Empire, the Tenth Legion was transferred to Eilat — and it is probably at this time that the walls of Jerusalem were built, with a perimeter

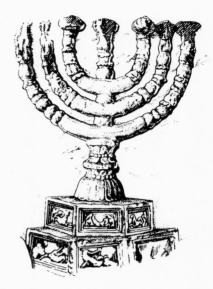

*Relief image of the golden* menorah *that was taken from Jerusalem*
(After the depiction on the Arch of Titus, Rome)

*Jerusalem and Bethlehem*
in a mosaic from the apse of the Church of St. Peter in Rome, fifth century (destroyed), from the book ***A History of Sacred Buildings Constructed by Constantine the Great*** by G.G. Ciampini, 1693

On the following pages:
***The Old City of Jerusalem, view from the north***

97

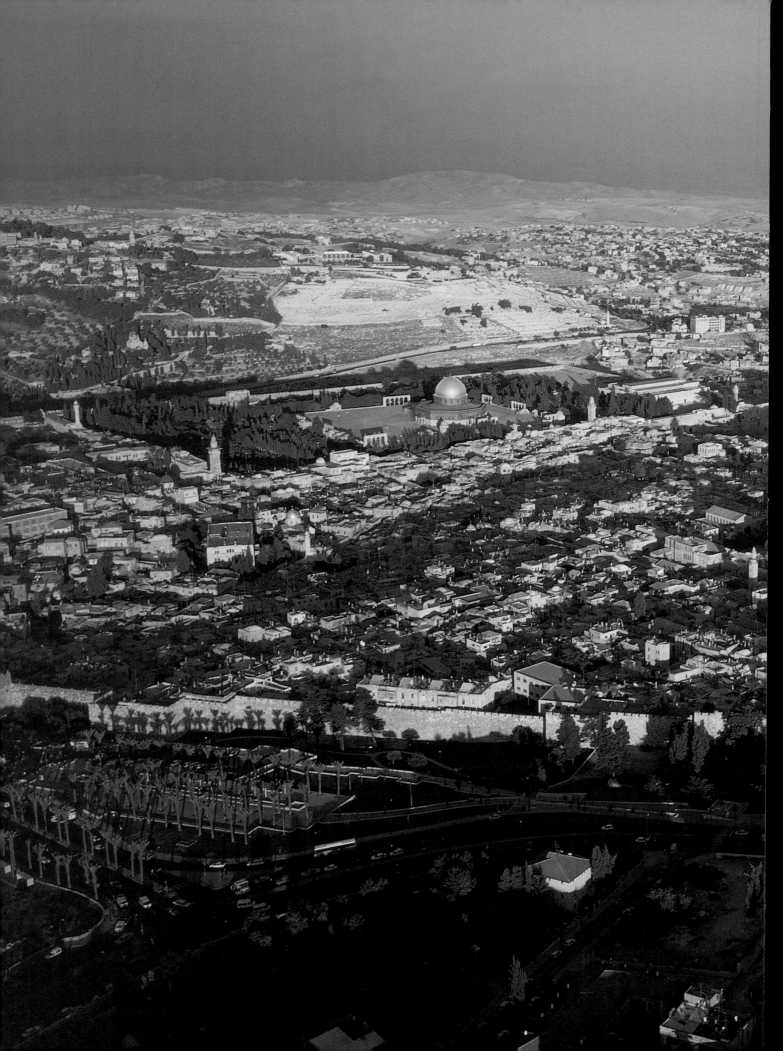

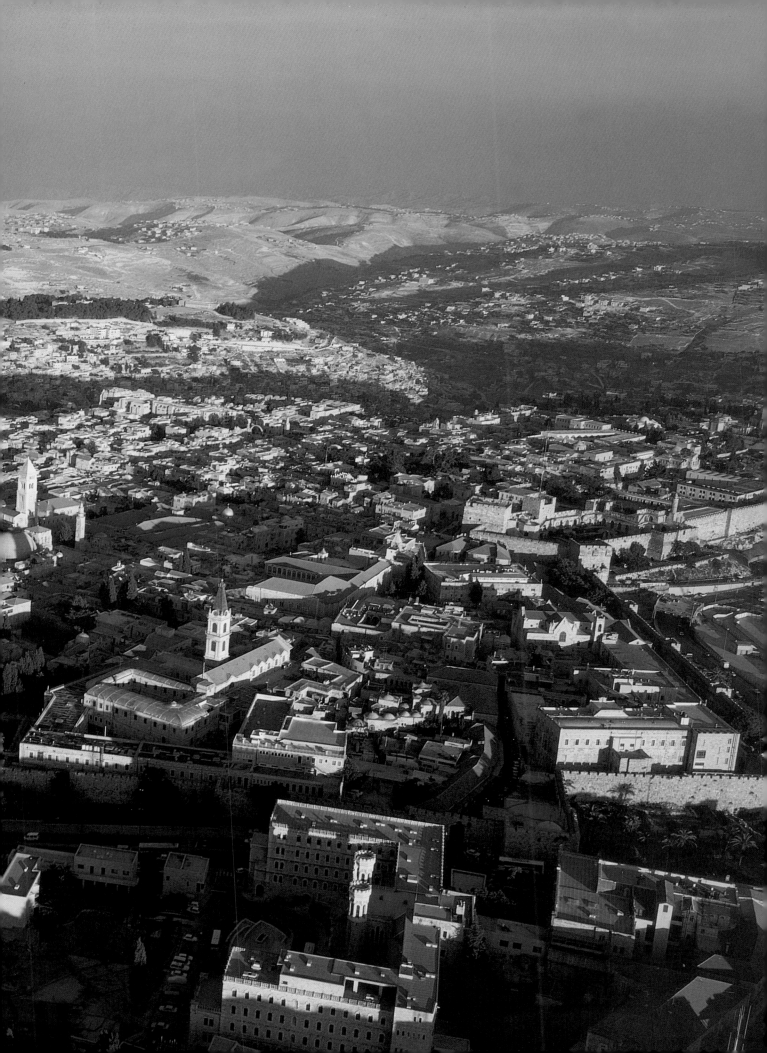

more or less like that of today. Throughout the Roman occupation the city developed extensively, and the extent of the walls is evidence that its area had grown very much since the beginning of the Roman period.

In the first third of the 4th century, during the reign of Constantine the Great, the Roman Empire was divided into two, and its eastern part was called Byzantium, after its capital. During this period the Christian religion began expanding gradually, until it became the ruling religion in the Byzantine Empire. In 326, Constantine, sympathizing with Christianity, built the Church of the Holy Sepulcher in Jerusalem, on the site where, according to Christian tradition, Jesus had been buried and had then risen again. He also built the Church of the Ascension, the Church of the Mount of Olives, as well as other churches. The face of the city changed, and it became the spiritual capital of the Byzantine Empire, the place of the great miracles wrought by the founders of the new religion. This change led to a great increase in the city's population, and to further building projects. Many pilgrims settled in Jerusalem, and the Kidron valley filled up with monks who made their homes in tombs from the First Temple period. The fame of the city, with all its magnificent buildings, spread throughout the Empire and even beyond it.

In 614 the Persians — the great enemies of the Byzantine Empire — managed to conquer large portions of the Middle East, including Jerusalem. Some historians think that the Persians were attracted to Jerusalem by rumors about great treasures kept in the city. The Persian conquest was most cruel — churches were burned, and priests were massacred in large numbers. Only after 15 years, in 629, did the Byzantine emperor Heraclius manage to once again annex Jerusalem to his empire, as an outcome of treaties with the Persians. The Golden Gate, which still stands in Jerusalem, was constructed to greet the emperor on his return to the city with the Holy Cross, which had been taken as booty by the Persians.

The renewed Byzantine rule did not last very long, and in 638 the city was captured by the Muslims. At first no emphatic change was felt in the city. The Muslims built mainly on the Temple Mount and its environs: on the Mount itself they built the Mosque of the Dome of the Rock (691) and the Mosque of Al-Aqsa (713-715); beside the Temple Mount they built magnificent palaces, and around the Tower of David they built the Citadel of Jerusalem. In 750 the Abbasids took over the Caliphate, and Jerusalem began to suffer from religious persecutions, and lost some of its earlier glory. In the early 9th

**Gold pendant, ring, and earring**
*3rd century (the Roman period),*
*found at Nahal Rakafot, Collection The*
*Israel Museum, Jerusalem*

**Tomb of King David**
*Detail from an illustration in the book*
**Journal of a Voyage in the Levant,**
*by the Frenchman, Henri de Bouveau,*
*1609*

*On the facing page:*
**The Church of the Holy Sepulcher,**
**Jerusalem,** *Eugene-Alexis Girardet*
*(1853-1907), date unknown, Collection*
*The Fine Art Society, London*

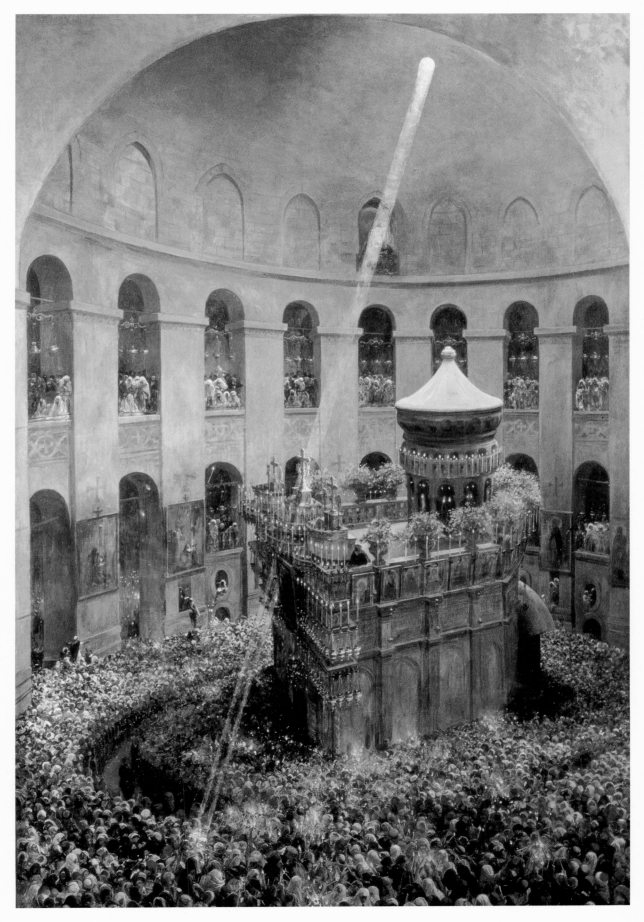

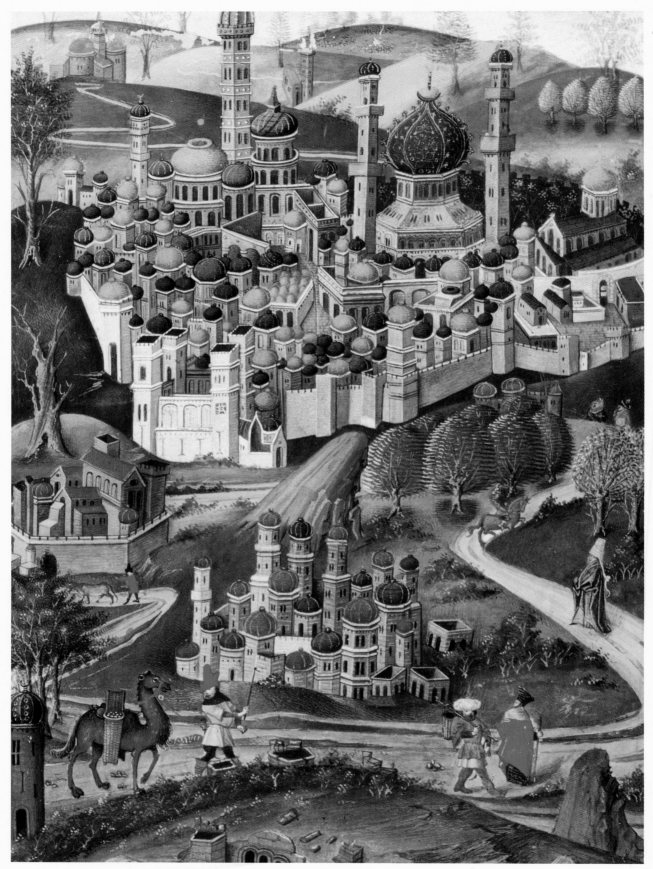

**A medieval view of Jerusalem**

From a French illuminated manuscript, 15th century, Collection Bibliothèque Nationale, Paris

century, the Christians in the city requested assistance from Charlemagne, emperor of the Holy Roman Empire, who initiated important building projects in the city. In 969 Jerusalem was captured by a new Muslim entity, the Fatimids. One of this dynasty's zealous rulers destroyed all the non-Muslim religious buildings in the city — including the Church of the Holy Sepulcher, which was almost entirely demolished, for the first time in its history (1009).

The early part of the 11th century was a period of rehabilitation of what had been destroyed, by both man and nature — for in 1033 the city was struck by a most severe earthquake. A group of merchants from the city of Amalfi in Italy, who had established trade links with the Fatimid rulers, managed to receive a permit to erect Christian buildings in Jerusalem, and built a hospice, monastery, and a public kitchen there. In 1048, through the efforts of the Byzantine emperors Constantine VIII and Constantine IX (Monomachus), the rehabilitation of the Church of the Holy Sepulcher was completed. The new building was a far cry from the beauty of the original one, but it served the needs of the community of worshippers. Likewise, the repair of the city walls was also completed at this time, and in return for their work the Christians who took part in this project received the "Christian Quarter", which is a center for Christians to this day. The period of rehabilitation ended at one stroke in 1071, with the capture of Jerusalem by the Seljuks,

*Plaque against the evil eye*
5th century (the Byzantine period), found in Jerusalem, Collection The Hebrew University, The Israel Museum, Jerusalem

a Turkish tribe who came from Central Asia. Their occupation of the city appears to have been very harsh, but very few descriptions of it survive. The many Seljuk conquests in the Middle East led to the closure of the land routes between Europe and Eretz-Israel, and to interference in trade with the East. and this atmosphere was one of the factors that provoked the Crusades.

In 1096 the First Crusade set out from Europe on its way east to the Holy Land. At the end of a prolonged journey they arrived at Antioch, in northern Syria, which they captured

after a long siege. In their great fervor to reach the Holy City, the Crusaders did not tarry in Antioch, and immediately after capturing the city they set out for Jerusalem, arriving at its gates on 6 June 1099. The Muslims took a number of defensive steps: they expelled all the Christian inhabitants from the city, to prevent them from acting as a fifth column

*The Sacred Rock in Jerusalem*
William Simpson (1823-1899), 1876, Collection The Fine Art Society, London

during a siege; they poisoned the water sources around the city; and they destroyed buildings outside the walls to prevent the Crusaders from using them. The capture of the city's outer wall was rapid, and had the Crusaders not slowed their advance they could have burst into the city immediately. Their pursuit of plunder, however, delayed the invaders and enabled the besieged inhabitants to reorganize. The city withstood the siege for five whole weeks, and it was only on 15 July 1099 that the walls and the city fell to the Crusaders. During three days of victory celebrations, the city's Muslim and Jewish inhabitants were slaughtered, and many description speak about the blood that flooded the city to the height of the horses' knees.

Within a short time the Crusaders organized a system of governance in the city. Godfrey of Bouillon, one of the commanders of the Crusader army, and the one who had led the penetration of the city, was elected Governor; a Patriarch was elected; and municipal institutions were established. The city, however, was practically uninhabited, and in order to tempt the Crusaders to settle in it, the authorities gave every settler a house of his own. Nevertheless, the population of the city remained sparse for years, and the attempts of King Baldwin I to deal with the problem — by exempting the city's merchants from taxes and by granting a variety of concessions — also were of little avail. In 1115 the king brought Christian Bedouin from southern

*The Walls of Jerusalem*

Abel Pann (1883-1963), 1918

Collection Tamar and Teddy Kollek,

The Israel Museum, Jerusalem

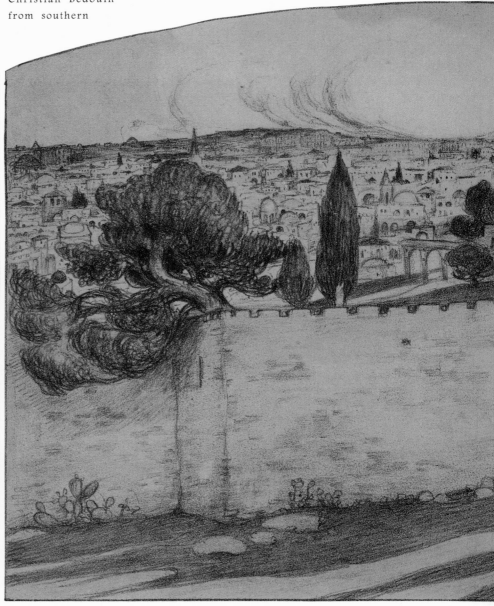

Transjordan and housed them in the former Jewish neighborhood, which was still uninhabited. The city gradually began to develop economically, benefiting from the revenues brought by pilgrims, from the activities of the monasteries and the churches, and from the fact that it was the capital of the Crusader kingdom (although it was never a central city in the kingdom, because unlike the coastal cities, it had no economic rear).

The history of Jerusalem in the 12th century is like a pageant of state occasions, for matters of state were decided there, and important public state ceremonies were held, such as the burials and the coronations of the various kings. From the variety of descriptions we get a picture of a lively city. In the course of the 12th century the Muslims tried several times to recapture Jerusalem, and once they even managed to advance from Transjordan as far as the Mount of Olives; in general, however, life in the city during this century was relatively peaceful. Even the earthquake which struck the city in 1170 did not significantly change the general picture.

In 1177 Saladin united Egypt and Syria under his rule, and opened a series of seasonal attacks on the Crusader kingdom of Jerusalem.

*Bracelet of gold beads and agate stones*
The Roman period, found in a tomb in Jerusalem, Collection The Antiquities Authority, The Israel Museum, Jerusalem

*Jerusalem*
Detail from a mosaic, 423-440, Church of Santa Maria Maggiore, Rome

*Tomb of the Kings of the House of David*
Illustration from the book **Lineage of the Patriarchs and the Prophets**, Heidelberg, 1659

*The Crusader assault on Jerusalem (1099) led by Godfrey de Bouillon*
From a French illuminated manuscript, 14th century, Collection Bibliothèque Nationale, Paris

**The Holy Sepulcher**
Detail from the mosaic Madaba map, c. 565, Church of St. George, Jordan

**Map of Jerusalem**
Based on the descriptions of the Christian traveler Arculfus, who visited the Holy Land in c. 670

Jerusalem was full of pilgrims who had come to gather together within its secure walls, but in October 1187 — after defeating the Crusader army at The Horns of Hittin — Saladin captured Jerusalem as well. In their war against the Crusaders, the Ayyubids developed a strategy of destruction, and after destroying the walls of Jerusalem, in 1219, they destroyed every fortified Crusader site that fell into their hands. The period of the reign of Saladin and his heirs — the Ayyubid period, as it is called, after the father of Saladin's dynasty — lasted only 63 years (1187-1250), but it was a very stormy one. Saladin's heirs fought against one another, and Jerusalem became the focus of their disputes. Because of the disagreements among the heirs, a large portion of the city was handed over to Christians led by the Emperor of Germany and King of Sicily, Frederick II of the Hohenstaufen dynasty, and the Christians thus gained another 15 years of rule in the city (1229-1244). In 1244 Jerusalem was captured by invaders from Central Asia, warriors of the Khwarazmi tribe, who wrought great destruction in the city and extended the defacement of the once magnificent Crusader city. Remains of buildings from the Crusader period may be seen in Jerusalem to this day, but without their distinctive ornaments, which were torn off and used again in Muslim buildings.

In 1250 the regiments of Ayyubid soldiers — soldier-slaves who were called "Mamluks", which in Arabic means slaves — revolted against their masters. The Mamluks, whose capital was Cairo, managed to sustain a state for a long period (1250-1560). Jerusalem, however, despite its very sacred status for the Muslims, was of no political or military importance for the Mamluk state. The city became a place of exile for high officials who had fallen out of favor with the Mamluk sultans, and was full of people who possessed much property, who at the termination of their exile were mostly ordered to return to Cairo, and were eliminated there. Since exile in Jerusalem was a kind of last period of grace in their lives, the exiles in this period frequently made use of their property and built many buildings in the city, which were donated to the Muslim charitable organizations in the city on condition that they would be administered by the donors' descendants for many generations. In this way the exiles ensured that at least a portion of their property would remain in their families' hands. Jerusalem became enriched with many beautiful Muslim buildings, and took on a truly Muslim character, which replaced the international atmosphere that had been prevalent there during the previous periods. In the writings of the many pilgrims the city is spoken of as ruined, not because it was in any way desolate, but because it had no walls, which was very rare for important cities in this period. The city itself, with all its civil and religious institutions, conducted a full urban life despite the absence of fortifications.

In 1516 Jerusalem was captured by the Ottoman Turks, who ruled there for 400 years (until 1917). In the Ottoman Empire, too, the city was of no particular political or military importance. It was not set at the head of a large province, and the province of Jerusalem was limited to the bounds of the city itself and the area of the neighboring city of Hebron, another sacred city which was not accorded any earthly importance beyond that. Fear of invasions by neighboring Bedouin tribes and of more European Crusades led Sultan Suleiman the Magnificent to rebuild the walls of Jerusalem (1537-1541), and to build water works in the city that would ensure a constant water supply. During the reign of Suleiman the Magnificent, the Mosque of the Dome of the Rock was renovated.

The 16th century was thus marked by significant improvements which changed the face of the city. After the death of Suleiman the Magnificent, however, the Ottoman Empire

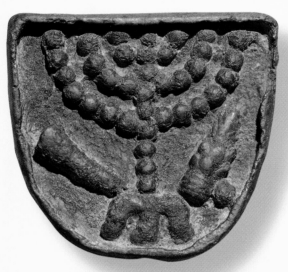

**Bronze stamp with menorah form**

*6th century (the Byzantine period), found in Jerusalem, Collection The Israel Museum, Jerusalem*

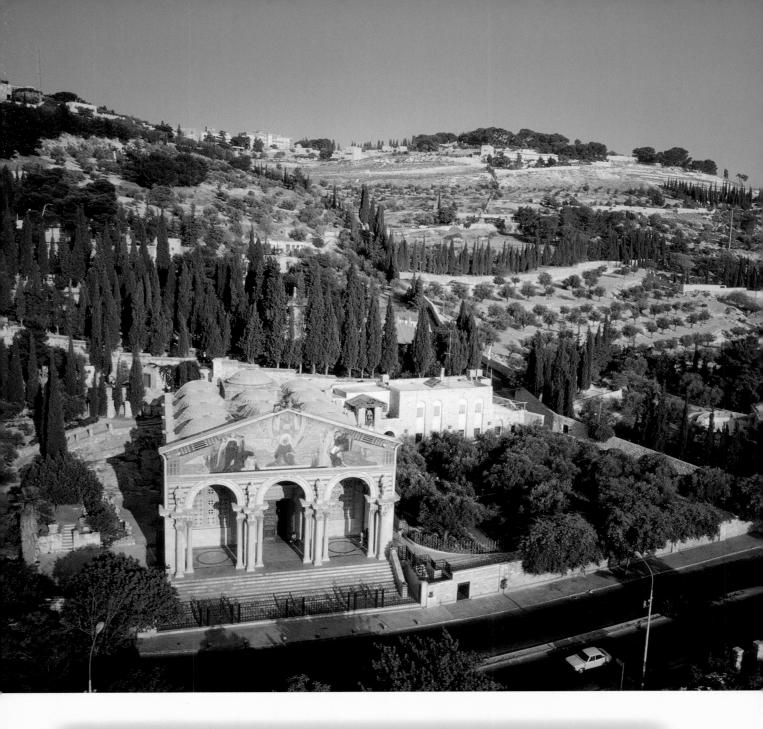

*The Church of All Nations, at the foot of the Mount of Olives*

The Kidron Brook was always the eastern boundary of Jerusalem, even at the time when the city's limited area corresponded to that of the hill of the City of David. The only spring in the vicinity, the Gihon Spring, rises in the brook's bed, and the area around the spring was famous for its gardens (the scriptural "Gardens of the King").

The brook also served as a boundary for Jerusalem's ancient graveyard, remains of which may still be seen today within the bounds of the village of Silwan on its eastern bank, and in the magnificent tombs of Absalom, Zechariah, and the priestly family of Hezir — and it also bounds the Mount of Olives, which slopes down to its eastern bank.

The western slope of the Mount of Olives is totally covered with graveyards, the largest and most important of which is the Jewish one. It was on this mountain that the people assembled after the destruction of the Temple, and it is thought of as "God's Footstool".

The sanctification of the Mount of Olives by the Jews also contributed to its sacredness to both the Christians and the Muslims. The Christians determined the summit of the mount as the place of Jesus's ascension to heaven, as is attested to by the many Christian remains that are scattered over it. At the foot of the mount is Gethsemane, which the Christians determined as the burial-place of Mary, mother of Jesus, as well as the place of Jesus's afflictions on his way to his imprisonment by the Romans. Because of these events that were attributed to it, the mount became a center for Christian pilgrimages.

entered a gradual decline, and continued to endure in a state of ongoing demise only because each one of the strong European powers feared that its territories would fall into the hands of one of the rival powers. The weak Ottoman sultan instituted a system of tax-collection by tender, and those who won extorted the population in the most cruel manner. This state of affairs led not only to much corruption, which spread through the entire Ottoman regime, but also to a terrible economic deterioration which characterized the entire period. The Ottoman Empire's need for help from the European powers in the Crimean War (1853-1856) enabled these powers to penetrate into Eretz-Israel in general and into Jerusalem in particular. They erected religious and government buildings of their own there, which made conditions a little easier for citizens of those powers, and especially for the Jews among them; only the autonomous rule of these powers by their consuls accorded their citizens security from the horrors of the harsh Ottoman regime. When the British captured Jerusalem at the end of the First World War (December 1917), they found a decimated and destitute city, without any organized infra-structures, and crying out for change.

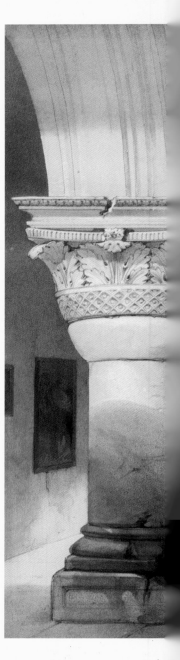

*Capital with cross*
*Byzantine period, found in Jerusalem,*
*Collection The Antiquities Authority,*
*The Israel Museum, Jerusalem*

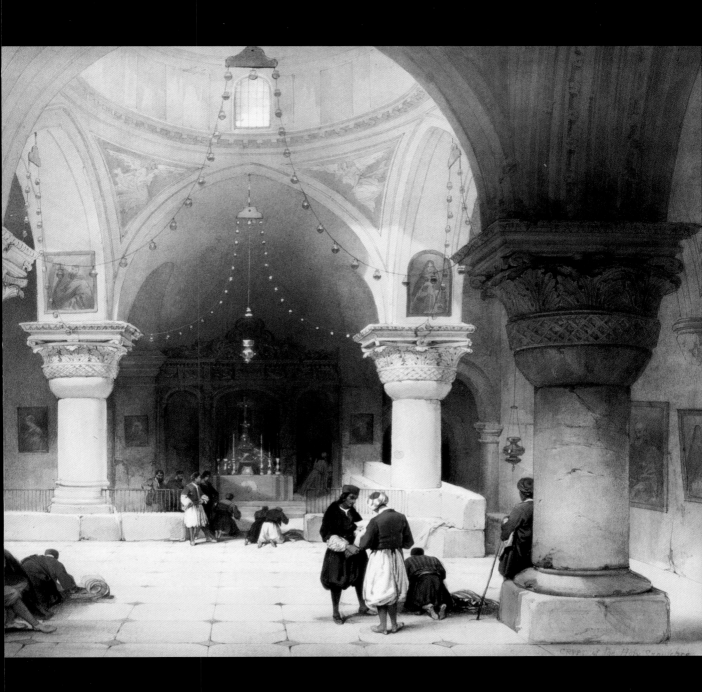

***Crypt of the Holy Sepulcher***
*David Roberts, 1842,*
*Stapleton collection, London*

*Convent of St. Saba* (detail)
David Roberts, 1839, Stapleton collection, London

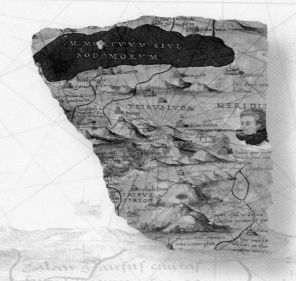

# The Judean Desert and the Negev

**70 C.E.** The Negev becomes part of the Province of Palestina-Prima

**106** The area of the province is extended to Transjordan, after the annexation
of the Nabatean kingdom by the Roman Empire

**4th century** Beginnings of the spread of Christianity in the region

**640** Conquest of the region by the Muslims

**19th century** The first archeological expeditions arrive
in the Negev and describe its remains

**1915** Construction of the Turkish railway in the northern Negev

**1917** The Negev is a battleground for the British and Turkish forces in World War I

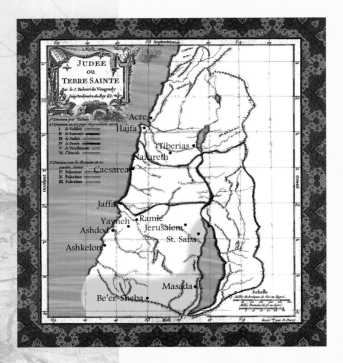

*The Judean Desert and the Negev, on a map of the Holy Land from 1790 by Robert de Vangondy, France*

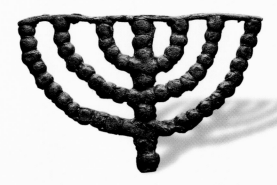

**Bronze menorah**

*6th century (the Byzantine period), found in the synagogue in Ein-Gedi, Collection The Antiquities Authority, The Israel Museum, Jerusalem*

he Negev is the largest of the regions of Eretz-Israel, covering more than sixty per cent of its area. Most of the Negev is actually desert, and only its northern portion allows for a livelihood from grazing and for a little agriculture in the rainy winter days.

Today, the main importance of the Negev (the Hebrew word means "wiped", *i.e.*, "dry") is that it is the only remaining land reserve in our densely populated country — but since ancient times the importance of the Negev has resided in its midway position, connecting the inhabited districts of the country with the Gulf of Eilat and the Red Sea. Before the signing of the peace treaty with Egypt, the port of Eilat was the State of Israel's only access route to the countries of the Far East and East Africa, where it has many economic interests. This strategic position guarantees the existence of the port of Eilat, although today, now that the Suez Canal is open to Israeli shipping, the latter is used more frequently in order to save on the expenses involved in transporting the merchandise from Eilat to the center of the country by land. After the signing of the peace treaty with Jordan, the connections between Eilat and the adjacent port of Akaba have been growing closer, augmenting the economic flourishing of Eilat and its environs, which are among the most important tourist areas in Israel.

Geographically, the Negev is divided into a number of regions. The Aravah basin passes

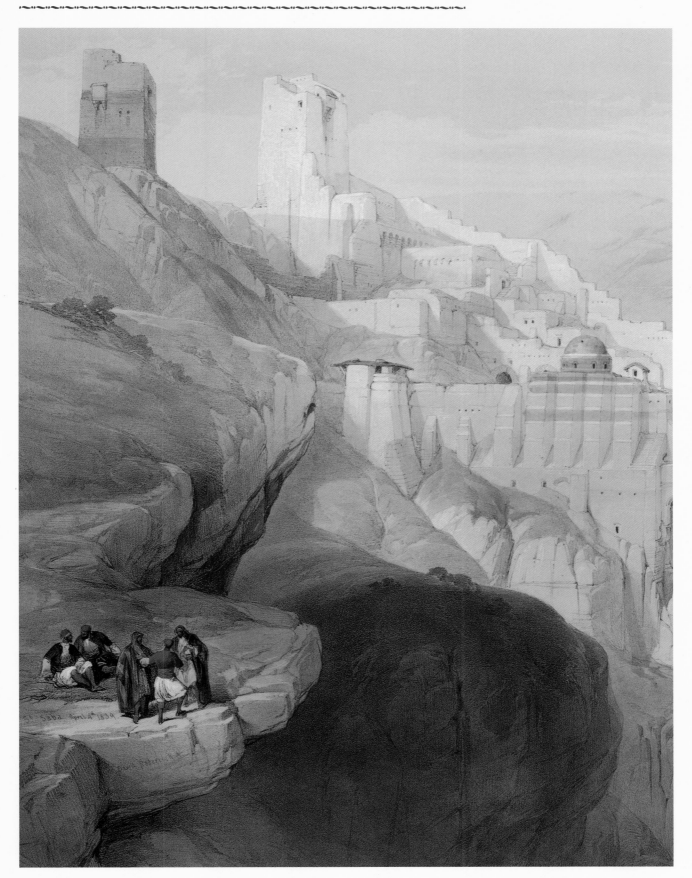

**Convent of St. Saba**

David Roberts, 1839, Stapleton collection, London

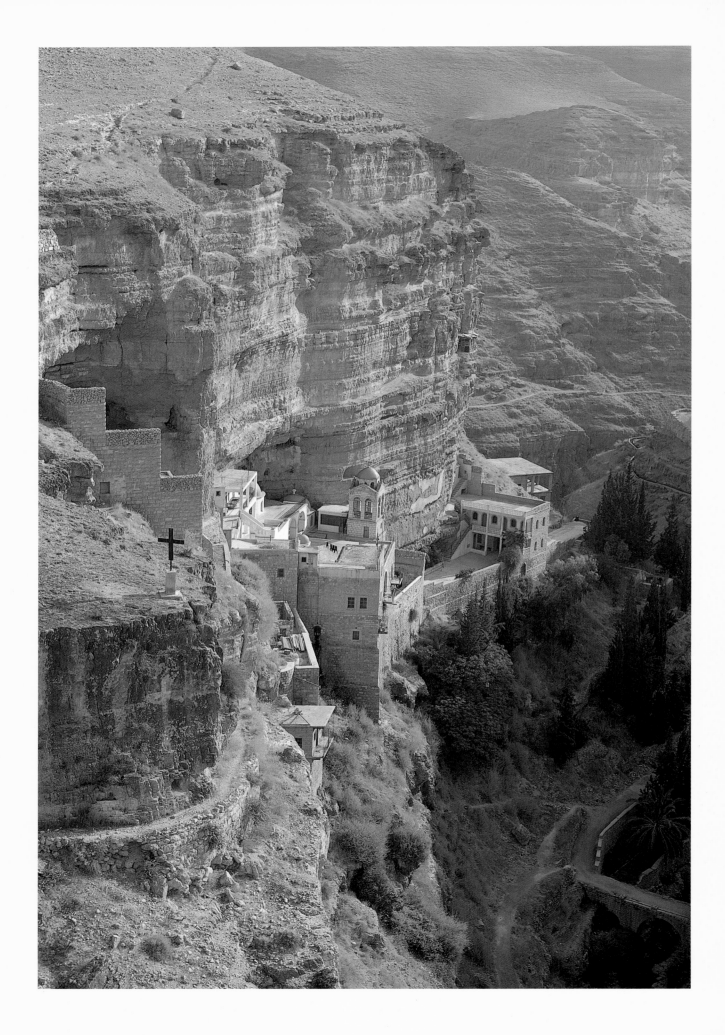

through its eastern part, extending from the Dead Sea to the Gulf of Eilat. The Aravah receives only underground water, which comes mainly from the mountains of Transjordan, that rise to a height of more than 1,600 meters and thus receive greater quantities of rainfall than the Negev Mountains to their west.

Today the Aravah is one of the centers of settlement in the Negev. The northern part of the Negev is mainly mountainous, and several mountain ranges cross it from the north-east to the south-west. The northernmost of these ranges contains the "Small Crater", the middle one contains the "Large Crater". and the southernmost range, which includes the highest of the Negev mountains, Mount Ramon, contains the "Ramon Crater". In these ranges we find remains of ancient settlements, which subsisted principally on grazing and on winter agriculture along the beds of the creeks (*wadis*). Extending to the south of the southernmost mountain range there are large, flat, and arid gravel plateaus (*hamadas*), where there are almost no signs of ancient settlements. The landscape alters only in the southern Negev, when we reach the relatively high granite mountains of the Eilat area, and here too there are hardly any signs of the existence

*On the facing page:*

### Convent of St. George in Wadi Kelt

*The creek of Wadi Kelt (kelt means a crevice from which abundant water springs, in the desert) cuts the north-eastern slopes of Mt. Scopus in the direction of Jericho. There are several springs in the wadi, and already in ancient times these were channeled to irrigate the southern part of the oasis of Jericho. Some scholars identify the wadi with the Kypros stream which is mentioned in Mishnaic sources as the place where "the blood of the victims of the war of destruction flowed" (the war referred to is the one in which Jerusalem was destroyed by the Romans in 70 C.E.); and today it is customary to see it as the brook Cherith, where the prophet Elijah dwelt (1 Kings 17:3-5), or the brook Perath, where the prophet Jeremiah hid his girdle (Jeremiah 13:1-7).*

*Because there was always water in the brook, it became a base for Christian monks already at the dawn of Christianity, and two monasteries are active there to this day. One of these, the beauty of which attracts many tourists, is the Monastery of St. George, which is maintained by Greek monks, and contains a unique mosaic floor. Inside the church there are also paintings from the Byzantine period, with depictions of saints, such as St. John of Choziba, a village which according to Christian tradition was situated in this vicinity. A Christian tradition also recounts that Joachim and Anna, the parents of Mary, the mother of Jesus, lived here for a brief period.*

*The spring water that wells up along the wadi is piped to Jerusalem. One of the springs, Ein-Kelt, supplied water to Herod's palaces in Jericho.*

of large ancient settlements. Only in several valleys in this region, where water collects in the winter, have traces of settlements been found, mainly from the early bronze period (the third millennium B.C.E.), which point to the presence of human habitation in the area (in the vicinity of the copper mines at Timna, and several other places).

Until the establishment of the State of Israel in 1948, the region was totally uninhabited, and only nomadic Bedouin lived there. During the Second World War the British government dispatched expeditions to the Negev, in the vain hope of finding minerals or oil there to supply the British war machine. A short while after the establishment of the State, several roads were built in the Negev, enabling penetration into the region as well as study of it.

The Negev is occasionally mentioned in the Scriptures, but habitation there goes back to much earlier times. The few springs that flow in the Central Negev attracted inhabitants already in the prehistoric periods, and small settlements arose around them. Traces of these settlements were found in an archeological survey that was conducted in the Negev in order to discover when settlement in the region had begun and whether any climatic changes had occurred in the course of the years. The survey showed that the main sustenance of these

**Vessels from the period of the Bar-Kokhba Revolt**

*c. 135, found in the Cave of Letters, Judean Desert, Collection The Antiquities Authority, The Israel Museum, Jerusalem*

***Sodom***

*Illustration from a Hebrew manuscript,*
*Collection British Museum, Jerusalem*
*(Inscription at bottom: "This is Sodom*
*when the angels overturned it")*

settlers came from hunting of wild animals such as goats, gazelles and wild sheep, and from gathering — as indicated by the variety of implements discovered there, such as millstones and various other grinding devices.

We know that the Negev was inhabited as far back as the early Stone Age, and that settlement there did not cease throughout the prehistoric periods, even though it was not as developed as the settlement in the more rainy northern regions of the country. I have already mentioned that settlements from the third millennium B.C.E. have been discovered in the region, and since the 1960s a number of seasonal settlements, from the Middle Bronze Age (about 2300-1950 B.C.E.) have also been discovered in the mountainous areas of the northern Negev.

The routes of the great military campaigns of the northern powers which sought to reach Egypt, or of the Egyptians themselves on their campaigns northward, passed along the main road that crosses the Sinai Peninsula and the Negev beside the sea — so that the Negev itself did not suffer from the effects of the rise and fall of the various powers in the latter part of the biblical period. During this interim period, Arab tribes originating in the Arabian Peninsula — the Nabateans — appeared in the Negev. They based their economy on the trade routes that they established, which crossed the Negev from the place of their domicile in Transjordan to the port of Gaza. The Nabateans established trading stations in the Negev — at Nitzana, Halutza, etc. — which also continued to exist in the Roman-Byzantine period, but this phase of the history of the Negev has not been adequately researched as yet. The repute of the Nabateans reached the cultured peoples of the period, and they are occasionally

***Palestine Campaign: The Action***
***of the 6th Mounted Brigade at***
***El Mughar*** *(13 November 1917),*
*James Prinsep Beadle (1863-1947), date*
*unknown, Private collection, London*

mentioned in the writings of the Greek and Roman historians.

During the reign of the Hasmonean kings in Judea, and with the capture of Gaza by Alexander Yannai, the trade routes of the Negev were blocked. Trade was renewed during the reign of Herod, and it appears that Herod collected a toll from the merchants who used the Negev routes. Most historians today call the principal route in the Negev — which leads

from Transjordan, through Nahal Nekarot to the northern Negev Plateau — "the Perfume Route", because perfumes were the principal product that the Nabateans transported from the countries of the Orient to the shores of the Mediterranean Sea. In the first century C.E., the Nabateans began developing agriculture as well throughout the Negev. Historians believe that they turned to agriculture because they needed large quantities of grain for the horse-breeding they engaged in at this time. During this period the creeks (*wadis*) in the Negev were filled with dams, water cisterns were dug everywhere, and systems of channels were built to bring water from the slopes, along the *wadis*, to the cisterns.

The Negev is not mentioned as frequently in sources from the Second Temple period as it is in the Scriptures, because the kingdom of Judea in the Roman period displayed no interest in the expanses of the Negev. The Romans themselves, however, did take an interest in the Negev, for two reasons: after the conquest of Eretz-Israel in 63 B.C.E., the Negev became the border of the Roman Empire, and they had to keep an eye on it as a strategic outlying area; in the course of these activities, the Romans learned about the wealth of the Nabatean commerce, and attempted to take control of it. Their efforts were of little avail for a long time, until 106 C.E., when struggles among the heirs of the Nabatean kingdom led to its annexation by the Romans, who thus extended the borders of their Empire to the east of Eretz-Israel. The Nabateans continued engaging in trade under the Roman yoke as well, but this declined with time, and the trade routes shifted further north to Syria, and were controlled by the inhabitants of Tadmor (Palmyra). The decline of the Nabateans was exploited by other Arab tribes, who began slowly penetrating into the Negev. The rock-paintings scattered throughout the Negev, which contain sketches depicting the shepherds' life and inscriptions left behind by pre-Muslim Arab tribes, indicate that such penetration occurred already in the 3rd and 4th centuries C.E. But the Nabatean towns, which had developed in the Negev concurrently with the development of their trade, did not disappear with the decline of their founders, and continued to prosper until the Muslim conquest of Eretz-Israel in the 7th century.

The Romans, during the period of their rule, based the defense of their borders on settlements of soldier-settlers who guarded the border and subsisted on agriculture as a supplement to the support that they received from the authorities. We know that the soldiers who served at the various *limes* [border, in Latin] stations included Arab cavalrymen and Illyrian cavalrymen (most of Illyria is on the borders of today's Yugoslavia). To this day, the border of the Roman Empire in Eretz-Israel, which the Romans called *limes Palestinae*, is marked with remains of these military-agricultural settlements. Ruins of their camps and fortresses are scattered mainly through the northern Negev, but also in the Aravah.

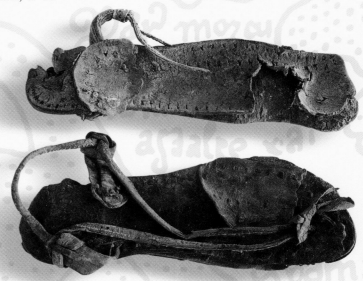

*Sandals*

2nd century, found in the Cave of Letters, Judean Desert, Collection The Antiquities Authority, The Israel Museum, Jerusalem

On the following pages:

**Masada with the Dead Sea in the background, view from the west**

*Mount Masada in the Judean Desert is like a natural fort: its summit is flat, and its steep sides enable access to the summit only by way of two narrow passes; this is why it is called Masada, Metzada in Hebrew, derived from the word* metzuda, *a fort.*

*The first source to mention Masada is Josephus, in his account of Herod's attempts to dethrone the Hasmonean kings (40-37 B.C.E.). At this time Herod and his family fled to Masada, which, according to Josephus, had been built by the High Priest Jonathan (it is not clear whether his reference is to Jonathan the brother of Judah the Maccabee, or to Alexander Yannai, whose Hebrew name was Jonathan.*

*Herod remembered the natural advantages of the mountain, and when he became king he built the strongest fort in the country on its top. He stationed a garrison there, which maintained the fort until the Great Revolt against the Romans (67-70 C.E.), when the fort was captured, with the aid of cunning, by a group of Jewish zealots who settled there with their families. After the destruction of Jerusalem (70 C.E.), the zealots managed to hold Masada for another three years, and it fell to the Romans only after a prolonged siege and a heroic struggle by its defenders.*

*Masada has become a symbol of the Jewish people's willingness to fight for its independence.*

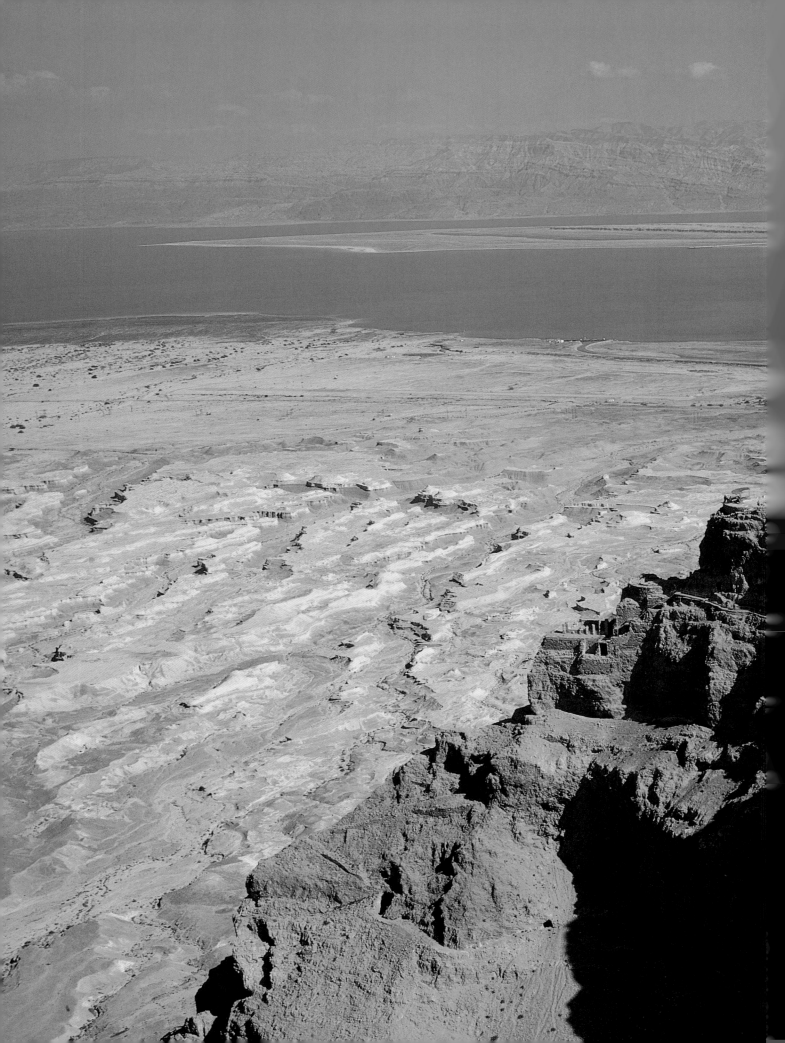

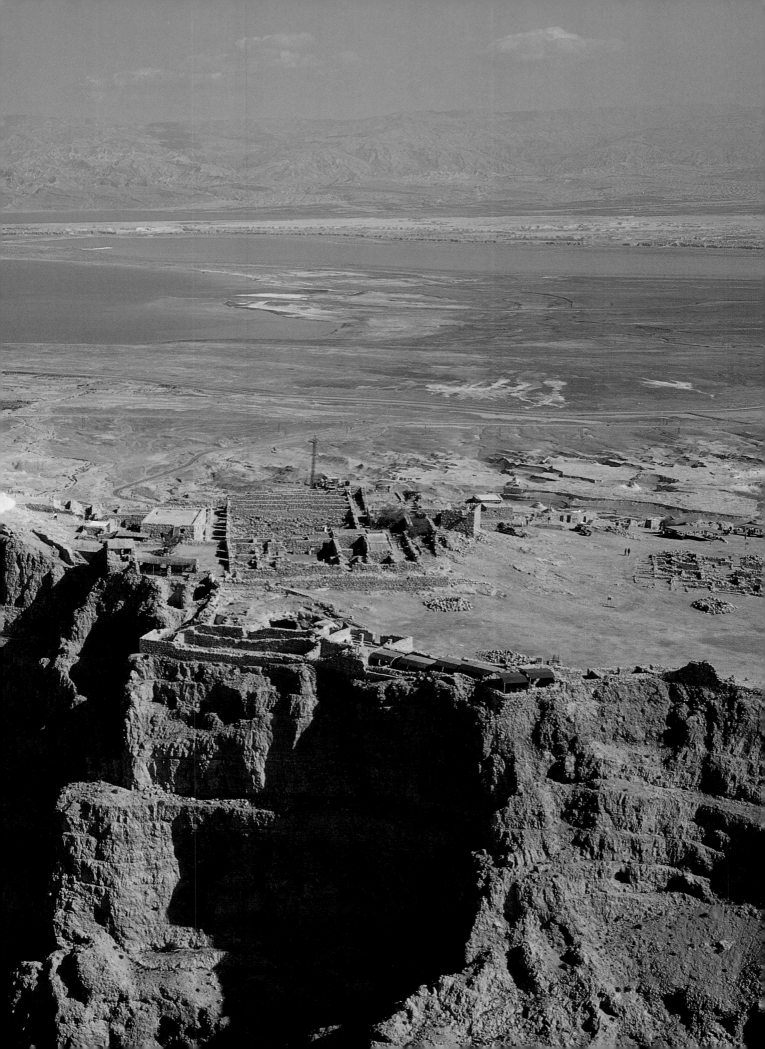

The *limes*, or border, of the Empire extended between Rafah, on the Mediterranean shore, and the south of the Dead Sea. At one point the border split into two, with one arm going

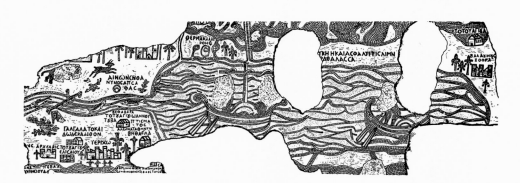

**The Dead Sea**

*Detail from the mosaic Madaba map*

*c. 565, Church of St. George, Jordan*

north towards the Judean Desert — an area difficult to rule, which was open from the direction of Transjordan. The Romans organized their border by dividing it into four zones: the Western zone, with its center at Ma'on, which is on the border of the Gaza Strip of today; the Gerar zone, with its center at Be'er-Sheva; and the zones of Hebron and Carmel in Judea, which defended the Judean Desert and its peripheries. South of the *limes* there was a sort of belt of Nabatean towns which continued to exist for hundreds of years, among them Halutza (the capital of the southern Negev), Rehovot, Shivta, Nitzana, Avdat and Mamshit.

During the period of Roman rule a new route to Eilat was opened through the Negev, in

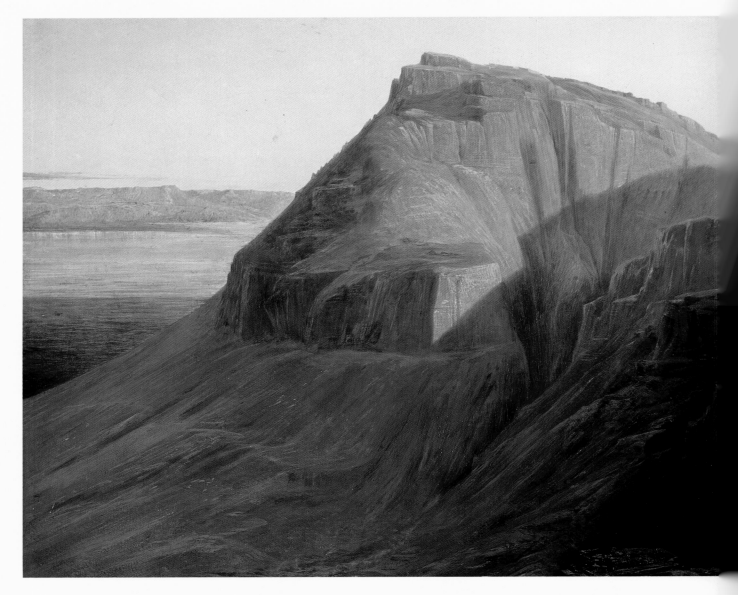

addition to the Aravah route. Along this new route, which passed through the center of the Negev, there were a number of stations: Lutz, Gashur, and Gerasa. In the late Roman period, Eilat's importance increased greatly, because it served as the starting-point for a chain of fortifications that defended the Empire along the Negev and Transjordan. These border changes occurred towards the end of the 3rd century, in the reign of the emperor Diocletian, who reorganized the Empire and transferred the Roman Tenth Legion from Jerusalem (where it had been based since the destruction of the Second Temple) to Eilat. For this reason the Aravah route was fortified as well, and its fortifications were set up in the east of the Aravah, because there were many sources of accessible water there. On the western side of the Aravah there were several stations: Hatzeva, Mohila, and Moah. With the major changes that the emperor Diocletian introduced into the Empire in the 3rd century, the form of defense that integrates agriculture and soldiery was abolished. This change led to a strengthening of the Arabs in the region, who settled in the camps that were abandoned by the soldier-farmers. The other towns in the Negev continued to exist after the decline in the military power of the Roman Empire, and began to deteriorate only after the Muslim conquest.

Towards the end of the Roman period and in the course of the Byzantine period, the population of Eretz-Israel increased rapidly, and a portion of it was compelled to move to the Negev because of the great density in the more comfortable regions. During the entire period Eilat served as a basis for maritime trade with the Far East, and for this reason it is mentioned in the writings of geographers and historians during several centuries. Already at the beginning of the 4th century — a relatively early period — Christian bishops lived in the city. Nonetheless, Eilat's remoteness from the centers of settlement led to its being perceived as a place of exile, and indeed we know about bishops who were sent into exile there by the church authorities. It should be noted that the Roman-Byzantine city of Eilat is being unearthed in the archeological excavations conducted in the region in recent years; its site, however, is not the Eilat of today, but the neighboring port-town of Akaba in Jordan.

The Christian occupation of the settlements in the Negev had a major influence on the region's development, and the landscapes of its ancient towns, which are being exposed today, were dominated by many churches. The Church organized itself effectively in the arid regions of the country, established bishoprics in them (we know of bishops whose names attest to their Nabatean origins), and settled clerics of various ranks in their towns. The economy at this time was based on the cultivation of grapes for wine and olives for oil, as we learn from documents that have been found at Nitzana, and this is evidence of a high degree of agricultural skills. A

**A boat on the Dead Sea**
*Detail from the mosaic Madaba map,*
*c. 565, Church of St. George, Jordan*

**Masada with the Dead Sea in the background**
*Edward Lear (1812-1888), date*
*unknown, Christie's collection, London*

new phenomenon in the Negev was tourism by pilgrims, who crossed it on their way to "Mount Sinai" and other sacred sites in the Sinai peninsula.

Descriptions of a flourishing economy in the Negev cease, as already noted, with the Muslim conquest, largely because of the rigorous tax-collecting instituted by the authorities. Some historians believe that the Muslim prohibition against growing vines was an additional cause of the region's economic decline. Nonetheless, it appears that the disappearance of the Negev settlements during the 8th and 9th centuries was not exclusive to this region, but rather reflects the decrease in the population throughout the entire country as a consequence of the harsh rule of the Abbasids (750-969), who persecuted the country's non-Muslim inhabitants.

The Muslims attributed great importance to the Gulf of Eilat, because of the legend that the prophet Muhammad had accorded rights and protection to non-Muslims living in Eilat. Eilat's importance grew due to the many Muslim pilgrims who passed through it on their way to the sites sacred to Islam in the country's interior. Likewise, pilgrims on their way to Mecca from North Africa and Egypt would also pass through Eilat after crossing the Sinai peninsula, continuing from there to their destination along the ascent of Wadi Yitem. In Arabic this ascent is called "Akabat-Eilat", which means "the Eilat Ascent", and this is the origin of the name of the town of Akaba in Jordan. The ascent which leads westward from Eilat, into the Sinai, is called "Ras-a-Nakeb", and in Hebrew, "Ma'aleh Eilat" ("the Eilat Ascent"). These passages served a most important function until the 20th century, when ships and airplanes replaced the overland camel caravans.

During the Crusader period too, Eilat and its port were of major importance. The first Crusader king, Baldwin I, quickly recognized the importance of Eilat's strategic position, which dominated

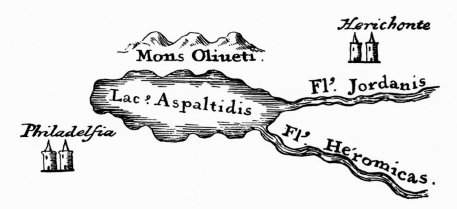

the route of the Muslim caravans to Mecca, and fortified the town and the small island (known today as Coral Island) close to the western shore of the gulf. With the establishment of the Crusader state, passage between Egypt and Syria was virtually blocked, and the northern tip of the Gulf of Eilat remained the sole connecting link between the major Muslim kingdoms, the Crusaders' greatest enemies. Hence the importance of control over Eilat was much greater than the small town's economic importance. Eilat's great strategic importance also provided sustenance for the settlements that arose alongside the road through the Aravah leading to the port town. The various water works, which enabled the flourishing

of agriculture along the Aravah road, were a by-product of the need to maintain the connection with Eilat.

Reports exist about the strange attempt of Renauld de Chatillon, a count from the Crusader principality of Transjordan, to capture Mecca: the count assembled a fleet at Eilat, and sailed south with it to the shore opposite Mecca, where his small army suffered a crushing defeat; he himself escaped alone, by the skin of his teeth, leaving the remnant of his army behind to die by the sword or to be taken as slaves. A German pilgrim heard that in the 13th century there were English and French slaves in Mecca, who also engaged in fishing along the coast for their Egyptian masters.

The Mamluks, who ruled in the region after Saladin and his heirs, continued to develop the pilgrims' route, but the town of Eilat gradually became less important, until it was merely another station on the route. At Ma'aleh-Eilat, a section of the route which was renovated by Qansuh al-Ghawr, one of the last Mameluke sultans (early 16th century), has survived, and a magnificent inscription which he carved there can be seen to this day.

The Ottoman conquest of the region did not ignore the apex of the gulf. Throughout all their years of rule in Eretz-Israel (1516-1917), the Ottoman sultans preserved the pilgrims' route, carving waterholes and digging wells along its sides. They assured the safety of the pilgrims by bribing the heads of the tribes through whose territories the route passed. In Akaba, which was relatively rich in water, a fort was constructed

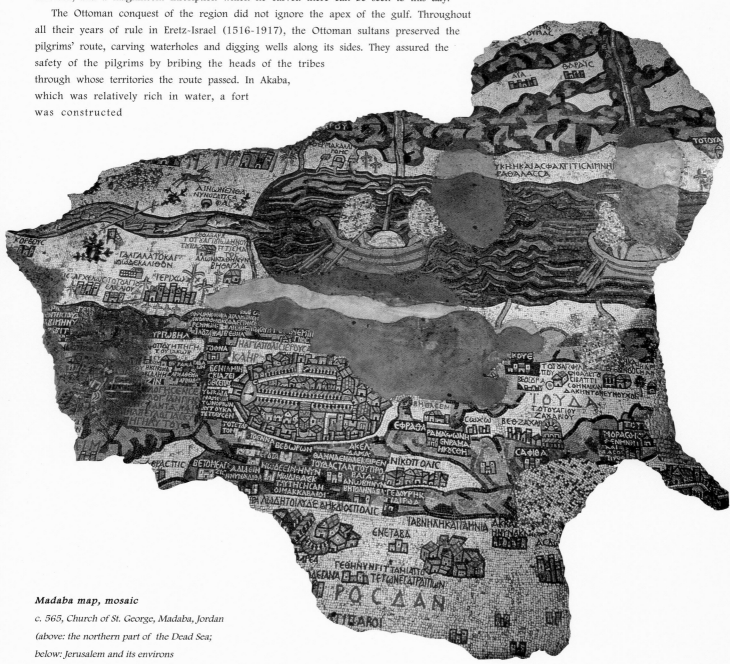

*Madaba map, mosaic*

*c. 565, Church of St. George, Madaba, Jordan*

*(above: the northern part of the Dead Sea;*

*below: Jerusalem and its environs*

already in the 16th century (the Ottoman sultan, Selim, stationed a garrison of Nubian soldiers there). This fort played a most important role in the history of the region until the early 20th century (when Akaba's importance declined after the Egyptians decided to conduct pilgrimages by sea, connecting with the newly constructed Hijaz railway). Nonetheless, because of Akaba's distance from the centers of government, the sultans used it as a place of exile for their political rivals (including Kemal Ataturk, the first president of modern Turkey). The capture of Akaba by the armies of Hussein, *sherif* of the Hijaz, with the assistance of Lawrence of Arabia (1917), was one of the climactic events of the First World War in the Middle East.

In 1906 a grave crisis occurred between Britain, which ruled Egypt at the time, and the Ottoman sultanate, and fears of armed conflict rose to the fore. The compromise that was reached led to the marking of an agreed border between the two powers, extending between Rafah and Taba — and this is also the international boundary which today separates Egypt and Israel.

Immediately after its establishment, the State of Israel began directing many resources to the Gulf of Eilat. A new city was built — the modern Eilat — containing a modern port serving the trade relations with East Africa and the Far East. The port only continued developing as a consequence of many years of hostility between Israel and Egypt and the closure of the Suez Canal to Israeli shipping, and together with tourism in the area, the port made Eilat one of the prominent city's in Israel's economy. The Aravah, as in ancient times, today still constitutes a connecting link between the center of the country and Eilat, and the development of settlements along the Aravah and in the northern Negev has become one of the State of Israel's important goals.

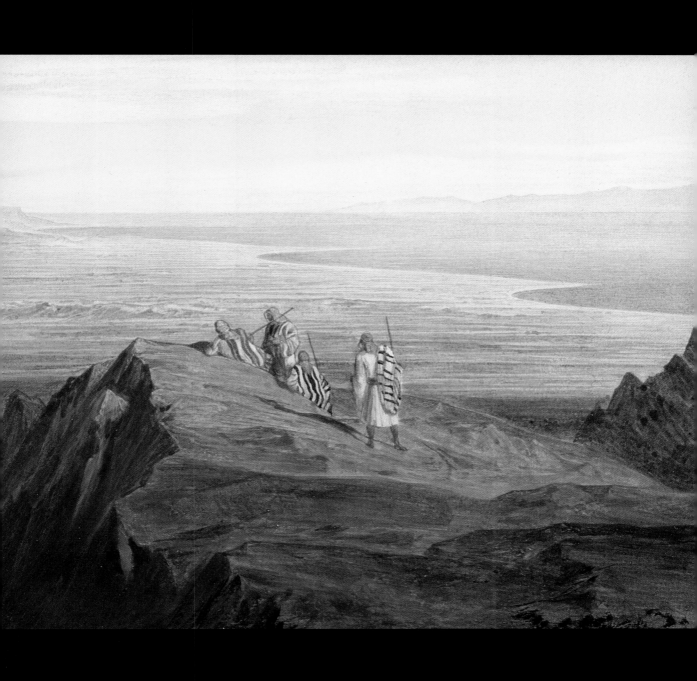

*Mt. Masada with the Dead Sea in
the background*
Edward Lear, c. 1858, Collection The
Israel Museum, Jerusalem

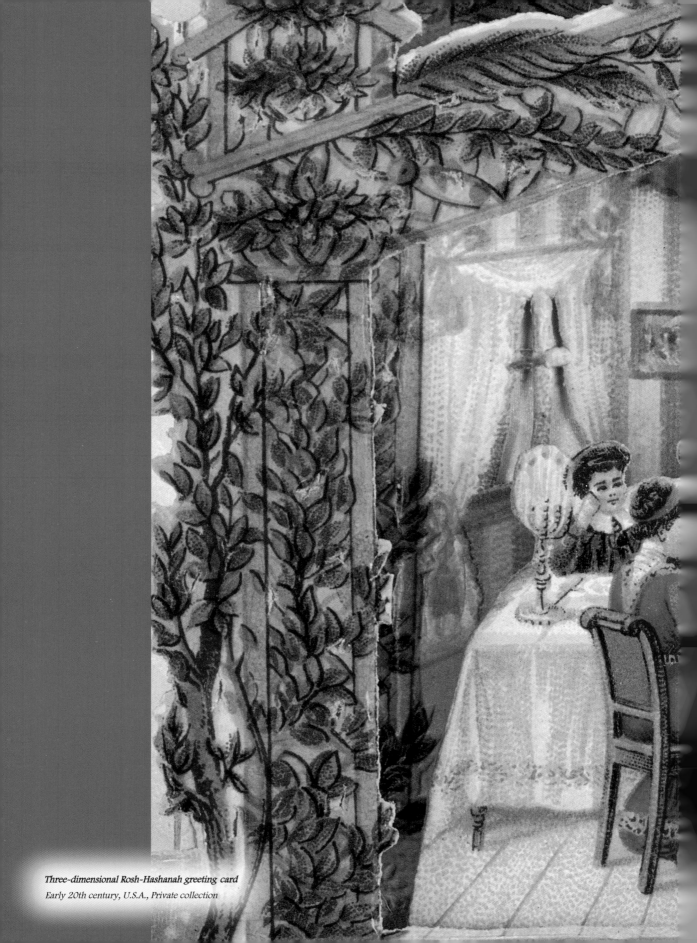

*Three-dimensional Rosh-Hashanah greeting card*
*Early 20th century, U.S.A., Private collection*

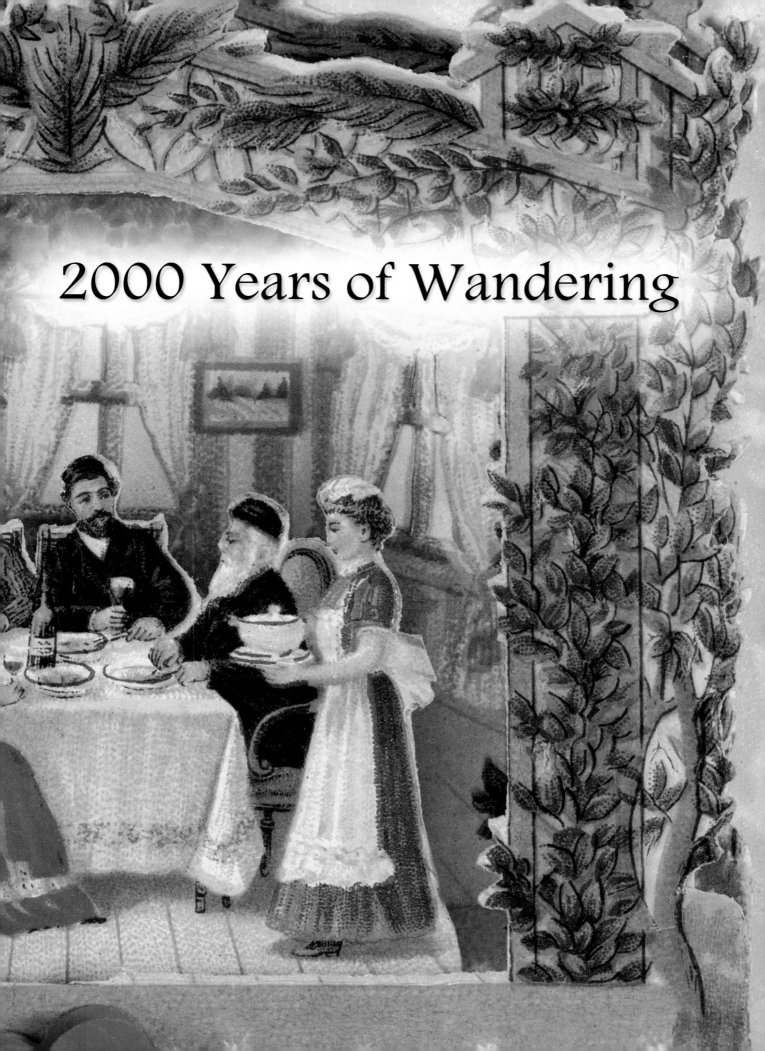

# 2000 Years of Wandering

# The Jewish Diaspora

Ram Ben-Shalom

Throughout antiquity, the Jewish people's religious and political center was in Eretz-Israel, although the two foundation events in the nation's life actually occurred outside the boundaries of the Land: the first — the divine manifestation to Abraham at Ur of the Chaldees, in Aram-Naharayim (Mesopotamia), and the first covenant between the nation's father and God, through which the world first received the idea of monotheism; and the second — the public divine manifestation at Mount Sinai, where the covenant between the nation and its God was established, and the Torah was given to the Israelites. But despite the Jewish people's persistent aspiration to base itself in Eretz-Israel and to realize its national and religious longings there, the Jewish Diaspora outside the Land has been a permanent phenomenon since those ancient times, until the present day. Most of the Jewish spiritual assets were created in the various dispersions of the Jewish people, and thinkers and writers (who will be referred to below) — such as Rabbi Saadiah Gaon, Rashi, Maimonides, Judah Halevi, the Ba'al Shem Tov, the "Vilna Gaon", and others — all lived and worked outside the boundaries of Eretz-Israel. Today too, most of the Jewish religious-spiritual creation is conducted in the largest of the dispersions, in the United States.

After the exile of King Jehoiachin to Babylon (598 B.C.E.), the destruction of the First Temple by Nebuchadnezzar, and the second departure to the Babylonian Exile (586 B.C.E.), and especially after the Return to Zion (538-516 B.C.E.), the Jewish people were divided between two principal centers: Eretz-Israel and Babylon. The proclamation by King Cyrus of Persia (538 B.C.E.), which gave Jews permission to return to Jerusalem and to rebuild the Temple, was indeed received with enthusiasm, but it did not lead to a mass exodus of Jews from Babylon, for the exiles had managed to adapt to the rich and developed regions in the Babylonian environment, and had become integrated in the new culture and economy. The two collectives of Jews in both Babylon and Eretz-Israel were not independent political entities. Eretz-Israel was a Persian province named Yahud, whose inhabitants paid taxes to the king of Persia and were granted social and religious autonomy.

At around the same time a small Jewish center also arose in Egypt. Its beginnings went back to the Babylonian period, during which Egypt had extended its involvement in Eretz-Israel, and had become a destination for migration. The Jewish center in Egypt received considerable reinforcement after the destruction of the First Temple, when exiles from Judah

* This chapter sketches, in general and preliminary lines, several stations in the history of the Jewish dispersions, from their earliest days until the beginnings of the modern period. Because of limitations of space it has been impossible to encompass every place where Jews have lived, or to discuss each one of the periods. Many important communities have been omitted from the historical survey, and extensive regions where there has been a significant Jewish presence have not been mentioned at all. The choice of particular topics and the neglect of various periods have stemmed from the wish to diversify the bounds of the discussion and to present a broad variety of forms of Jewish life, of economic and social activity and of spiritual creation.

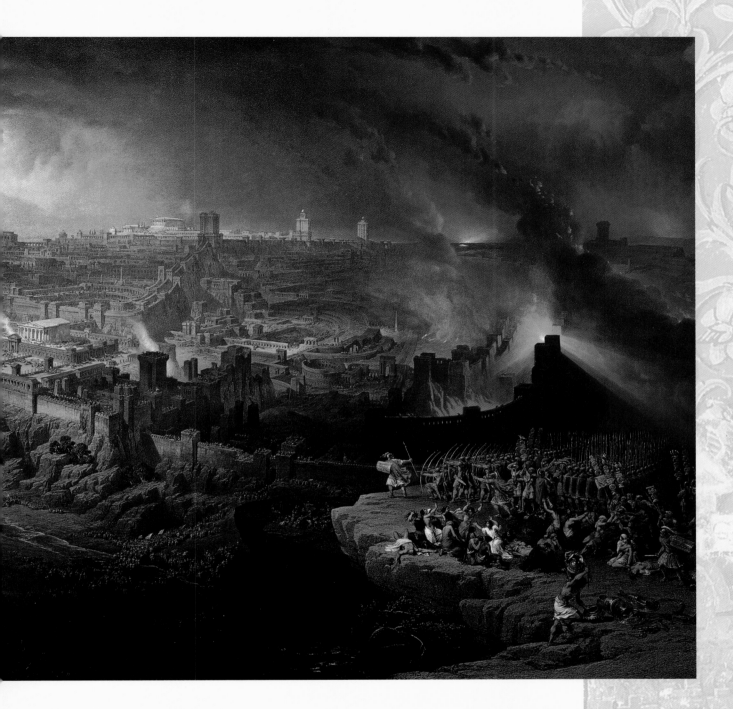

migrated there despite the explicit objections of the prophet Jeremiah. A large number of the exiles were refugees in flight from the sword, but they also included Jewish soldiers, who became part of the Egyptian army of the XXVI Dynasty of Pharaohs. Particularly known from this period was the Jewish army colony at Elephantine. Its soldiers were called *"Heila Yehudia"* and their task was to guard Egypt's southern border. The colony prospered during the period of the Persian occupation (after 525 B.C.E.), and ceased to exist in about 399 B.C.E.. In the Persian period another wave of migration reached Egypt, following which Jewish soldiers became part of the Persian garrison.

*The Destruction of Jerusalem in 70 C.E.*

*David Roberts, 1842, Stapleton collection, London*

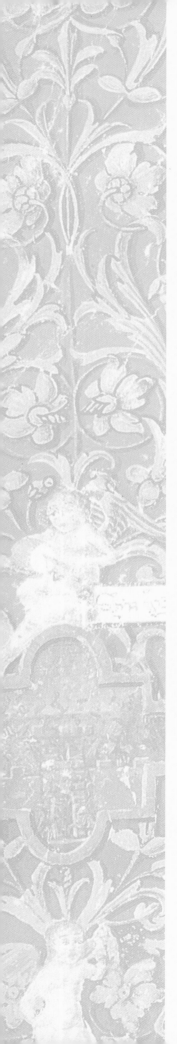

# The Hellenistic-Roman Period

After Alexander the Great's conquests in the East, Eretz-Israel, Babylon and Egypt came under Greek-Hellenist rule, and for a short while all the Jews were under one political roof. After Alexander's death (323 B.C.E.), however, the wars among his heirs began, and at their conclusion (285 B.C.E.) the Empire was divided among three kingdoms: the kingdom of Macedonia in the West, which included Greece; the Seleucid kingdom, which ruled in Syria, Lebanon, and parts of Asia Minor, Iraq and Iran; and the Ptolemid kingdom, which ruled principally in Egypt, Eretz-Israel, and the Aegean Islands. The Hellenist kingdoms fought with one another alternately until, in a slow and prolonged process which came to an end in 30 B.C.E., they were successively conquered by the Romans.

During the Hellenist period Eretz-Israel maintained its central position among the Jewish people by virtue of the religious role assigned it in the Scriptures, and especially because of the importance of the Temple in Jerusalem, which was the Jewish religion's place of ritual worship. Nonetheless, the majority of the Jewish people lived in the Diaspora. Few documents about the Jewish center in Babylon remain from this period. The Jews in Babylonia maintained their national identity and coped in their own way with the influence of the local culture, both the Babylonian and the Persian, and with the penetration of Hellenist culture. Babylonia regained its important place on the stage of Jewish history only later, during the period of the Talmud, from the 3rd century C.E. onward.

Other important centers arose beside the Babylonian dispersion. The reasons for the spread of Jews in the region were principally economical. The important Jewish philosopher Philo of Alexandria (c. 20 B.C.E. – 50 C.E.) already remarked that "one country cannot provide economically for the Jews, because they are many in number". Jews migrated to Egypt, whether by force (as prisoners of war) or voluntarily, already during the reign of Ptolemy I (323-283 B.C.E.), who captured Jerusalem. Especially renowned during the reign of Ptolemy II Philadelphus (284-246 B.C.E.) was the Jewish community in Alexandria, which was a most important center of Hellenist culture. The organizational framework of the Jews in Alexandria was called a *politeuma*, i.e., a national (or religious) group entitled to certain political rights, chiefly the right to an independent judiciary system and a community establishment. The Jews lived in their own neighborhoods and also in the other parts of the Hellenistic *polis*. They had many synagogues, a Council of Elders (*gerusia*), to supervise their affairs, and autonomous educational institutions. This form of organization (and forms similar to it) became the distinguishing mark of Jewish life in the dispersions until the modern period.

The Septuagint was produced in Alexandria in the 3rd century B.C.E.. This is a translation into Greek, first of the Pentateuch and later of the entire Hebrew Scriptures, which was also the first translation ever from any Eastern language into Greek. The legend goes that King Ptolemy II sent an official delegation to Eleazar the High Priest in Jerusalem, and asked for his assistance in translating the Torah. The High Priest acceded to his request, and sent 72 elders to Alexandria. On their arrival the elders were asked 72 questions, and they completed the task of translation in 72 days. The translators worked in pairs, and when all the translations were compared it turned out that they were identical in every detail. It is possible that the essence of the story is based on something that really did happen: the king gave instructions to have the Torah translated after Hellenist scholars had begun to take an interest in the Jewish religion and its values, in the context of their intellectual curiosity about the cultures of the East. The Septuagint served as a basis and an inspiration for the extensive spiritual creation of Hellenist Jewry in the following generations, and naturally

enough it was also chosen by the early Christians, who spoke Greek, as a source for the New Testament and other sacred Christian texts.

The growing prestige of Jews in the court of Ptolemy II was also the background for the first anti-Jewish literary writing. The Egyptian Hellenist priest Manetho described the history of the Jewish people and the constituting national event of the exodus from Egypt in his essays, employing a negative interpretation of excerpts from the Scriptures. In his writings, the Jews in Egypt are described as a colony of lepers, who were isolated from the population and sent to work as slaves in the stone quarries. They revolted under the leadership of a priest by the name of Osarsiph (Moses), who gave them a set of laws (the Torah) which was none other than a distorted plagiarism of the laws of Egypt. Manetho's story served as an inspiration for anti-Jewish literature in the Hellenist-Roman period — a literature which engendered the first blood libel about the Jews, who, so the story went, once every seven years used to catch a Greek and kill him while performing cannibalistic rituals on his body.

After the conquest of Eretz-Israel by the Seleucid kingdom (202-200 B.C.E.), Jews became an important factor in the politics of the Ptolemid kingdom, which aspired to regain control of Eretz-Israel. The High Priest, Onias IV, decided to migrate to Egypt after it became clear to him that the Seleucid kingdom had made the High Priesthood a position that could be bought. Many Jewish migrants followed him to Egypt, especially after the upheavals in Eretz-Israel during the persecutions by Antiochus Epiphanes and the Hasmonean Revolt (168-142 B.C.E.). Ptolemy VI saw Onias as an ally, and allotted him and the Jews "the land of Onias", which extended along the eastern region of the Delta. This was an army colony which was responsible for Egypt's defense in one of its most sensitive regions. At its center (in the city of Leontopolis) the temple known as "Onias's House" was built.

Julius Caesar, who landed in the port of Alexandria in 48 B.C.E. and encountered fierce resistance by the city's inhabitants, received assistance from the Jews who lived there. He rewarded them by granting them a charter of rights, which served as a judiciary and political foundation on which the rights of Jews were based in later generations throughout the Roman Empire: Jewish communities were not numbered among the prohibited political groupings, and their right to judiciary and religious autonomy was recognized. These rights were later confirmed by the emperors Augustus and Claudius.

The decline of Egyptian Jewry and of the community in Alexandria is connected with the revolt of the Jews in the dispersions, which broke out during the reign of the emperor Trajan (115-117 C.E.). The revolt broke out as a consequence of bad relations between the Jews and the Greek population in the Hellenist cities. Moreover, after the destruction of the Second Temple (70 C.E.), national, political, and religious zealotry increased among the Jews in Egypt, and was inflamed by the economic decrees promulgated by the Romans and the social discontent of the Jewish farmers. The revolt took a high toll from the Jews in Egypt: many lost their lives, and the community in Alexandria lost is judiciary autonomy. The spiritual synthesis which had been forged in Egypt between Judaism and Hellenism came to an end, and the creative powers of the magnificent Jewish community in Alexandria were stilled.

*Above:* **Burial plaque**
*4th-5th centuries, Rome, Collection*
*The Jewish Museum, New York*

*Below:* **Burial plaque**
*3rd-4th centuries, Rome, Collection*
*The Jewish Museum, New York*

## The Byzantine Period

ewish communities were dispersed throughout the Roman world around the Mediterranean Sea: the Iberian Peninsula, Gaul (France), Italy, Greece, the Balkans, Asia Minor, Syria, Cyprus, Crete, Eretz-Israel, Egypt and North Africa. The continuous physical existence of these Jewish communities did not cease after Christianity became the religion of the Empire during the reign of the emperor Constantine (306-337). The Jews engaged in commerce and in various branches of manufacture, and were renowned during a long span of time for their skills in the crafts of silk and purple, cloth dying and hide tanning. The judiciary status of the Jews in Byzantium (as the Eastern Roman Empire was called after Constantine moved his capital to the village of Byzantium and called it Constantinople) was based on the earlier Roman law, which retained its authority and weight in this period as well. It is true that at this time there began a slow and prolonged process of ousting Jews from public positions, intervening in their religious affairs, and discrimination in the social and economic domains (for example, they were forbidden to establish new synagogues, and their testimony against Christians was not legally acceptable); but just as the Roman Empire became more and more Christian, so Christianity became more and more Roman. The heads of the Church were constrained to accept the existence of the dense network of Jewish communities throughout the entire Mediterranean basin — communities possessing a mutual affinity with one another and a common national and religious identity. The Jews had always been involved in the Mediterranean region, and were recognized by the law and by the local population as a legitimate element in society. Although two hundred or so years later the Jews became second-class citizens, they still remained citizens.

The status and the existence of the Jews in the Christian world were also defined theologically by the Church, in the formulation of Augustine (354-430), the greatest of the Church Fathers in the West. Augustine interpreted the verse "Kill them not, lest my people forget; scatter them by Your power and bring them low, O Lord our shield" (Psalms 59:12 ["OT": 59:11]) as referring to the Jews, and stated that they were not to be killed because

**Jewish or Christian bronze stamp**

*3rd-4th centuries (the Byzantine period), Collection British Museum, London (Inscription on the stamp: "the property of Leontios")*

they served as a testimony (*testimonium*) of the Christian truth. The Jews were the people who had received the Law, and they still observed it, and in this way they served as a testimony of the coming of the Messiah and the Redemption. However, Augustine continued, care should be taken that the Jews live in a humiliating state of subjugation, because in their humiliated situation they constituted a testimony of the triumph of Christianity over the historical nation of Israel and of God's choice of "the true Israel" (*verus Israel*), the Christians. According to this conception, the Jewish people had completed its historical role in the world, and had to make way for the Church. The relations between the two religions became anchored in Christian art in the allegorical figures of *Ecclesia* and *Synagoga* — two women, sisters and rivals, who symbolized the Church and the Synagogue. The figure of *Ecclesia*, always on the right, symbolized goodness and justice. She wore a crown on her head and held a scepter in her hand, expressing her triumph and her dominion in the world. The figure of *Synagoga* was always on the left, her head lowered, her scepter broken and her eyes covered. She was a queen who had lost her dominion because of her sins, and her covered eyes symbolized the blindness of the Jews, who did not see the deeper religious truth of the Holy Scriptures.

Between the years 415 and 429 the Byzantine authorities decided not to appoint a new Jewish "Patriarch" [*nassi*] in Eretz-Israel, after the last *nassi* had died with no sons to succeed him. In this way the Christian empire allowed the institution of the "Patriarchs" to die out, without issuing a legal order to abolish it; at the same time, they ordered that the money which the Jews in the Empire had used to contribute to this institution would henceforth be paid to the emperor's treasury. The Christians perceived the destruction of the Second Temple and the Jews' loss of political sovereignty in Eretz-Israel as the fulfillment of Jesus's prophecies and as a historical expression of God's abandoning of His people. Likewise, according to the Christian interpretation of Genesis 49:10, Jacob had prophesied to Judah that he (Judah) would lose the rod of dominion in his inheritance when God's messenger, Jesus, came to the world. This was one of the reasons for the abolition of the institution of the "Patriarchs", which for the Jews in Eretz-Israel and the dispersions symbolized the continuation of their sovereignty (even if only

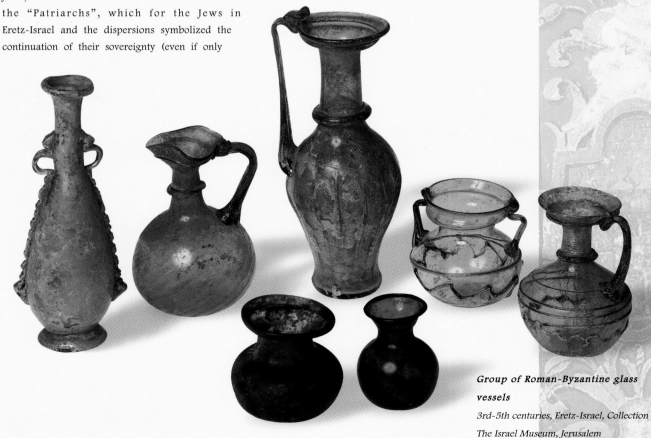

*Group of Roman-Byzantine glass vessels*

3rd-5th centuries, Eretz-Israel, Collection The Israel Museum, Jerusalem

partial and symbolic) in Judah. This step deprived the Jewish people of the symbol of its national unity and its natural and historical right to sovereignty. The Jews found a real and symbolic substitute for the "Patriarch" [nassi] in Eretz-Israel in the institution of the Head of the Exile [Rosh ha-Golah], which was becoming consolidated at this time in Babylonia under the rule of the Persians.

Another attempt at religious oppression of Byzantine Jewry was made during the reign of the emperor Justinian (527-565), who sought to restore the former glory of the Roman Empire in the western part of the Mediterranean basin, while eradicating the Christian heretical movements in the East. After reorganizing the judiciary systems by means of a new book of laws (Corpus iuris civilis), Justinian published a new law (novella), the Deuterosis ("the secondary law"), which forbade Jews to engage in the Jewish "Oral Law" — the Mishnah and the teachings [midrashim] of the parabolic "Tellings" [Agadah] and the "Observances" (Halakhah). While not explicitly prohibiting Judaism, Justinian hoped that in this way he would bring about Judaism's self-annihilation through its severance from the sources of its spiritual creativity. This Byzantine prohibition against engaging in the Oral Law did indeed lead to a cessation of literary creation of texts on the observances and the teachings of the Agadah, but concurrently it led to the finding of creative substitutes, such as liturgical verse [piyyut]. This situation assisted Babylonian Jewry to take the place of the Eretz-Israeli center in the leadership of the Jewish people, and ultimately to the acceptance of the Babylonian Talmud as superior to the Eretz-Israeli Talmud (the Jerusalem Talmud).

The difficult situation of Byzantine Jewry may explain the support given by Jews in Asia Minor, Syria and Eretz-Israel, to the army of Sassanid Persia, which initiated a campaign to conquer the Byzantine territories in the early 7th century. Jews who participated in the fighting on the Persian side, in Eretz-Israel (614) and in the dispersions, delivered besieged cities — such as Caesarea in Cappadocia (Asia Minor) — to the Persians. It is usually thought that the Bar-Kochba Revolt (132-135) was the Jews' last attempt to regain their political independence, but it turns out that even after this the Jewish people did not lose its aspirations for political independence. Jewish participation in military warfare was not so exceptional a phenomenon in later antiquity. It is true that over the centuries the Christian Church, by adopting the Augustinian conception of the testimony, created and fostered the image of the weak and persecuted Jew, deported from one place to another like a leaf in the wind after being thoroughly exploited; later additions to this included images of Jews as parasites sucking the marrow of Christian society, and as being in contact with the Devil and the demons. But the image of the debased Jew engaged in the contemptible occupation of lending money for interest (usury), like Shylock, is not valid for the period we are discussing; its origin is a later one, from the late medieval period, in the quite limited region of the Jewish centers in northern France and Ashkenaz. In the 7th century Jews still wielded weapons and could ally themselves with various political powers in order to realize their national goals. Already during the reign of Justinian (in 532), Jews fought in North Africa, on the side of the Vandals and the Barbarians, against the Byzantine army — and in Naples too Jews fought on the side of the Ostrogoths against the Byzantine army (536). The Byzantine historian Procopius was astounded by their courage, and described how they attempted to persuade the inhabitants of Naples to reject the capitulation proposals of the Byzantine commander Belisarius.

The Jews' religious and political power also manifested itself in outlying regions situated between the major regional powers. In about the year 500, the king of Himyar (the Yemen region) abandoned the pagan religion and adopted Judaism (or at least a certain kind of Judaism) as the state religion. The legend tells about a prophesy which he heard from two Jews from the town of Medina in the Arabian Peninsula, and about a divine miracle performed by these two Jews, which convinced him and his people to convert to Judaism. At the same time, the Jewish religion was already well known in the Arabian Peninsula, and the monotheistic idea had already been absorbed many years before this by the pagan Arab tribes. Free Jewish tribes dwelt in the Arabian Peninsula in the period of the *Jahiliyah*

(religious ignorance) prior to Islam. They engaged in agriculture, commerce and manufacture, made alliances with Arab tribes, and even fought beside them in their wars. The king of Himyar thus knew the monotheistic idea, and his adoption of Judaism was an attempt to halt the expansion of Byzantium and Persia by means of Christianity and Zoroastrianism. His reliance on Judaism, in this instance, ended in failure. Byzantium — which saw Himyar as an important strategic position controlling the silk and spices trade routes to the Far East — sent Christian Ethiopia to attack it. The Ethiopian force conquered the region (525) and killed the last Jewish king, Joseph Assar Do-Noes.

About two hundred years later a similar phenomenon developed in the region between the Caspian Sea and the Black Sea, when the royal house of the Khazars (a people of Turkmen origin) adopted Judaism. In this case too, the legend tells about an angel of God revealing himself to the king of the Khazars in a dream, and about his sincere conviction of

the truth of the Jewish religion. It is reasonable to assume, however, that here too the conversion of the Khazars was an attempt to protect the independence of the kingdom against two powers; Byzantium, which was seeking to expand and extend its influence by means of the Christian mission, and the Muslim Caliphate, which according to the idea of the *Jihad* was commanded to fight pagan peoples to the death. Jewish Khazaria held out for about 230 years, until it fell to the Russians (965) and ceased to exist as a Jewish kingdom. Rumors about the independent Jewish kingdom of Khazaria reached as far as the Iberian Peninsula, and aroused the national pride of the Jews in Muslim Spain. In an exchange of letters between Hisdai Ibn-Shaprut, the leader of the Jews of Spain, and Joseph, King of the Khazars, the two told one another about the grandeur, wealth, and magnificence of their respective countries. The legend of the conversion of the king of Khazaria served as a background for the important book by Judah Halevy, *The Book of the Kuzari*, which was written in the early 12th century.

*The Profanation of the Host*
Paolo Uccello (1397-1475), c. 1468,
Collection Palazzo Ducale, Urbino, Italy
(The Christian woman forced by a Jewish
pawnbroker to redeem her cloak at the
price of the consecrated host)

# Jews in the Islamic World

*T*he Arab tribes which set out from the Arabian Peninsula in 632 took control of most of the Middle East in the course of thirty years, and established the Caliphate, which extended from India, Persia, Syria and North Africa to the Pyrenees. For the first time in the history of the Jewish Diaspora, the traditional division into two Jewish centers based in two rival empires collapsed, and the majority of the Jewish people lived under the one political roof and shared the same general culture. Eretz-Israel gradually began to lose its status as

*Portion of a synagogue wall*

16th century, Isfahan, Collection the Jewish Museum, New York

the first and foremost of the Jewish centers, concurrently with the rise in importance of the Jewish center in Babylonia, whose leading institutions had been based in Baghdad since the days of the Abbasid Caliphate.

Under the Islamic rule the Jews were considered as one of "the peoples of the Book" — a nation to which God had given a sacred book similar to the Koran. Islam permitted Jews, and Christians as well, to maintain a social autonomy and to observe their religion. They were given the status of *dhimmah* (protected people) in exchange for payment of a poll tax (*jizyah*) and a land tax (*kharaj*), from which Muslims were exempt. The Jews were constrained to give up the right to wield weapons, but they were guaranteed the security of their lives and properties. Islam's attitude to the members of the monotheistic religions was more pluralistic than Christianity's attitude to the minorities, but discriminatory regulations, known as the "Covenant of Omar", were promulgated against the "*dhimmis*". The latter were forbidden to hold public office, to build higher buildings than those of the Muslims, and to establish new houses of worship. Their social inferiority was emphasized by decrees about how they were to dress: blue veils for the Christians, yellow ones for the Jews, and red ones for the Samaritans. The purpose of these regulations was to prevent close social contact between the Arabs and the local population in the occupied regions — but in practice many of the regulations were not implemented, and were exercised with severity only at times of rising religious fanaticism.

Two ancient institutions headed the world (ecumenical) leadership of the Jews: the Head of the Exile [*Rosh ha-Golah*], and the *yeshivot* (academies, which were the central authoritative religious bodies). According to the Jewish tradition, the institution of the Head of the Exile originated in Babylon, in the time of the Exile of Jehoiachin, and the tradition also lists a long line of descendants of the king (of the House of David) who succeeded him in this position. Although we should not entirely dismiss this tradition, there is no reliable historical evidence about Heads of the Exile and their deeds until the 2nd century C.E. During the Sassanid Persian period, the Head of the Exile had a permanent position at the king's court. He owned many assets and maintained a court of his own. His authority over the Jews and his symbols of precedence (such as the special items of dress) were preserved during the Muslim period as well. The Head of the Exile was elected to his position in an impressive ceremony in the presence of the heads of the *yeshivot* and the wealthy members of the community, and his appointment required the written approval of the Caliph. In the first stage the Head of the Exile was the real head of the Jewish hierarchy and had the right to appoint the heads of the *yeshivot* in Babylonia, but after some time the *yeshivot* acquired more power, which led to a bilateral and equal division between these two institutions in the hierarchy and the economic and spiritual control over the Jewish communities. From the late 10th century on, the authority and powers of the Head of the Exile gradually dwindled, until he became subject to the heads of the *yeshivot*.

*A Hebrew astrolabe*

*c. 1859, Iran, Collection the National Maritime Museum, Haifa (signature: Eli Sarona)*

The heads of the *yeshivot* were sages who were called *Geonim*. The two oldest *yeshivot*, Sura and Pumbedita, had been situated in Baghdad since the rise of the Abbasid Caliphate, and another *yeshivah* existed in Eretz-Israel. The *yeshivot* functioned as a supreme religious court ruling on all matters connected with Jewish law (*Halakhah*) in the Jewish communities. *Halakhic* questions were sent to them from remote countries, and they led the Jewish communities in the various domains of life. In this period (which is sometimes called "the period of the *Geonim*"), the Babylonian *Geonim* managed to ensure that the entire Jewish people observed a uniform way of life, based principally on the Babylonian Talmud. Moreover, from the mid-ninth century on, the Babylonian *Geonim* abolished the precedence of Eretz-Israel on all matters connected with determining when to intercalate the year with an additional month, and the dates of the beginnings of months, and instituted a permanent calendar that was observed throughout the Jewish Diaspora. The religious struggle between Babylonia and Eretz-Israel over the leadership of the nation reached its peak during the dispute about the calendar (921-922), in the course of which the Passover was celebrated on different dates in

*Embroidered Sabbath tablecloth*

*1806, Iran, Collection The Jewish Museum, New York*

**Rosewater flasks**

*Early 20th century, Yemen, Collection*
*The Israel Museum, Jerusalem*

*On the facing page:*
**Zodiac**
*From a Hebrew illuminated manuscript,*
*Florence, 1492, Private collection*

different places in the world. The decision was finally made in favor of Babylonia, due to the authority and personality of Rabbi Saadiah Faiyumi, who later became known as Rabbi Saadiah Gaon (882-942).

The spiritual and literary work of Rabbi Saadiah Gaon changed the cultural patterns of medieval Jewish society. He translated most of the books of the Hebrew Scriptures into Arabic, and also wrote commentaries on most of them. By means of his translation and interpretation project he managed to create a fruitful dialogue with a large Jewish public which had already become so involved in the Arabic culture that it had lost its mastery of Aramaic and written Hebrew. This project also created a counterweight to the powerful influence of the Karaite movement. Saadiah Gaon introduced new literary models borrowed from Arabic culture into Jewish literature, and exposed the Hebrew *piyyut*, which was principally religious verse, to the themes of Arabic poetry. He was the first to compile a Hebrew-Arabic dictionary, and, taking his inspiration from the Arabic science of grammar, he instituted a method of Jewish grammar. He also wrote the important philosophical book *Beliefs and Opinions*, which aimed to establish the principles of the Jewish religion on the basis of reason. In this book he instituted an ordered system of Jewish thought, which was influenced by the Muslim philosophic current of the Kalam.

Jewry's openness to the multiplicity of cultural hues in Islam found conspicuous expression in Muslim Spain (Al-Andalus). From the mid-8th century on, Spain was ruled by the Ummayyad dynasty of kings, who had broken away from the Abbasid Caliphate. During the reign of the Ummayyad caliph Abd al-Rahman III (912-961), the Jewish physician Hisdai Ibn-Shaprut rose to eminence. He conducted diplomatic contacts with delegations which arrived in Cordova from Byzantium and from Germany, and engaged in political negotiations with the kingdoms of Navarre and Leon. From his high position at the Caliph's court, he established a Jewish court which adopted the patterns of the Arabic culture. He financed Jewish men of letters and of science to enable them to engage in creative work in both the religious and the secular domains, and brought about a flourishing integration between Jewish religious study of the Torah and the precepts (*Halakhah*) and "Greek wisdom" — a merging of the religious and the secular domains that characterized the spiritual creative endeavor in Spain in future generations as well. Ibn-Shaprut also brought scholars from distant regions to Cordova. One of these was Dunash ben-Labrat, who was born in Fez, in Morocco. Dunash, who had studied at the Sura *yeshivah* under Saadiah Gaon, enriched Andalusian Hebrew poetry by introducing Arabic prosody, which differentiates between short and long vowels, into it. This was the beginning of a period which many call the "Golden Age" of Spanish Jewry.

Generations of religious sages, men of science and poets continued to arise in Spain even after the break-up of the Ummayyad Caliphate into small principalities (*taifas*) in the early 11th century. In this period, the poet Samuel Halevi ibn-Nagrela (993-1056), known as Samuel Ha-Nagid, lived in the principality of Granada, and was the vizier of the kings Habbus and Badis. His poems describe the wars he led as head of Granada's army against neighboring principalities, and the hedonistic life of the court with its wine banquets, gardens, and competitions among poets. Samuel Ha-Nagid also engaged in commentary on the Talmud, and supported religious scholars in Spain and in other countries. In this period the integration of general and scientific learning with Jewish religious learning found conspicuous expression in the works of the poet Solomon ibn-Gabirol (1020-1058). He wrote sensitive sacred verse — such as the *piyyut* "The Kingly Crown" (*Keter Malkhut*), which was included

in the Sephardic version of the Jewish prayer book — as well as the Neo-Platonic philosophical book *Source of Life* (*Mekor Hayyim; Fons vitae*). Ibn-Gabirol's book had a major influence on the development of philosophy in Western Europe in the late medieval period. Until the 19th century it was attributed to a Muslim philosopher by the name of Avicebron, and the Jewish character of the sacred poet was not discerned in it at all. This phenomenon casts light on the successful integration between the cultural distinctiveness of the Jews in Spain and their full participation in the general scientific endeavor.

The Jewish centers in Muslim Spain were destroyed during the 1140s, after the conquest of Al-Andalus by the Almohads (a Muslim Berber tribe from North Africa), and the promulgation of an edict of forced conversion against the Jews. A portion of the Jews chose to adopt Islam and to live as forced converts; another portion migrated to the Christian states in the Iberian Peninsula, and others preferred to flee to Muslim regions. Of especial renown among the latter was Rabbi Moses Ben-Maimon (Maimonides, "the RaMBaM"), who migrated to Egypt and became the leader (*Nagid*) of Egyptian Jewry in the Ayyubid period. In his literary works, Maimonides brought the long-standing Andalusian tradition to full flowering. He wrote the *Mishneh Torah* ("Repetition of the Law"), which became the basic book for Jewish *halakhic* rulings, and the philosophical book *Guide for the Perplexed*, which became the canonical work of the Jewish philosophical school in the late medieval period.

# Jewish Communities in Western Europe and the "New World": The Medieval and Modern Periods

Jewish habitation in Western Europe began already in the Roman period, but information about the Jews there before the medieval period is very meager, and it is not known whether continued habitation was maintained in each place. In the early medieval period (from the 9th century to the 10th) Jewish centers developed and prospered in Germany and France, particularly after the emperor Charlemagne (768-814) and his heirs began encouraging Jewish immigration from Italy and Spain into the Frankish kingdom. The Carolingian emperors granted the Jews writs of privileges, which accorded them the right of domicile, the security of their lives and their property, the right of independent organization and autonomous administration of their religious life, exemption from customs payments and the right to travel freely from place to place in order to take part in local and international commerce and in the feudal economy. The development of cities in northern Europe from the 11th century on accelerated the growth of the Jewish communities. An important and independent center of Torah learning and of *piyyut* composition developed in Germany (Ashkenaz), in the Rhine Valley (the communities of

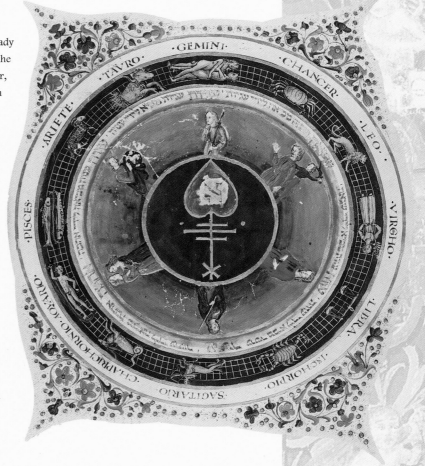

Speyer, Worms, Mainz, Cologne, Trier, and Bonn). The religious leaders at this center dared to pass *halakhic* rulings in opposition to the views of the Babylonian *Geonim* and the Eretz-Israeli *halakhic* tradition. The greatest of the religious scholars in Ashkenaz in this period was Rabbenu Gershom Me'or ha-Golah ("Luminary of the Diaspora"; died in 1028), who drew students from distant places such as Provence and Spain to the community in Mainz. Ashkenazi Jewry attributed to Rabbenu Gershom many regulations which were mandatory for all the Jews in Ashkenaz, among them the regulation that prohibits a man to marry more than one woman. This regulation in effect determined the character of the monogamous Ashkenazi family.

Beside the Torah study and the *piyyut* composition, esoteric learning, too, developed among the *hasidic* (pietist) circles in Ashkenaz. This tradition, which had been brought to Germany from Italy by the Kalonymus family, also influenced the development of an extreme ascetic moral conception. The moral conceptions of the Ashkenazi *hasidim* were put down in writing by the movement's leader, Rabbi Judah he-Hasid (died in 1217), in his essay *Book of Hasidim*, and were later absorbed by most of the Jews in Germany. During the First Crusade (in 1096), the Crusaders conducted pogroms among the Jews of the Rhine, and sought to convert them to Christianity. Many of the Jews refused to convert, and gave their lives on the altar of their faith. From this time on, the idea of "*kiddush ha-Shem*" (martyrdom; literally: "sanctification of the Divine Name") became a central ideal of Ashkenazi Jewry, and was cultivated mainly among the Ashkenazi *hasidim* in the 12th and 13th centuries.

The Jews of Western Europe were exposed to the teachings of the Babylonian *Geonim* principally through the compilation and distribution of their writings by Rabbi Joseph Tov Elem (c. 980-1050), who lived in central France. The Torah center in France, which for a long time was dependent on the scholars of Germany and Provence, became an independent center of learning and teaching with the arrival in Troyes of Rabbi Solomon ben Isaac ("RaSHI", 1040-1105), who had studied at the *yeshivot* in Worms and Mainz. Rashi's commentaries on the Scriptures and the Talmud attained to high esteem, and also spread to Spain. Reading the Torah with Rashi's commentary beside it became part of the basic education received by Jewish boys until the modern period. Many Torah scholars, when citing verses from memory, had difficulties distinguishing between the actual passages and Rashi's commentaries. Rashi's commentary on the Talmud also became an essential tool in the study of *halakhic* issues. His work provided a basis for generations of students and scholars (known as "Tosafists" [*tosafot* = additions], who examined his commentaries critically and wrote remarks about it. In the course of time the method of learning known as *pilpul* — a complicated comparison of texts from different places in the Talmud, bringing out the contradictions among them, and attempting to explain them in various ways — developed in the *yeshivot* in France and Germany. This method required excellent memory and powers of concentration, and a scholar who was good at *halakhic pilpul* was considered as a master of high religious stature. Yet *pilpul* also aroused resistance, and some scholars saw it as injurious to the education of Torah students, who at times turned the *halakhic* debate into frivolous word-play.

From the 12th century on, and mainly during the 13th century, relations between the Christians and the Jews began to deteriorate. The Jews were increasingly pushed out to the

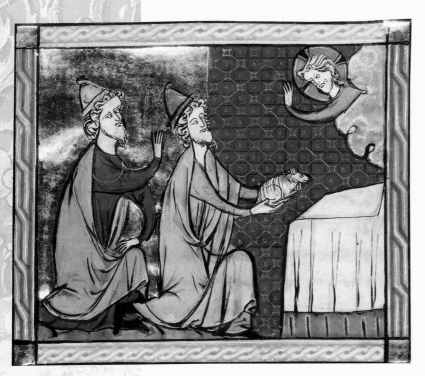

*A sacrificial rite* (detail)
*From a French Bible, 13th century,*
*Collection The Pierpont Morgan Library,*
*New York*

On the facing page:
**Torah Crown**
*Made by George Kahlert the Younger,*
*c. 1782-83, Breslau, Collection The*
*Jewish Museum, New York*

**Purim noisemaker, made of silver,**
**glass stones, topaz**
*19th century, Western Europe, Collection*
*The Jewish Museum, New York*

**Marriage rings**
*17th-18th centuries, Italy, Collection The*
*Jewish Museum, New York*

margins of society, together with other minority groups such as the Catharist heretics and the lepers. At the Fourth Lateran Council (1215), convened by Pope Innocent III, the Christian Church redefined its boundaries. The Council's decisions also affected the Jews. It resolved to limit the interest on loans made by Jews, to differentiate them in their dress, and to prohibit their employment in public positions which involved authority over Christians. In the course of the 13th century the Jews were obliged to wear the "sign of the Jews" (generally a circle colored yellow, red, or white) or the Jews' pointed hat, as was the case in Germany. Concurrently, tensions arose in the large cities between the Jews and the rising Christian burgher class. The Jews were pushed out of international commerce, and in countries such as Germany, France and England they were force to engage exclusively in money-lending for interest. In the cities, the social hostility against the Jews was inflamed by the missionary preaching of the Mendicants — alms-collecting Dominican and Franciscan monks. In this period, too, the blood-libel was reborn in England and Germany, and spread from there in all directions. Gradually the kings of the European states ceased to need the service of the Jews. As a consequence of this, the Jews were expelled, first from England (1290) and then from France (a general first expulsion in 1306, and another expulsion, after they had been allowed to return, in 1394). In Germany no centralized government had developed, so the Jews there were only expelled from certain regions and cities (e.g., the expulsion from Cologne in 1424).

The largest concentration of Jews in Western Europe was in the Iberian Peninsula. From the 11th century on, but mainly from the 13th century on, the Christian states in Spain renewed their *reconquista* (re-conquest), and gradually regained possession of the areas that had been conquered from them by the Arabs in the 8th century. The kings of Aragon, Navarre, Castile, and Portugal wanted to resettle the country, which had been devastated by the wars, and to develop commerce in the cities. In this political situation, the Jews played an important role in the service of the kings and the aristocracy. Many of the Jews in Spain had lived under Muslim rule until the Almohad invasion (c. 1150), and thus knew the Arabic language and the Muslim culture well. The kings of Spain needed the Jews' administrative knowledge, and appointed many of them as tax-collectors, diplomats, translators, suppliers and physicians. Jews also took an active part in transmitting the contents of Muslim science to the lands of Christian Europe. They translated scientific essays from Arabic into Hebrew, Latin, and the vernacular local

*Genesis*

*Illuminated page from a Hebrew Bible manuscript, 14th century, Italy,*

*Collection The Municipal Library, Modena*

languages, and also wrote original scientific essays in the domains of astronomy, astrology, and mathematics, created astronomical instruments (such as astrolabes, clocks, and calipers), and drew compasses and maps of the world.

The Jewish courtiers in Spain adopted the model of courtly behavior of the Muslim period. The Jewish courtier hired sub-courtiers as secondary administrative officials, and aggrandized his name by supporting intellectuals, poets and scientists. The courtiers adapted themselves to the customs of the Hispanic culture. They were called by the noble title "Don", wore magnificent clothes, and participated in parties at the Christian court. Their way of life not infrequently provoked sharp attacks. It was claimed that they were infected with sexual promiscuity, and that they scorned the religious commandments. They, on the other hand, did not see anything wrong with their behavior, and argued with pride that their philosophical learning led to a more correct religious way of life. The courtiers not infrequently acted to help the Jewish communities, and claimed that their wealth and prosperity reflected God's will.

Maimonides' book *The Guide for the Perplexed* laid the basis for the growth of Jewish philosophy in Spain. Beside the Aristotelian currents, a Neo-Platonic philosophy developed, based on the writings of the scriptural commentator Abraham ibn-Ezra. In the 13th and 14th centuries the popularity of philosophy among the Jews aroused opposed spiritual trends, whose proponents feared the negative effect it might have on the observance of the religious commandments. A succession of sharp social polemics shook the communities in Spain and Southern France, until in 1305 Rabbi Solomon ibn-Adret (the RaSHBA), the leader of the Jews of Aragon, proclaimed a ban on studying philosophy before the age of 25. The ban, however, did not lead to the hoped-for result; rather, philosophy flourished during the years following the proclamation, and the ban may have actually led to an opposite result by arousing greater interest in philosophy.

A major role in the movement of opposition to radical philosophy was taken by the Kabbalists. The doctrine of the Kabbalah had established itself in Spain in the

*Silver Hanukkah lamp*
*Made by Johann Valentin Schuler, c.1680*
*Frankfurt, Collection The Jewish Museum,*
*New York*

*Torah binder*
*Made by Shimshon Kurzman,*
*c. 1848, Bayreuth, Bavaria, Collection*
*The Jewish Museum, New York*

early 13th century, among the circle of Kabbalists in Gerona (in Catalonia), who had received most of its esoteric traditions from an earlier Kabbalist center that had been active in Provence. The Gerona Kabbalists included Ezra ben-Solomon and Azriel of Gerona, and the renowned scriptural commentator and interpreter of the *Halakhah*, Rabbi Moses ben-Nahman (the RaMBaN; Nahmanides). Another Kabbalist center was founded in Burgos, but Kabbalah in Castile reached its peak with the composition of *The Zohar* ("The Radiance"; 1275-1285), which was attributed to the *Tanna* (one of the Sages of the Mishnah) Rabbi Shimon Bar-Yochai. *The Zohar* (which was later canonized as a sacred text) was probably written by

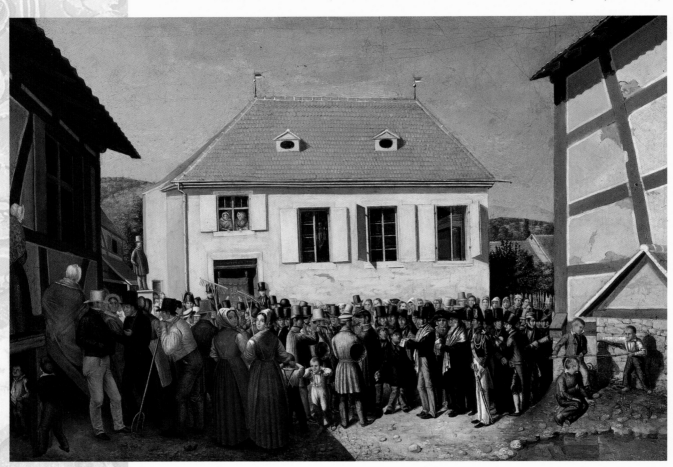

**Dedication of a synagogue in Alsace**
*Anonymous painter, c. 1828,*
*Collection The Jewish Museum, New York*

On the facing page:
**Silver Kiddush cup**
*Made by Thomas Ringler, c. 1700,*
*Nuremberg, Collection The Jewish Museum, New York*

**Silver Torah finials**
*Made by Jeremias Zobel, c. 1720,*
*Frankfurt, Collection The Jewish Museum, New York*

a circle of Kabbalists, one of whom was Rabbi Moses de Leon. Beside the rationalist tendencies introduced by philosophy, the Kabbalah helped to preserve the vitality of the Jewish religion, and accorded a metaphysical meaning to the observance of commandments.

In 1391 extensive pogroms against the Jews broke out in Spain, with disastrous results. Mobs incited by the sermons of the Archdeacon of Seville, Ferrant Martinez, burst into the Jewish neighborhoods in Castile and Aragon in order to kill Jews and plunder their property. Many communities were destroyed and entirely razed, many of the Jews in Spain died "for the sanctification of the Divine Name", and many saved their own lives by converting to Christianity. Thus the historical phenomenon of forced converts (*anusim, conversos*) developed in Spain. During the years after this, large communities of *conversos* in Spain lived beside the Jews. In the course of the 15th century these "New Christians" were joined by tens of thousands of Jews who converted voluntarily in response to missionary pressure and social and economic edicts. The physical proximity between the Jews and the *conversos* was accompanied by strong economic and social ties, but also aroused friction and hatred. Among the Christians, the *conversos* aroused strong envy and economic competition, which led to the growth of hostile public opinion and the development of racist hatred and the promulgation of discriminatory laws based on "purity of blood" ("*estatutos de limpieza de sangre*"). During

this period Christian suspicions that the *conversoss* were secretly observing the Jewish commandments and customs gradually increased until, due to pressure from the clergy, the Catholic monarchs Ferdinand and Isabella agreed to institute the Spanish national Inquisition (1478-1480), whose task was to investigate and eradicate the religious heresy that was spreading among the *conversos*. In the 1480s the Inquisition was vigorously active, and accused many people of Judaization. Hundreds of *conversos* were burned in "acts of faith" (*autos de fe*), and thousands were forced to "repent" with various penances. Finally, through the pressure of the Grand Inquisitor, Tomás de Torquemada, the Catholic monarchs agreed that the only solution to the problem of heresy was to expel the Jews who were living beside the *conversos* and exerting a bad influence on them. After completing the *reconquista* with the capture of the last Muslim stronghold in Granada (1492), Ferdinand and Isabella expelled the Jews from Spain, bringing the period of fruitful co-existence that had been created among Jews, Muslims and Christians in Spain to a tragic end.

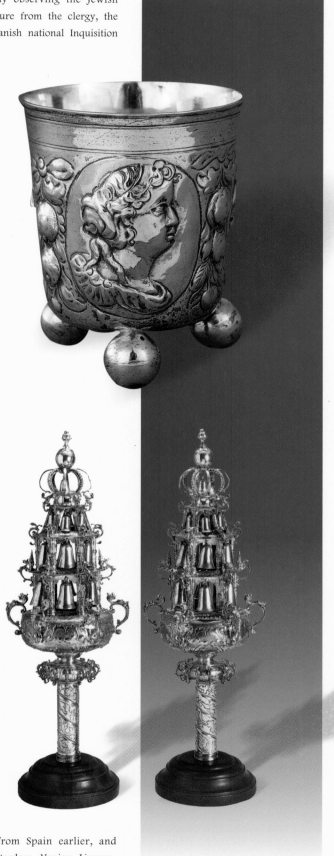

The number of Jews expelled from Spain is disputed, and the estimates range between one hundred thousand and three hundred thousand people. Most of the expelled Jews turned to Portugal, because of the common land border between the two countries. They were permitted to stay there for only eight months, but did not manage to leave the country in time. Many were sold into slavery, and about 700 children were separated from their parents and sent to São Tomé Island. In 1497, the king of Portugal, Manuel I, wanted to marry the daughter of the kings of Spain, and was therefore obliged to accept the condition posed him by Ferdinand and Isabella, and to expel all the Jews in Portugal. After promulgating the expulsion edict, Manuel decided that expelling the Jews would only bring harm to his kingdom, and promulgated an edict of compulsory conversion, which immediately turned them all into forced converts. From that time on, Jews no longer lived in the Iberian Peninsula, but the spirit of Judaism was preserved among the circles of forced converts for many years.

After the Inquisition was instituted in Portugal as well (1536), many of the forced converts decided to leave the Iberian Peninsula and to migrate to the Ottoman Empire, to Italy, to France, and to Protestant countries such as the Netherlands and Germany. Some of them reverted openly to Judaism, and others preferred to conduct a Christian way of life within communities of *conversos*. They exploited their connections in the Iberian Peninsula to build an intricate international mercantile network. The Spanish (Sephardi) dispersion in Western Europe was small in number compared with the communities of expulsees from Spain in the Ottoman empire, and the new centers which arose in the West were different in their social and cultural character from the Jewish communities in the Mediterranean basin. The forced converts who migrated to Italy, Turkey and the Balkans were received by communities of Jews who had been expelled from Spain earlier, and became absorbed into them. In contrast, the Jewish centers in Amsterdam, Venice, Livorno, Hamburg, London, Bordeaux and Bayonne were originally established by forced converts who

returned to Judaism, and therefore new and different community frameworks were established in these places. These communities opened themselves to the introduction of modernity, and the beginnings of processes of enlightenment and assimilation began to appear. Many of the forced converts had acquired broad scientific learning at the universities of Spain and Portugal, and they continued their scientific and cultural dialogue with the Christians in the countries they migrated to as well. Some of them developed a skepticism towards religious institutions (both Jewish and Christian), and Christian spiritualism prepared the way for the view that faith and inward identification with Judaism was superior to strict observance of the commandments. A distinctive expression of these trends was embodied in the lives of Uriel da Costa and Barukh Spinoza. Da Costa committed suicide after he was excommunicated in a humiliating ceremony by the Amsterdam community. Spinoza, who was also excommunicated by the Jewish religious leaders in Amsterdam, severed himself from the Jewish community and lived for the rest of his life (he died in 1677) outside of any religious framework.

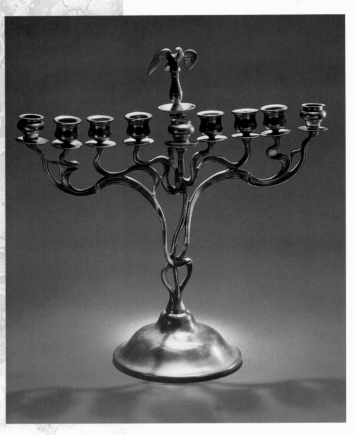

**Hanukkah lamp with American Eagle**

*c. 1900, U.S.A., Collection The Jewish Museum, New York*

The descendants of the forced converts were also the first to reach the American continent. Some of them even formed part of the crew of Christopher Columbus' expedition (1492), and others participated in the conquests by the "*conquistadores*" in Mexico, Peru, and Chile. At first, "New Christians" were not permitted to settle in America, but they continued to migrate to there, and even the institution of a branch of the Spanish Inquisition in America did not halt their settlement in the "New World". In the course of the 17th century the Spanish-Portuguese dispersion became a most important factor in the view of colonialist countries such as the Netherlands and England, which sought to exploit the *conversos*' mercantile networks, and even encouraged Jewish merchants from Western Europe to settle in their provinces on the American continent. The first overt Jewish community in America was established in Recife, in north-eastern Brazil (1642), after the conquest of this region by the Dutch. The Jews in Recife were granted full equality of rights, their status was officially recognized in the "honored writ of rights" (*Patenta Onrossa*) which they received from the authorities, and Isaac Aboab da Fonseca was appointed rabbi of the community. However, when the region fell to the Portuguese once again (1654), the Jews of Recife dispersed to various places: some returned to Amsterdam, others went to colonies in the Caribbean islands. and some of the refugees reached New Amsterdam that same year and became part of the first nucleus of the community in New York (the name given to New Amsterdam after the English conquest). In the 18th century, many Jews from Germany and Poland joined the English colonies in North America, establishing the Ashkenazi dominance among the Jewish communities there. As inhabitants of a country of immigration with a pluralistic tradition in its attitude to minorities, the Jews in the English colonies enjoyed many civil rights. They took an active part in the colonists' struggle for independence (1765-1781) and attained to emancipation before the Jews in Western Europe.

The French Revolution (1789) led to a change in the civil status of the Jews on the European continent. In 1790 the Spanish-Portuguese dispersion in France obtained full equality of rights, and a year later emancipation was accorded to all the Jews in France. Napoleon, who wanted to integrate the Jews into the French political system, established the "Consistory" ("*Consistoire*"), the central organization of Jews in France (1808). The French army's conquests spread the idea of emancipation to Italy and the Low Countries as well.

*On the facing page:*

**Woman's headpiece,**

*Early 20th century, Morocco, Collection The Israel Museum, Jerusalem*

**Rural necklaces**

*Early 20th century, Morocco, Collection The Israel Museum, Jerusalem*

Also in the 18th century, Jews in the German principalities drew closer to the ideas of the Enlightenment, and aspired to blend the Jewish tradition with the German culture. The most prominent of these was the philosopher Moses Mendelssohn, who translated the Torah into German and appended a modern, rationalistic Hebrew commentary to it (1780-1783). The following generation of Jews in Germany saw the rise of the major movements of modern Judaism: the Reform movement, the Neo-Orthodox movement, and the discipline of the "Science of Judaism", which was instituted in Berlin with the founding of "The Society for the Culture and Science of Judaism" (1819). In the 19th century Jews obtained equal rights in the Austro-Hungarian Empire, and in countries such as Denmark, Sweden, and Switzerland. The Emancipation accelerated the processes of modernization and of the integration of the Jews into their surroundings, but these trends, which brought the Jews closer to European society with its culture and its liberal values, were accompanied by the rise of modern anti-Semitism. In the late 19th century the anti-Semitic movement in France engendered the Dreyfus Affair (1894), which provoked Theodore Herzl to political activity and to the founding of the Zionist movement at the Basle Congress (1897).

# Expulsees from Spain in North Africa and the Countries of the Ottoman Empire

The majority of the expulsees from Spain migrated to North Africa and the countries of the Ottoman Empire. Some of them moved to Italy, but after the French conquest (1495) many of these joined their brethren in the Ottoman countries. In Morocco the Jews from Spain settled in the big cities, such as Fez, Meknes, and Marrakesh, and some in the coastal cities. Frequent disputes broke out between them and the local-born Jews over the correct customs or over the leadership of the community, and in these places the Spanish immigrants overshadowed the local Jews. In their cultural, social and organizational structure the new communities resembled the communities in Spain, but in southern Morocco the Spanish (Sephardic) influence was almost indiscernible. In Algeria and Tunisia the expulsees joined communities in which there was already a prominent Sephardic presence from the time when the refugees of the 1391 pogroms had arrived there. In Egypt, too, the expulsees from Spain became a major factor in the community and its leadership. The important halakhic scholar Rabbi David ibn-Zimra (the RaDBaZ, 1479-1573) attained to a prominent position there.

In the 17th and 18th centuries, the Jews in North Africa, and especially the merchants in Morocco, took advantage of the interest the Western European countries were taking in the region, and of the conflicts of interests between Spain and Germany, on the one hand, and England, France and the Low Countries, on the other. Jewish families served the *sherifs* of Morocco for many generations. They were sent on

diplomatic missions, served as translators, leased tax-collecting rights and sugar refineries, and engaged in all the branches of Mediterranean trade. The European presence in North Africa and the penetration of Western capitalism led to the increased importance of the coastal cities, and to the migration of Jews to them from the country's interior. In the course of time, due to the pressure of the European powers, the living conditions and legal status of the Jews in the lands of the Maghreb improved. As the Western influence increased, the process of granting the Jews equal rights accelerated, and the discriminatory "Covenant of Omar" regulations were abolished. Concurrently, tension grew between the Jews and the Muslim population, who resisted the European colonialism and did not approve of the Jews' cooperation with it.

Expulsees from Spain and Portugal arrived in their multitudes in the cities of the Ottoman Empire in the Balkans and Asia Minor, and already in the first generation they outnumbered the local Jewish inhabitants of longstanding, such as the *Romaniots* (speakers of Greek). In cities such as Salonika and Safed the Jews comprised the

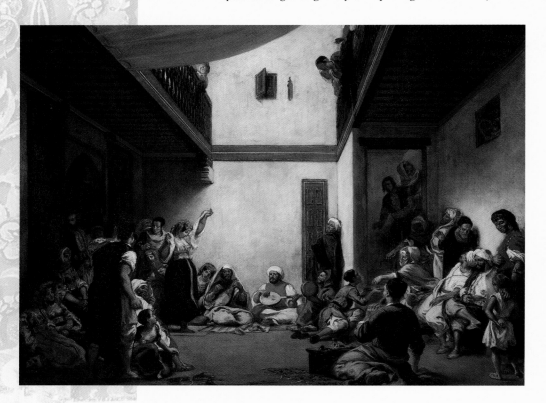

**A Jewish wedding in Morocco**
*Eugène Delacroix (1798-1860), 1839,*
*Collection The Louvre, Paris*

majority of the population, and in Istanbul they comprised about ten per cent of the entire population. They settled in separate communities ("*kehalim*"), on the basis of their city, province or country of origin (Castile, Catalonia, Aragon, Lisbon, Seville, Cordoba, etc.). In the big cities the number of these separate communities came to several dozens, while in smaller towns there were two to six of them. With time, due to inter-marriage, disputes and splits, the separate communities — including those of non-Sephardic origin, such as Jews from Provence or Italy — became mixed with one another. The large number of expulsees led to the absorption of the *Romaniots* into the Sephardic majority, and ultimately to the almost total disappearance of their Greek language, Byzantine customs, form of prayer, and way of life. The communities no longer preserved their initial origins, but they continued to maintain their separate organizations and their names.

The expulsees and their descendants engaged in international trade. They built a network of family and economic connections which was based on their extensive geographical distribution around the Mediterranean basin. They became well integrated into the Ottoman economic system, and many of them attained to prominent positions as physicians or financiers in the courts of the Sultans. They also brought knowledge from Spain which assisted in the development of new industries in the fields of textiles and weaving. The spiritual flourishing of the Kabbalist center in Safed in the 16th century, for example, was indeed an outcome of the arrival in this town of Isaac Luria ("HaARI"), Moses Cordovero, Hayyim Vital, Solomon Halevi Alkabez, and others, but the existence of the center in Safed was made possible because of the town's rapid economic development after the weaving and wool-dyeing industries had become established there. One of the most prominent religious

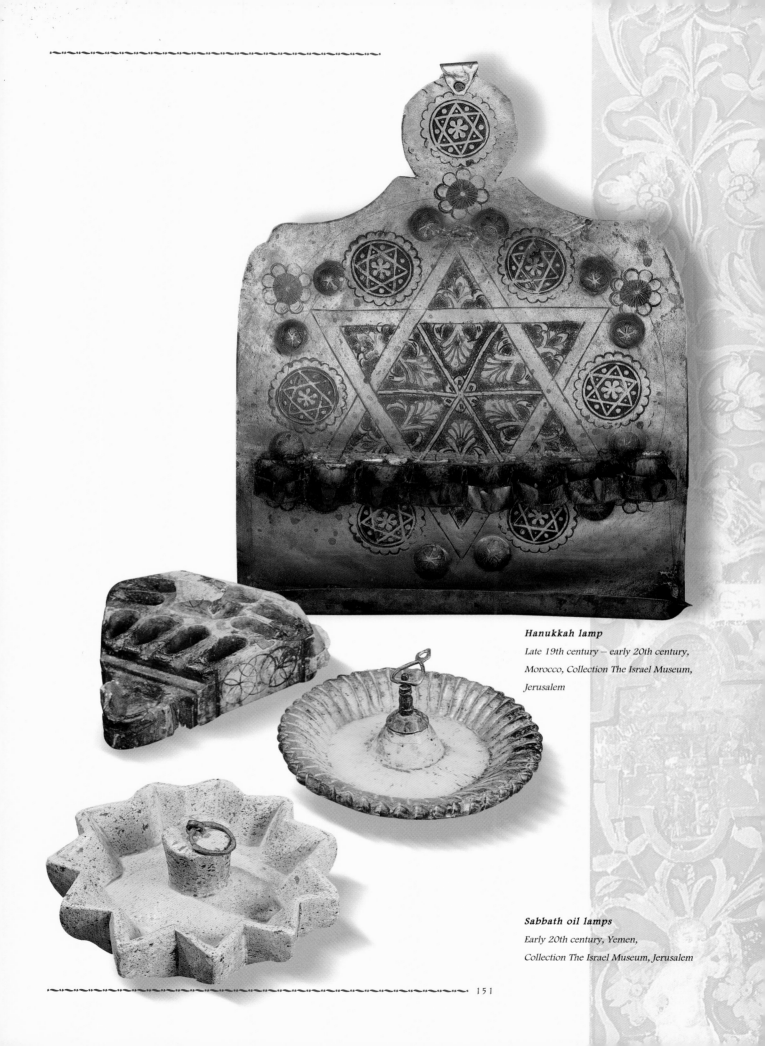

**Hanukkah lamp**

*Late 19th century – early 20th century,*
*Morocco, Collection The Israel Museum,*
*Jerusalem*

**Sabbath oil lamps**

*Early 20th century, Yemen,*
*Collection The Israel Museum, Jerusalem*

scholars among the expulsees in Safed was the *halakhic* teacher and Kabbalist Rabbi Joseph Caro (1488-1575), the author of *Beit Joseph* ("House of Joseph) and of the *Shulhan Arukh* ("Prepared Table"), which became the fundamental codex for *halakhic* rulings for all the Jewish people. In the 17th century the Jewish centers in Safed and Salonika declined because of the collapse of the Ottoman textile industry. The Jewish community in Istanbul remained stable, and another important Jewish center began to develop in Smyrna. Many of the Jews

in Salonika, Safed and the cities in the Balkans migrated there, and were joined by a new wave of forced converts who had fled from Portugal.

The rich and erudite background of the forced converts from Portugal proved fertile soil for the growth of the biggest messianic movement in the history of the Jewish people — the Sabbatarian movement. The movement was led by Sabbatai Zevi (1626-1676), who was born in Smyrna. Its evangelist was Nathan of Gaza, who had met Sabbatai Zevi in Jerusalem, and claimed to have had a vision that the latter was the Messiah. The messianic fervor swept through the Jewish communities in Eastern and Western Europe, the Ottoman countries, North Africa and Yemen, and for a brief period created an inner spiritual unity throughout the entire Jewish world. The experience of the imminent Redemption faded after Sabbatai Zevi converted to Islam under the pressure of the Turks (1666). Appendages of the movement, who remained loyal to their Messiah even after his conversion, developed an underground Sabbatarian theology in the spirit of the Lurianic Kabbalah, which said that the Messiah had to descend to the roots of impurity and sin (the "shells") in order to redeem the "sparks" of the divine from there and to bring repair ("*tikkun*") to the world. Some historians point to the long-range ramifications of the Sabbatarian movement: on the one hand, the new world consciousness which the movement brought to its believers, while breaking the rules of the tradition and abolishing *halakhic* prohibitions and commandments — a consciousness which matured in the 18th century among assimilated Jews and those involved in the Enlightenment movement; and, on the other hand, the esoteric Sabbatarian mysticism and the introversion of the messianic idea from the public domain to that of the individual. These factors penetrated into the spiritual world of the Jews in Eastern Europe, and contributed to the shaping of the Hasidic movement.

*Jewish Musicians at Mogador*
*Eugène Delacroix, 1847,*
*Collection The Louvre, Paris*

# The Jews in Eastern Europe

*U*ntil the modern period, the Jews in Eastern Europe constituted the largest Jewish dispersion. The earliest knowledge we have about Jews in Russia and Poland stems from the early Middle Ages, but the growth and consolidation of Jewish life there began in the late 12th century and the early 13th century. This was the period when the Kingdom of Poland began to flourish, and its rulers encouraged the immigration of merchants (including Jews) from Western Europe, principally from Germany and Bohemia. The first writ of rights was accorded to the Jews in Poland in 1264 by Duke Boleslaw of Kalisz, and this later became the basis for other privileges. After the pogroms and expulsions suffered by the Jews in Ashkenaz during the 14th and 15th centuries, many of them chose to migrate eastwards to Poland. Most of the demographic growth of the Jewish population in Poland occurred in the period between 1500 and the pogroms of 1648-1654, when hundreds of communities were exterminated by regiments of Cossacks, Tatars, and Ukrainian peasants. The majority of the Jews lived in small towns, and only about a third of them in rural districts. The Jews engaged in trade, the leasing of estates, craft, and money-lending at interest, and supplied administrative and marketing services. As a consequence of the depletion of the Christian population in the towns and of the high birth-rate among the Jews, the Jewish population of the towns increased to the point that the phenomenon of the "*shtetl*" — a town with an absolute majority of Jews, in which life has a distinctively Jewish character — came into being.

The organizational framework of the Jews in the Diaspora was generally the local community. Each community ran its affairs by itself, by means of its elected institutions: the religious court, the scribe, the cantor, the tax assessors, and the leadership. However, the great extent of Polish Jewry, and the geographical spread of its scattered communities, created a need for supra-community organizations, and the mid-16th century saw the foundation of the Council of Four Lands in the Kingdom of Poland, and the Council of the Land of Lithuania in the Principality of Lithuania. These two councils supervised the local communities by virtue of their authority as supreme religious courts and as bodies that could promulgate regulations, but they did not violate the autonomy of the Jewish communities. They used to lease the taxes due from all the Jews in the kingdom, and impose the payments on the communities, and they also directed Jewish economic life and instituted various arrangements connected with the leasing of lands and the management of estates. The Jews regarded the councils as an expression of political status, so when the councils were abolished in 1764 by a decision of the *Sejm* (the parliament of Polish nobles), the Jews felt grievously insulted.

The fame of the Torah center in Poland spread afar, due to the *yeshivot* which arose there in the 16th and 17th centuries, and to the heads of these *yeshivot*, who attracted many students from Italy, Germany, Holland, Bohemia, and other countries. One of the first of these heads of *yeshivot* was Jacob Pollak, who established his *yeshivah* in Cracow, and also attained to recognition and appointment as "[Chief] Rabbi of the Jews" (1503) by the king of Poland, Alexander Jagellon. In later generations, famous religious scholars active in Poland included Rabbi Solomon Luria (died in 1573), and Moses Isserles (died in 1572), whose essay *Ha-Mapah* ("The Tablecloth") was added to Joseph Caro's *Shulhan Arukh*. Joel Sirkes (1561-1640), head of the *yeshivah* in Cracow, in his book *Bayit Hadash* ("A New House"), polemicized with Caro's *halakhic* rulings in the latter's book *Beit Joseph*.

**Beaker of a Jewish Burial Society**
*1691, Bohemia, Collection The Jewish Museum, New York*

In the second half of the 18th century, the Hasidic movement spread through Eastern Europe. The founder of the movement, Israel Ba'al Shem-Tov ("the BeSHT", 1700-1760), developed a method of worshiping God that was based on the doctrine of the Kabbalah but gave the traditional mystical concepts an invigorating interpretation, the essence of which was inner experience by the individual, by way of devotion to God. He taught a small group of select students, among whom Dov Baer, the "*Magid*" from Mezhirech (1710-1772), was the most prominent. In the following generations the movement spread through Poland, Volhynia, Podolia, Galicia, Byelorussia and Lithuania. The students of the "*Magid*" developed the forms of the Hasidic "court", and "the teaching of the *Zaddik*". Their courts became places of pilgrimage even for the popular strata of the Jewish public, and in them the various ways of administering the heritage and of educating Hasidim were evolved. The most prominent students of the "*Magid*" were Rabbi Levy Isaac of Berdichev, Rabbi Elimelech of Lyzhansk, and Rabbi Shneur Zalman of Lyady.

The Hasidic movement aroused strong opposition among the established leadership of the Jews in Eastern Europe. Those who opposed it, the "Mitnagedim", were led by the leaders of the community in Vilna, headed by the "Vilna Gaon", Rabbi Elijah (died 1797). In 1772 the Lithuanians called on all the other communities to join them in their struggle and to pronounce a ban on the deviant sect of Hasidim. The leaders of the Hasidim and their supporters were persecuted by their opponents. They were dismissed from their public positions and many lost their livelihood. In the course of the polemic with the Mitnagedim, the Hasidim also involved the gentile authorities, and as a consequence of a series of reciprocal acts of informing many on both sides were harmed. All the attempts by the Mitnagedim to curb the growth of Hasidism failed, and in 1804 the Russian authorities recognized the Hasidim's right to maintain separate prayer meetings of their own. As an ideological response to Hasidism, the scholastic rabbinate in Lithuania developed a new educational method, which was instituted by Rabbi Hayyim of Volozhin (1749-1821). In the early 19th century, the "*Mussar* [ethical behavior] movement*", which integrated profound Talmudic study with high moral demands, arose among the Mitnagedim in Lithuania. Both movements, Hasidim and Mitnagedim alike, were also constrained at this time to confront the new "threat" to the tradition from the Enlightenment (*haskalah*) movement.

After the division of Poland (1795), the Jews there were included within the bounds of the Russian and the Austrian empires. The processes of modernization penetrated into the traditional Jewish society only in the second half of the 19th century. The reforms instituted by Czar Alexander II of Russia (1855-1881) led to the collapse of the method of large agricultural estates, which undermined the economic basis of the Jews of the *shtetls*, but at the same time the Jews benefited from an improvement of their political rights. The penetration of the Enlightenment into Eastern Europe, the discriminatory edicts, trends of state anti-Semitism and pogroms accelerated the process of emigration of Jews from Russia to the West and especially to the United States. This mass migration changed the social character of United States Jewry and created a blend of the East-European Orthodox tradition and the local American tradition. On the background of the weakening of the old organizational structure of the Jewish community in the United States, and in light of the new economic and social possibilities, Reform Judaism became established as the central current in United States Jewry, but Orthodox frameworks of life continued to exist beside it, and the new current of Conservative Judaism was born. These currents, beside the Zionist movement, largely shaped the Jewish discourse during the entire 20th century.

**Torah mantle**

*Made of velvet, embroidered with beads and metallic threads, 1870-71, Galicia, Collection The Jewish Museum, New York*

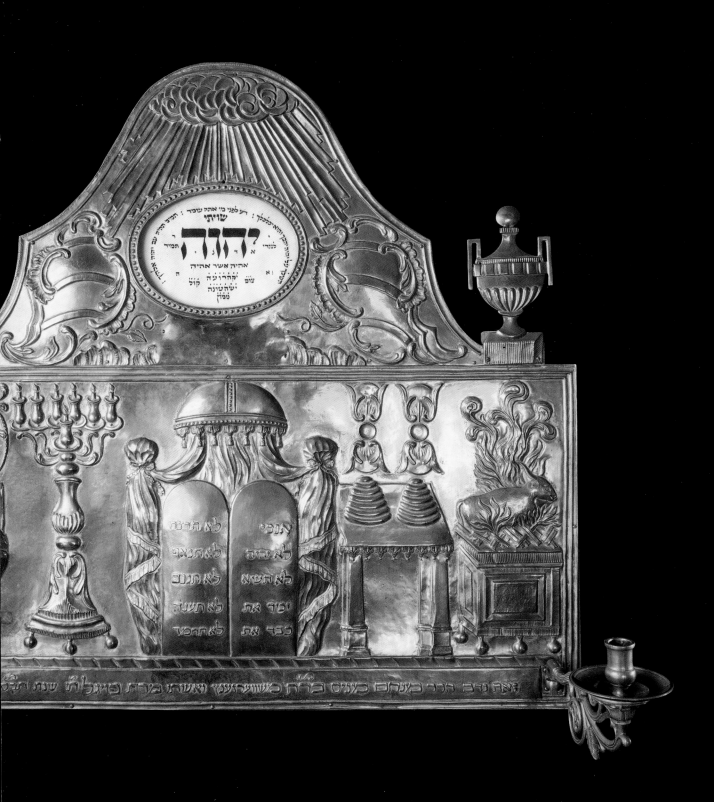

**"Shiviti" plaque**

*Gilt brass, and ink on parchment,*
*1803, Prussia, Collection The Jewish*
*Museum, New York*

# Acknowledgments

The authors and the publisher wish to thank the libraries, museums, and private collectors listed below for permitting the reproduction of works of art in their collections and for supplying the necessary photographs.

# Sources

Collection The Antiquities Authority, The Israel Museum, Jerusalem: 20, 21, 24, 26, 34, 36, 44, 46, 47, 50, 58, 59, 62, 72, 79, 92, 105, 110, 114, 116, 118.

Collection Biblioteca Nazionale, Turin: 51.

Collection Bibliothèque Nationale, Paris: 48, 56, 66, 90, 102, 106-107.

Collection The British Library, London: 93.

Collection The British Museum, London: 134.

Collection Chateau de Versailles, France: 54.

Collection The Fine Art Society, London: 101, 103.

Collection The Israel Museum, Jerusalem: 19, 30, 32, 40, 44, 45, 52, 70, 73, 78, 82, 88-89, 97, 100, 103, 104-105, 108, 127, 135, 140, 149,151.

Collection The Jewish Museum, New York: 133, 138, 139, 143, 145, 146, 147, 148, 153, 154, 155.

Laor Collection, Jewish National and University Library, Jerusalem: 12, 27.

Collection The Louvre, Paris: 28-29, 36-37, 56-57, 67, 150, 152.

Collection Municipal Library, Lyon, France: 64-65.

Collection Municipal Library, Modena: 144.

Collection Musée Conde, Chantilly, France: 15, 68-69.

Collection The National Maritime Museum, Haifa: 139.

Collection The Pierpont Morgan Library, New York: 84-85, 142.

Stapleton Collection, London: 25, 33, 63, 75, 76, 83, 87, 95, 111, 112, 115, 131.

Albatross: 17, 35, 53, 74, 80-81, 94, 98-99, 109, 117, 120-121.

Art Resource: 15, 28-29, 36, 40-41, 42-43, 56-57, 67, 84-85, 125, 134, 142, 150, 152.

Bridgman: 14, 25, 33, 51, 54, 56, 63, 64-65, 66, 69, 75, 76, 83, 86, 93, 95, 101, 103, 106-107, 111, 115, 119, 122, 131, 137.

Shai Ginott: 22-23, 38-39, 60-61.